THE ART OF
COMMEMORATION
IN THE RENAISSANCE

Irving Lavin. Randall Hagadorn photographer. From the Shelby White and Leon Levy Archives Center, Institute for Advanced Study, Princeton, NJ, USA.

THE ART OF COMMEMORATION IN THE RENAISSANCE

THE SLADE LECTURES

IRVING LAVIN

EDITED BY

MARILYN ARONBERG LAVIN

ITALICA PRESS
NEW YORK & BRISTOL
2020

Copyright © 2020 by Marilyn Aronberg Lavin
Studies in Art and History Series
Visit our website at: http://www.italicapress.com/index009.html.

ITALICA PRESS, INC.
99 Wall Street, Suite 650
New York, New York 10005
inquiries@italicapress.com

All rights reserved. No part of this publication may be reproduced, stored in a retrieval system, or transmitted, in any form or by any means, electronic, mechanical, photocopying, recording, or otherwise, without prior permission of Italica Press. It may not be used in a course-pack or any other collection without prior permission of Italica Press.

Library of Congress Cataloging-in-Publication Data
Names: Lavin, Irving, 1927-2019, author. | Lavin, Marilyn Aronberg, editor.

Title: The art of commemoration in the Renaissance : the Slade Lectures / Irving Lavin ; edited by Marilyn Aronberg Lavin.
Other titles: Lectures. Selections
Description: New York : Italica Press, 2020. | Series: Italica press studies in art and history series | Includes bibliographical references and index. | Summary: "In the early 1980s, Irving Lavin delivered The Slade Lectures at Oxford University exploring his idea that the Italian fifteenth-century revival of ancient art was an outward sign of fundamental changes in humanity's perception of the inner self. This volume publishes for the first time six essays, which he based on those lectures and which he continued to work on until his death in 2019: Memory and the Sense of Self; On the Sources and Meaning of the Renaissance Portrait Bust; On Illusion and Allusion in Italian Sixteenth-Century Portrait Busts; Great Men Past and Present; Equestrian Monuments; and Collective Commemoration and the Family Chapel" — Provided by publisher.
Identifiers: LCCN 2020039172 (print) | LCCN 2020039173 (ebook) | ISBN 9781599103907 (hardcover) | ISBN 9781599103914 (paperback) | ISBN 9781599103921 (kindle edition) | ISBN 9781599104058 (adobe pdf)
Subjects: LCSH: Art, Italian — Themes, motives. | Art, Renaissance — Italy — Themes, motives. | Self-perception.
Classification: LCC N6915 .L297 2020 (print) | LCC N6915 (ebook) | DDC 709.45 — dc23
LC record available at https://lccn.loc.gov/2020039172
LC ebook record available at https://lccn.loc.gov/2020039173

Cover Illustration: Giovanni di Ser Giovanni Guidi, called Scheggia, *Triumph of Fame*, birth tray, 1449. New York, The Metropolitan Museum of Art, acc. no. 1995.7

CONTENTS

List of Illustrations	vi
Preface by Marilyn Aronberg Lavin	xvi
1. Memory and the Sense of Self: On the Role of Memory in Psychological Theory from Antiquity to Giambattista Vico	1
Notes	21
2. On the Sources and Meaning of the Renaissance Portrait Bust	23
Antiquity	27
The Middle Ages	30
The Transition to the Renaissance Bust	33
Conclusion	34
Appendix	38
Chronological checklist of inscribed Florentine portrait busts of the Quattrocento	38
Notes	41
3. On Illusion and Allusion in Italian Sixteenth-Century Portrait Busts	51
Notes	66
4. Great Men Past and Present	69
Notes	102
5. Equestrian Monuments: The Indomitable Horseman	107
Notes	132
6. Collective Commemoration and the Family Chapel	135
Notes	166
Bibliography	169
Index	183

ILLUSTRATIONS

Frontispiece. Irving Lavin. Randall Hagadorn photographer. From the Shelby White and Leon Levy Archives Center, Institute for Advanced Study, Princeton, NJ, USA ii

Fig. 1.1. David inspired by Melodia. Paris Psalter. 10th c. Paris, Bibliothèque nationale de France, Ms. Gr. 139, fol. 1. 2

Fig. 1.2. St. Mark inspired by his Muse (Sophia?). 6th c. Rossano, Codex Rossanensis, fol. 121r. 3

Fig. 1.3. Robinet Testard, Minerva, in Évrard de Conty, *Échecs amoureux*. France (Cognac), c. 1496–98. Paris, Bibliothèque nationale de France, Ms. Fr. 143, 117v. 5

Fig. 1.4. Nicola Pisano, *Fortitude*, marble, 56 cm, 1260. Pisa, Baptistry, pulpit. 5

Fig. 1.5. "Disease man," with diagram of the brain cells (sensus co[mmun]is, cellula ymagi[n]a[iv]a, cella estimativa vel r[ati] onis, cella memo[rati]va), c. 1400. Paris, Bibliothèque nationale de France, Ms. Lat 11229, fol. 37v. After Clarke Dewhurst, *An Illustrated History of Brain Function*, Fig. 34. 11

Fig. 1.6. Diagram of perception and brain function (s[ensu]s c[ommu]nis, ymagi[na]t[iv]a. Estimacio, memoracio, cogitacio, pia mater, dura mater), 1367. John Pecham, *Perspectiva communis*. Vienna, Oesterreichische Nationalbibliothek, Ms. 5210, fol. 56v. After Clarke and Dewhurst, Fig. 57. 11

Fig. 1.7. Mnemosyne and Calliope. White ground lekythos. After *Monumenti antichi*. Universitätsbibliothek Heidelberg 17 (1906), pl. XXVI. 13

Fig. 1.8. Guillaume de Deguilville, *Pelerinage de vie humaine*. Paris, Bibliothèque nationale de France, Ms. Fr. 823, 1393. Grace Dieu shows the pilgrim a suit of armor, fol. 27. After Kolve, *Chaucer*, Fig. 25. 14

Fig. 1.9. Guillaume de Deguilville, *Pelerinage de vie humaine*. Paris, Bibliothèque nationale de France, Ms. Fr. 823, 1393. The pilgrim throws off his suit of armor, fol. 34r. Kolve, Fig. 28. 14

ILLUSTRATIONS

Fig. 1.10. Guillaume de Deguilville, *Pelerinage de vie humaine*. Paris, Bibliothèque nationale de France, Ms. Fr. 823, 1393. Grace Dieu introduces Lady Memory to the pilgrim, fol. 34v. Kolve, Fig. 29. 14

Fig. 1.11. Guillaume de Deguilville, *Pelerinage de vie humaine*. Paris, Bibliothèque nationale de France, Ms. Fr. 823, 1393. Lady Memory takes up the pilgrim's armor, fol. 35v. Kolve, Fig. 30. 14

Fig. 1.12. Juno–Mercury, early fifteenth century. John Ridewall, *Fulgentius Metaforalis*. Rome, Biblioteca Apostolica Vaticana, Ms. Pal. Lat. 1066, fol. 223v. After H. Liebeschütz, *Fulgentius Metaforalis*. Leipzig: B.G. Teubner, 1926, pl. II. 15

Fig. 1.13. The ventricles of the brain (s[ensu]s co[mmun]is/ ymagi[nativ]a, fantasia/extimat[iv]a, me[m]oria/motiva). Agostino Trionfo, *Opusculum de cognitione animae*. A. Achillini, ed. Bologna, 1503, sig. f.[viii]. After Clarke and Dewhurst, Fig. 34. 17

Fig. 1.14. Diagram of brain functions and cosmology (sensitiva/ imaginativa, cogitativa/aestimativa, memorativa/motiva). R. Fludd, *Utriusque cosmi maioris scilicet et minoris, metaphysica, physica atque technica historia*. 2 vols. Oppenheim: De Bry, 1617–21, II.1:217. After Clarke and Dewhurst, Fig. 57. 17

Fig. 2.1. Bust of Aurelia Monnina. 3rd c. Staatliche Museen, Berlin. 24

Fig. 2.2. Mino da Fiesole, Bust of Piero de' Medici, 1453. Museo Nazionale del Bargello, Florence. 24

Fig. 2.3. Jacopo del Sellaio, Scene from the Story of Esther, detail. Galleria degli Uffizi, Florence. 25

Fig. 2.4. Jacopo del Sellaio, Scene from the Story of Esther, detail, Banquet of Vashti. Galleria degli Uffizi, Florence. 25

Fig. 2.5. Development of Roman Bust Forms, after Bienkowski. 27

Fig. 2.6. Votive Terracotta from the Temple of Vignale. 2nd c. BCE. Falerii Veteres, Museo Nazionale di Villa Giulia, Rome. 27

Fig. 2.7. Roman Tomb Monument. 1st c. BCE. Cloister, S. Giovanni in Laterano, Rome. 28

Fig. 2.8a–b. Bust from a tomb at Palestrina (front and side). 2nd c. BCE. Museo Etrusco Gregoriano, Vatican Museums. Rome. 28

Fig. 2.9a–b. Terracotta Bust of a Man (front and side). 2nd c. BCE.
Staatliche Museen, Berlin. 29

Fig. 2.10. Terracotta bust of a Man. 1st c. BCE. Museo Nazionale
delle Terme, Rome. 29

Fig. 2.11. Workshop of Peter Parler. Bust of Wenceslaus I, c.1375.
Cathedral, Prague. 30

Fig. 2.12 Bust of a Man. Mid-13th c. Cathedral, Acerenza. 30

Fig. 2.13. Reliquary Bust of a Saint. 14th c. Church of St. Ursula,
Cologne. 31

Fig. 2.14. Donatello, Reliquary Bust of St. Rossore, c.1424.
Museo di S. Matteo, Pisa. 32

Fig. 2.15. Donatello(?), Bust of a Youth, c. 1440. Museo Nazionale
del Bargello, Florence. 33

Fig. 2.16. Antonio Rossellino, Bust of Matteo Palmieri, 1468.
Museo Nazionale del Bargello, Florence. 35

Fig. 3.1. Attributed to Antonio Rossellino, or Desiderio da
Settignano. Bust of a Lady, 1470s. Staatliche Museen, Berlin. 52

Fig. 3.2. Andrea del Verrocchio, Bust of a Lady holding Flowers, 1475–80.
Museo Nazionale del Bargello, Florence (Photo Alinari). 53

Fig. 3.3. Bust of "Matidia" (Vibia Sabina), 3rd c. Galleria degli
Uffizi, Florence. 53

Fig. 3.4. Francesco Laurana, Bust of Beatrice d'Aragona, 1475.
Frick Collection, New York (formerly collection of John D.
Rockefeller, Jr.). 54

Fig. 3.5. Andrea del Verrocchio, Bust of Giuliano de' Medici, 1475.
National Gallery of Art, Washington, DC. 55

Fig. 3.6. Francesco da Sangallo, Bust of Giovanni delle Bande Nere,
c.1520. Museo Nazionale del Bargello, Florence (Photo Alinari). 55

Fig. 3.7. Michelangelo, Bust of Brutus. Museo Nazionale del
Bargello, Florence (Photo Anderson). 57

Fig. 3.8. Bust of Caracalla, 212 CE. Museo Archeologico
Nazionale, Naples (Photo Anderson). 57

Fig. 3.9. Baccio Bandinelli, Bust of Cosimo I de' Medici, 1544.

ILLUSTRATIONS

Museo Nazionale del Bargello, Florence. 58

Fig. 3.10. Bust of Antinous, 131–32 CE. Museo del Prado, Madrid. 59

Fig. 3.11. Benvenuto Cellini, Bust of Cosimo I de' Medici, 1546–47. Museo Nazionale del Bargello, Florence (Photo Alinari). 60

Fig. 3.12. Leone Leoni, Bust of Charles V, 1549. Museo del Prado, Madrid (Photo MAS). 61

Fig. 3.13. Alessandro Vittoria, Bust of Doge Nicolò da Ponte, 1585. Seminario Patriarcale, Venice (Photo Böhm). 62

Fig. 3.14. Guglielmo della Porta, Bust of Pope Paul III. Museo Nazionale di Capodimonte, Naples (Photo Anderson). 63

Fig. 4.1. Achilles and Polixena, after Giotto, mid-15th c. Florence, Biblioteca Laurenziana, Ms. Strozzi 174, fol. 1r. 70

Fig. 4.2. The Nine Worthies, fresco, 1430s. Palace of the Marquis of Saluzzo, La Manta (Piedmont). 72

Fig. 4.3. Petrarch, *De viris illustribus*, frontispiece, 1379. Paris, Bibliothèque nationale de France, Ms. Lat. 6069 F. 75

Fig. 4.4. "Gloria," Petrarch, *De viris illustribus*, frontispiece, before 1388. Paris, Bibliothèque nationale de France, Ms. Lat. 6069 I. 76

Fig. 4.5. Petrarch, *De viris illustribus*, frontispiece, c. 1400. Darmstadt, Universitäts- und Landesbibliothek, Ms. 101. 77

Fig. 4.6. Giotto di Bondone, *Justice* and *Injustice*. Fresco, 1302–5. Scrovegni (Arena) Chapel, Padua. 78

Fig. 4.7. Ambrogio Lorenzetti, *Justice* and *Good Government*, 1338–39. Palazzo Pubblico, Siena. 79

Fig. 4.8. After Altichiero, *War of Jerusalem:* Troops Entering the City. Drawing. Paris, Museé du Louvre, Coll. Rothschild 848v. 80

Fig. 4.9. After Altichiero, *War of Jerusalem:* Troops Entering the City. Drawing. Prato, Coll. Loriano Bertini. 80

Fig. 4.10. Triumphal procession of Vespasian and Titus. Drawing. Paris, Museé du Louvre, R. F. 28 899. 81

Fig. 4.11. Medallions in Window Embrasures, Loggiato of the Sala Grande, 1364. Palace of the Scaliger, Verona. 82

Fig. 4.12. Altichiero, Marcus Antoninus Bassianus, detail of Fig. 4.11. 83

Fig. 4.13. Mosaic medallions of saints. Intrados, begun 547 CE.
S. Vitale, Ravenna. 84

Fig. 4.14. Roman Coin: Maximinus I Thrax (Flavius Magnus
Maximus Augustus), Emperor 235–38. 84

Fig. 4.15. Drawing after Roman Coins. Mansionario Codex, 1313–20.
Rome, Biblioteca Apostolica Vaticana, Ms. Chig. I,VII, 259. 85

Fig. 4.16. Sala dei Giganti (originally painted by Altichiero?, 1367–
79). Palace of Francesco il Vecchio da Carrara, Padua. 87

Fig. 4.17. Sala dei Giganti, Domenico Campagnola and Stefano
dall'Arzere. Fresco, 1539–40. Palace of Francesco il Vecchio
da Carrara, Padua. 88

Fig. 4.18. Petrarch, *De viris illustribus,* Scenes from Roman History.
Darmstadt, Universitäts- und Landesbibliothek
Landesbibliothek, Ms. 101, fols. 4v, 6v. 88

Fig. 4.19. Giotto di Bondone (?), *St. Francis Liberating the Repentant
Hermit,* 1290–96. S. Francesco, Upper Church, Assisi. 89

Fig. 4.20. Giotto di Bondone, Section of North Wall. Scrovegni
(Arena) Chapel, Padua. 90

Fig. 4.21. Donatello, *St. George,* bronze copy, after original,
1410–15. Or San Michele, Florence. 91

Fig. 4.22. Altichiero, *Petrarch in his Study,* c.1400. Sala dei Giganti,
Palace of Francesco il Vecchio da Carrara, Padua. 91

Fig. 4.23. Francesco da Barberino, *Documenti d'Amore:* Gloria.
Rome, Biblioteca Apostolica Vaticana, Ms. Barb. Lat. 4076, fol 85r. 93

Fig. 4.24. Francesco da Barberino, *Documenti d'Amore:* Gloria.
Rome, Biblioteca Apostolica Vaticana, Ms. Barb. Lat. 4077, fol. 74r. 93

Fig. 4.25. Francesco da Barberino, *Documenti d'Amore:* Amor. Rome,
Biblioteca Apostolica Vaticana, Ms. Barb. Lat. 4076, fol. 99v. 94

Fig. 4.26. Francesco da Barberino, *Documenti d'Amore:* Amor. Rome,
Biblioteca Apostolica Vaticana, Ms. Barb. Lat. 4077, fol. 88v. 95

Fig. 4.27. Maestro delle Vele (?). *Allegory of Divine Love,* c.1320.
Web of Crossing Vault. S. Francesco, Lower Church, Assisi. 96

Fig. 4.28. Silver medallon, Emperor Probus (276–82 CE), obverse;
Triumph, reverse. 96

ILLUSTRATIONS

Fig. 4.29. Charioteer from the Basilica of Junius Bassus, Opus
Sectile, 318–30. Museo Nazionale Romano, Palazzo Massimo,
Rome. 97

Fig. 4.30. Giovanni di Ser Giovanni Guidi, called Scheggia, *Triumph
of Fame,* birth tray, 1449. New York, The Metropolitan Museum of
Art, acc. no. 1995.7. 98

Fig. 4.31. Apollonio di Giovanni, *Triumph of Fame,* 1460–70.
Florence, Biblioteca Ricciardana, Ms. 1129. 99

Fig. 5.1. Sarcophagus of Piero Farnese, 1367. Museo dell'Opera
del Duomo, Florence. 110

Fig. 5.2. Engraving of the Monument of Pietro Farnese, formerly
in the Duomo of Florence. 110

Fig. 5.3. Paolo Uccello, Equestrian Monument to John
Hawkwood. Fresco, 1436. Duomo, Florence. 111

Fig. 5.4. Bicci di Lorenzo, Cenotaph of Cardinal Corsini.
Detached fresco, c.1422. Duomo, Florence. 112

Fig. 5.5. Inscription to Q. Fabius Maximus, after 209 CE.
Museo Archeologico Nazionale, Florence. 113

Fig. 5.6. Paolo Uccello, Drawing for the Hawkwood Monument,
c.1436. Gabinetto dei Disegni e delle Stampe, Galleria degli
Uffizi, Florence. 115

Fig. 5.7. Tomb of Paolo Savelli (d.1405). Sta. Maria dei Frari, Venice. 116

Fig. 5.8. Veronese Sculptor, Tomb of the Scotti-Gonzaga family.
An Equestrian Knight Holding a Falcon (detail of relief on sar-
cophagus lid, Veronese breccia, c.1300. S. Giovanni in
Canale, Piacenza. 117

Fig. 5.9. Pirro Ligorio, Drawing of a Roman Equestrian Tomb.
Sketchbook. Naples, Biblioteca Nazionale, Ms. XIII.B.B., 301. 118

Fig. 5.10. Attributed to Pol de Limburg, Medallion of Constantine
on Horseback. Copper alloy, 9.3 cm diam., c.1407. New York,
The Metropolitan Museum of Art, acc. no. 1988.133. 118

Fig. 5.11. Nebuchadnezzar Commanding the Three Youths to
Worship his Image, sarcophagus of St. Ambrose, 4th c. CE.
Sant'Ambrogio, Milan. 119

Fig. 5.12. Holy Family in Egypt with Falling Idols and Broken
Column, stained glass, c.1295. S. Francesco, Assisi. 120

Fig. 5.13. Giovanni Villani, *Istoria Fiorentina*, mid-14th c. Rome,
Biblioteca Apostolica Vaticana, Ms. Chigi L.VIII, 296, fol. 70r. 120

Fig. 5.14. Attributed to Benedetto Antelami, Equestrian Oldrado
da Tresseno, 1233. Palazzo della Ragione, Milan. 121

Fig. 5.15a–b. Bonino da Campione, Tomb of Cansignorio della
Scala, d.1387. Sta. Maria Antica, Verona. 121

Fig. 5.16. Cangrande della Scala, d.1329. Removed from top of
his tomb. Sta. Maria Antica, Museo di Castelvecchio, Verona. 122

Fig. 5.17. Portrait relief of Alberto d'Este, 1393. Facade, Cathedral,
Ferrara. 123

Fig. 5.18. [Reconstruction] Antonio di Cristoforo and Niccolo
Baroncelli, Arch and Equestrian Statue of Niccolò III d'Este,
1443. Facade, Palazzo Ducale (now Palazzo Municipale), Ferrara. 124

Fig. 5.19. Facade of Palazzo Ducale, Ferrara, with Equestrian
Monument of Niccolò III d'Este. Woodcut, detail. Biblioteca
Estense, Modena. 124

Fig. 5.20. Drawing of Bronze Equestrian Statue of Niccolò III
d'Este, c.1443. Unpublished, Coll. Angelo Bargellesi-Severi,
Ferrara. 124

Fig. 5.21. Pedestal, attributed here to Leon Battista Alberti, c.1451.
Facade of Palazzo Ducale, Ferrara. 125

Fig. 5.22a. Equestrian statue of Marcus Nonius Balbus the Younger,
from Herculanum forum. Marble, c.50 CE. Museo
Archeologico Nazionale, Naples. 126

Fig. 5.22b. Filippino Lippi, Statue of Marcus Aurelius, detail of fresco,
1488–93. Carafa Chapel, Sta. Maria sopra Minerva, Rome. 126

Fig. 5.23. Equestrian Monument of Ercole I, d'Este. 17th-century
woodcut copy of design. (After Maresti). 127

Fig. 5.24. Arnolfo di Cambio, Ciborium, c.1300. Sta. Cecilia in
Trastevere, Rome. 128

Fig. 5.25. Detail of 5.24. 128

Fig. 5.26. Arch of the Money Changers, 4th century; incorporated into S. Giorgio in Velabro, Rome, in the 7th century. 128

Fig. 5.27. Aureus of Claudius (10 BCE–54 CE), with Monument to Drusus. 130

Fig. 5.28. Donatello, The Gattamelata Equestrian Monument. Bronze, 1447–53. Piazza del Santo, Padua. 130

Fig. 5.29. Andrea del Verrocchio, The Colleoni Equestrian Monument. Bronze, formerly gilded, Istrian marble base, 1480–96. Campo di SS. Giovanni e Paolo, Venice. 131

Fig. 5.30. Leonardo da Vinci, drawings for Trivulzio Monument. Pen and ink, 1503. Windsor Castle. 131

Fig. 6.1. Mausoleum of Rolandino de'Passaggeri, c. 1305. S. Domenico, Bologna. 136

Fig. 6.2. Roso de Parma, Tomb of Pietro Cerniti, d. 1338. Museo Civico Medievale, Bologna (Photo: Italica Press). 136

Fig. 6.3. Pyramid of Cestius, Merchant's Tomb, 18–12 BCE. Rome, near Porta S. Paolo. 137

Fig. 6.4 (below L). Spina (turning point) Roman Circus, Vienne, France; popularly called "Tomb of Pilate." 137

Fig. 6.5 (below R). Reconstruction of pyramidal topped tomb. Al-Dana, Syria. 137

Fig. 6.6. Mastino II, Cangrande della Scala, d. 1351. Museo di Castelvecchio, Verona. 138

Fig. 6.7. Bonino da Campione, Tomb of Cansignorio, d. 1375. Sta. Maria Antica, Verona. 138

Fig. 6.8. Ground Plan, Sta. Croce, Florence. 141

Fig. 6.9. Baroncelli Chapel, 1328, General View. End of South Transept, Sta. Croce, Florence. 141

Fig. 6.10. Attributed to Giovanni di Balduccio di Pisa, Tomb of Baroncelli. Facade, Baroncelli Chapel, Sta. Croce, Florence. 142

Fig. 6.11. First Tomb of the Bardi Family, 1332. End of North Transept, Sta. Croce, Florence. 142

Fig. 6.12. Bardi di Vernio Chapel, North Transept, View of left wall. Sta. Croce, Florence. 143

Fig. 6.13. Bardi di Vernio Chapel, Maso di Banco and Taddeo
Gaddi, Tomb niche with Deposition. Sta. Croce, Florence. 143

Fig. 6.14. Bartolini Chapel, Right Wall, frescoes by Lorenzo
Monaco, 1420–25. Sta. Trìnita, Florence. 143

Fig. 6.15. Bartolini Chapel, General View from outside.
Sta. Trìnita, Florence. 144

Fig. 6.16. Benozzo Gozzoli. Painted Altarpiece surrounded by
Scenes of the Crucifixion and Saints, fresco, 1452. S. Francesco,
Montefalco. 144

Fig. 6.17. Antonio Ciaccheri Manetti, Antonio Rossellino, et al.
Chapel of the Cardinal of Portugal, 1460–72, View toward
the Tomb. S. Miniato al Monte, Florence. 145

Fig. 6.18. Chapel of the Cardinal of Portugal, View of the
Entrance. S. Miniato al Monte, Florence. 146

Fig. 6.19. Chapel of the Cardinal of Portugal. S. Miniato al
Monte, Florence. Vault. 147

Fig. 6.20. Chapel of the Cardinal of Portugal. S. Miniato al
Monte, Florence. Pavement. 147

Fig. 6.21. Chapel of the Cardinal of Portugal. S. Miniato al
Monte, Florence. View of Back Wall. 147

Fig. 6.22. Chapel of the Cardinal of Portugal. S. Miniato al
Monte, Florence. View of Left Wall. 147

Fig. 6.23. Filippo Brunelleschi, Old Sacristry, 1421–40.
S. Lorenzo, Florence. 148

Fig. 6.24. Antonio Rossellino, Tomb of the Cardinal of Portugal.
S. Miniato al Monte, Florence. 149

Fig. 6.25. Desiderio da Settignano, Tomb of Carlo Marsuppini,
1453–64. Sta. Croce, Florence. 150

Fig. 6.26. Donatello, Tomb of Pope John XXIII (Baldassare
Coscia, d. 1419), 1425–27. Baptistry, Florence. 151

Fig 6.27. Antonio Rossellino, *Mithras Slaying the Bull*. Detail of
Fig. 6.24. 152

Fig. 6.28. Antonio Rossellino, *Chariot of the Soul*. Detail of Fig. 6.24. 152

ILLUSTRATIONS

Fig. 6.29. Sassetti Chapel, 1483–86. General View. North Transept, Sta. Trìnita, Florence. 153

Fig. 6.30. Domenico Ghirlandaio, View of the Right Wall, Sassetti Chapel. Sta. Trìnita, Florence. 154

Fig. 6.31. Domenico Ghirlandaio, Statue of David, left Exterior Pilaster, Sassetti Chapel. Sta. Trìnita, Florence. 155

Fig. 6.32a. Donatello, *David*. Bronze, 1430–1440. Museo Nazionale del Bargello, Florence. 156

Fig. 6.32b. Verrocchio, *David*. Bronze, 1473–1475. Museo Nazionale del Bargello, Florence. 156

Fig. 6.33. Triumphal Column of Trajan, 106–113 CE. Forum of Trajan, Rome. 157

Fig. 6.34. Domenico Ghirlandaio, *The Vision of Augustus on the Aracoeli*. Exterior facade, Sassetti Chapel. Sta. Trìnita, Florence. 158

Fig. 6.35. Francesco Sassetti's Tomb, Right Wall, Sassetti Chapel. Sta. Trìnita, Florence. 159

Fig. 6.36 (L), Sestertius of Vespasian, obverse, 71 CE; (R)Bust of Francesco Sassetti, detail of Fig. 6.35. 159

Fig. 6.37. Domenico Ghirlandaio, Donors Flanking Altarpiece. Sassetti Chapel, Altar Wall, bottom tier, Sta. Trìnita, Florence. 159

Fig. 6.38. William Sedgwick, Double tomb of Bishop Richard Fleming, 1640–41. Cathedral, Lincoln. 160

Fig. 6.39. Domenico Ghirlandaio, *Nativity of Christ*, altarpiece, 1485. Sassetti Chapel, Sta. Trìnita, Florence. 161

Fig. 6.40. Domenico Ghirlandaio, *Confirmation of the Rule of St. Francis*, Altar Wall, top tier. Sassetti Chapel, Sta. Trìnita, Florence. 162

Fig. 6.41. Domenico Ghirlandaio, *St. Francis Revives the Notary's Son*, Altar Wall, middle tier. Sassetti Chapel, Sta. Trìnita, Florence. 162

PREFACE

IN THE EARLY 1980s, Irving Lavin was invited to deliver The Slade Lectures at Oxford University, and he took it as an opportunity to develop an idea he had long considered but never articulated: that the Italian fifteenth-century revival of ancient art was an outward sign of fundamental changes in humanity's perception of the inner self. The change started when the individual emerged from the Middle Ages and began to exhibit a previously unknown awareness of the past as opposed to the present. He became a person who could make choices about his own existence on the basis of a new internal consciousness. This "new man" chose what he saw in the classical world as a higher culture and, having absorbed and transformed it, made it his own. The new mode of being not only transformed his actions in life, it also became the basis for a new manifestation in the arts in a style we call Renaissance.

To develop this idea, in what Irving called *The Art of Commemoration in the Renaissance,* he studied the Renaissance contribution under several rubrics. Chapter 1, "Memory and the Sense of Self: On the Role of Memory in Psychological Theory from Antiquity to Giambattista Vico," looks at attitudes throughout history toward memory and the search for its anatomical location in the brain. Then, stepping out into the dominion of artistic representations, he offers two essays on what is perhaps the most important unit of identity, and one of the most characteristic of the Renaissance: the portrait bust in marble and bronze. Chapter 2, "On the Sources and Meaning of the Renaissance Portrait Bust," treats the fifteenth-century revival of ancient forms. Chapter 3, "On Illusion and Allusion in Italian Sixteenth-Century Portrait Busts," analyzes official portraiture. These two essays, both published independently, have become fundamental teaching resources. Chapter 4, "Great Men Past and Present," takes up the fact that great men and great minds in the past were now being superseded by contemporaries. Commemorating their deeds led to cycles of images in large-scale fresco cycles and in miniature manuscript illumination. Chapter 5, "Equestrian Monuments: The Indomitable Horseman," drawing from the imperial realm, became the Renaissance sign of

PREFACE

heroism and power, offering guidance to, and gratitude from, a civic public. Chapter 6, "Collective Commemoration and the Family Chapel," describes the prosperous civilian family as a devotional unit as seen in their private chapels. Built within parish and monastic churches, the chapels are the apogee of Renaissance commemoration, reflected in every element of the design — architectural decoration, frescoed walls, altarpieces, sculptured tombs — in which are evinced the connection between personal past and present to the fullest extent.

Having completed these studies in lecture form, Irving did not rush to publication. In fact, through the years and until his death in 2019, he continued to expand, contract, develop, and update the material, never quite satisfied with the extravagant array of objects and ideas he was presenting. During his final days, we agreed that I would put the lectures into literary form, that is, complete the notes and bibliography, and oversee the publication. For this last step I turned to Eileen Gardiner and Ron Musto, whom we had known since their recent-PhD days at the American Academy in Rome, and whose remarkable creation, Italica Press, we had followed closely over the years. Italica Press, New York published festschriften for each of us: *Rome Italy Renaissance: Essays Honoring Irving Lavin on His 60th Birthday (IL60)*, Marilyn Aronberg Lavin, ed. (1990); and *Medieval Renaissance Baroque, A Cat's Cradle in Honor of Marilyn Aronberg Lavin*, David A. Levine and Jack Freiberg, ed. (2010). To Eileen and Ron I offer heartfelt gratitude; it is a joy to see the series published under their expert guidance. Unquestionably, Irving also would have been pleased. I also extend my gratitude to Jack Freiberg, student, teacher, colleague, and friend, who gave generously of his editorial expertise to this enterprise.

Marilyn Aronberg Lavin
Princeton, NJ, August 2020

1. MEMORY AND THE SENSE OF SELF
ON THE ROLE OF MEMORY IN PSYCHOLOGICAL THEORY
FROM ANTIQUITY TO GIAMBATTISTA VICO

ONE OF THE FIRST FRUITS of the transfer of the Warburg Institute from Germany to England before the second world war was a remarkable little book by one of the most stimulating, but now, alas, scarcely appreciated art-historical minds of that generation, Roger Hinks (d. 1963). Hinks' *Myth and Allegory in Ancient Art* was first presented as a series of lectures at the Warburg Institute in 1935.[1] Hinks was deeply affected by the teachings of Ernst Cassirer and the Warburg School, and the main thrust of the work is to analyze the way the Greeks represented reality symbolically, shifting from unconscious myth to explicit allegory. He associated this process with the gradual detachment of the individual consciousness from the total consciousness of the social group, a process that distinguished Greek civilization from any other. The book's three chapters define and trace this development in three basic contexts. The first chapter is devoted to the symbolic representation of the natural order, that is, the universe of space and time, the second is devoted to the social order, and the last to what Hinks calls the mental order.

Hinks himself was interested primarily in classical civilization, and the main focus of his attention is on the emergence of rational modes of thought in antiquity. The theme of his last chapter, however, seems to me of fundamental importance to the historian of art who seeks to understand how this classical legacy of symbolic representation became the visual culture of the West.

The essential point of Hinks' third chapter is to establish the insoluble bond between memory and civilization. It is the possession of a memory that makes humans historical beings, and it is their capacity for being historical that gives them a personality. The emergence of memory and the evolution of personality are two aspects of a single phenomenon, namely, the detachment of the self-conscious individual from the group. The central, irrational core of human self-consciousness, individuality, was symbolized in antiquity by the notion of the "daemon," or genius. This spirit of the self expressed, in

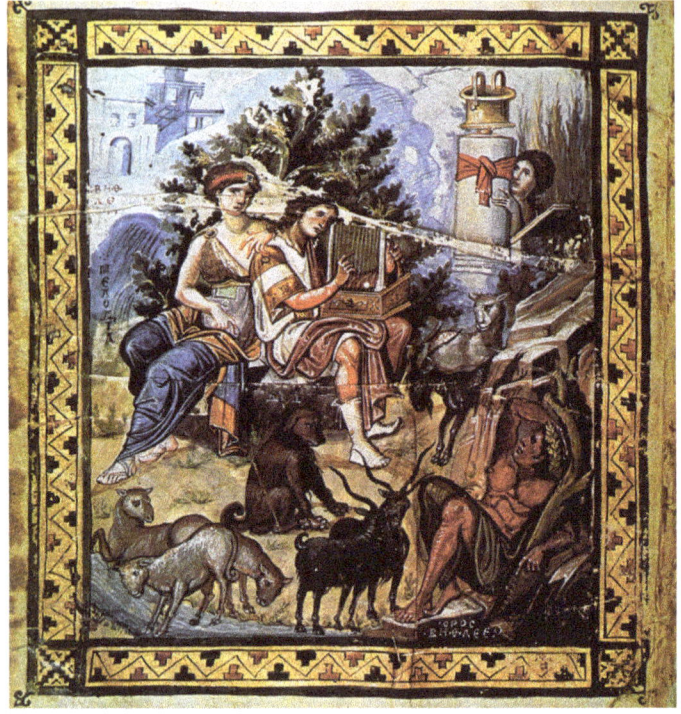

Fig. 1.1. *David inspired by Melodia*. Paris Psalter. 10th c. *Paris, Bibliothèque nationale de France, Ms. Gr. 139, fol. 1r.*

effect, the relationship between memory and personality. Hinks had the insight to realize further that inner self-awareness was expressed visually through representations of the dialogue taking place between a human and its daemon, notably in images of practitioners of the various arts inspired by their respective muses [Figs. 1.1 and 1.2]. The role of memory in the definition of human consciousness in such depictions is implicit in the fact that memory itself, personified as Mnemosyne, was conceived as the mother of the muses through her union with Zeus, the father of the gods.

Hinks did not explore, indeed, I suspect he did not perceive, the implications of his analysis of the development of symbolic visual

CHAPTER 1 ❧ MEMORY AND THE SENSE OF SELF

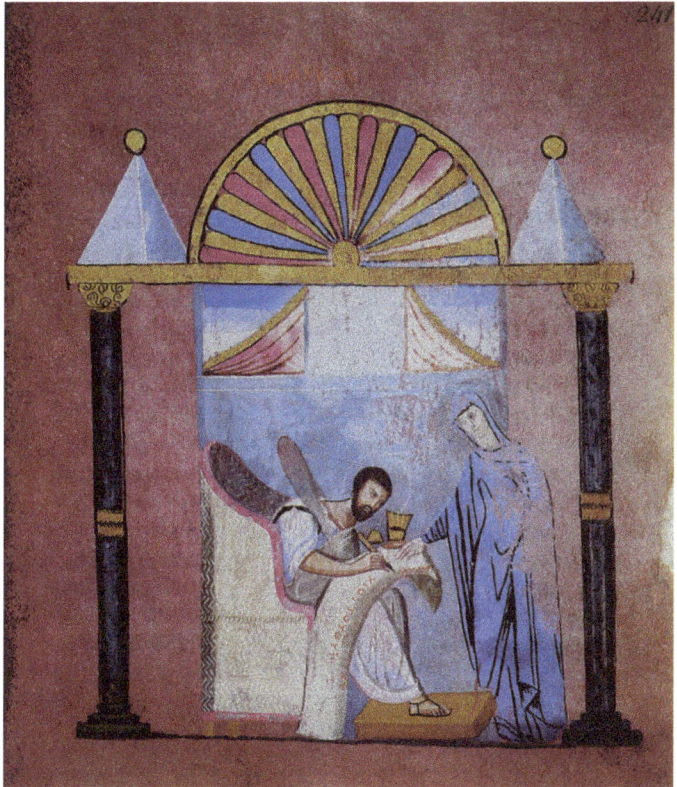

Fig. 1.2. St. Mark inspired by his Muse (Sophia?). 6th c. Rossano, Codex Rossanensis, fol. 121r.

thought for an understanding of the operation of historical tradition as such. Yet, I believe the idea of interdependence between memory and personality provides a valuable insight into the paradoxical union of retrospection and innovation, of historicism and modernism, that characterizes the Renaissance. The forms of symbolic representation developed in antiquity could serve by their very nature as signs of awareness by which one's own awareness could be gauged. References to classical prototypes constituted not only an act of memory and homage but also an act of self-assertion. This process differs from the one described by Hinks since it involves an

additional level of awareness in which the past is explicitly distinguished from, and conceived as subservient to, both the present and the future.

The point of departure for my interest in the subject is an historical and historiographical paradox to which, whether consciously or not, we have been heir since the Renaissance. One of the cornerstones of modern historiography is that the basic organization of historical time into three divisions or periods — ancient, medieval, and modern — was an achievement of the Renaissance. This was the notion of there having been a distant, ancient classical civilization that was destroyed by the establishment of Christianity and the barbarian invasions, resulting in a cultural decadence. That was, in turn, succeeded by a new contemporary time in which the ancient world is reborn. This historical structure can be traced ultimately to Francesco Petrarch (1304–74) in the mid-fourteenth century. The paradox to which I refer consists in the simultaneous emergence, on the one hand, of a fixed, perspective view of a distant past and, on the other hand, of a sense of the present as a new, distinctly modern era in the definition of which the past plays an essential role. This way of thinking about history can be seen as a reflection of the dual nature of the Renaissance itself, which while looking back to antiquity for authority, also found license to bring forth something new. There was in fact a twofold break with medieval tradition, a leapfrog return to an ideal golden age in the remote past, and an equal and opposite thrust forward toward an ideal future based on current achievements and ambitions.

It is a remarkable fact that although the retrospective and innovative aspects of the Renaissance have often been studied separately, the relationship between these two terms of the paradox has not been brought clearly into focus. By and large, the Renaissance interest in the past has been conceived alternatively as essential and intellectual, or as incidental and social. In the first case, the revival of ancient culture is seen more or less as an end in itself, the character of the Renaissance determined mainly by progressively greater liberation from medieval convention and increasingly complete assimilation of classical values. In the second conception, the essence of the

CHAPTER 1 ❧ MEMORY AND THE SENSE OF SELF

Fig. 1.3 (L). Robinet Testard, Minerva, in Évrard de Conty, Échecs amoureux. France (Cognac), c.1496–98. Paris, Bibliothèque nationale de France, Ms. Fr. 143, 117v.
Fig. 1.4 (R). Nicola Pisano, Fortitude, marble, 56 cm, 1260. Pisa, Baptistry, pulpit.

Renaissance lay in the development of a new social order, of which the revival of antiquity was merely a symptom, the outward mask of an increasingly secularized attitude toward the world.

In the essential, intellectual view, what was new about the Renaissance was its retrospection. This attitude received its most concise and compelling formulation in Erwin Panofsky's famous definition of the Renaissance achievement as the reintegration of classical form with classical content. Panofsky (1892–1968) observed that the classical heritage was never completely lost in the Middle Ages, but that when ancient personages occurred in art, for example, they were shown either as contemporaries or in some exotic guise [Fig. 1.3] and, conversely, when classical forms occurred they would be given some contemporary or quite alien meaning [Fig. 1.4]. Panofsky's definition was based on the notion of historical distance, that is, a sense of remoteness that made it possible to dissociate ancient culture from the strictures and disapprobation of Christianity. In Panofsky's definition the revival is self-contained as well as essential, since reintegration of classical form and meaning is a self-sufficient and self-justifying process, akin to and in many ways precedent for our own

"scientific" historical attitude which makes reconstructing the past an end in itself.[2]

The view of Renaissance interest in antiquity as an incidental symptom of a new social order was represented in the mid-nineteenth century by Jacob Burckhardt (1818–97), notably in the opening paragraphs of the chapter on the revival of antiquity in his *Civilization of the Renaissance in Italy*.[3] Burckhardt is at pains to emphasize, as one of the chief propositions of his book, that the conquest of the western world was achieved not through the revival of antiquity alone, but through its union with what he calls the genius of the Italian people. Burckhardt goes on to observe that the degree of independence which the national spirit maintained in this union varied according to circumstances. In the modern Latin literature of the period, he says, it was very small, while in plastic art, as well as in other spheres, it was remarkably great. In this book Burckhardt does not actually deal with the visual arts, but he says in the general introduction he had intended to fill the gap by a special work on "The Art of the Renaissance." Of course, Burckhardt did write a great deal about art, and if one takes the wonderful series of lectures on Renaissance sculpture as an example, one is indeed astonished by the passion with which he describes the originality of and independence from classical tradition displayed by the Italian masters through the High Renaissance. Time and time again he stresses, often with very subtle observations, the effects of form and emotion in the differences between the Italian works and their classical antecedents. The explanation he gives for the Renaissance enthusiasm for antiquity was that it reflected a social revolution in which the noble and the burger came together on equal terms, so that a society developed which felt the need for culture and had the leisure and the means to obtain it. Antiquity then became the guide, leading the way from the fantasy world of the Middle Ages to an understanding of the actual physical and intellectual world.

In my view, neither of these attitudes helps to resolve the paradox of the Renaissance, the coincidence of a new sense of the past with a new sense of the present; neither perceives an inner, organic and

CHAPTER 1 ※ MEMORY AND THE SENSE OF SELF

necessary relation between retrospection and innovation. In my view, we must explore the possibilities of an alternate understanding of the attitude toward the past which emerged in the Renaissance, not as an end in itself, nor as merely a symptom of change in social structure, but rather as an essential ingredient in the radical redefinition of the self that is signified by the conception of modernity.

I am convinced that such a relationship existed, and I believe it functioned in two ways. One kind of role the past may be said to have played in the definition of the present was exemplary: the past was seen as a model to be imitated, the prestige of the prototype serving as justification for a claim to attention and admiration made by the imitation. The second use of the past was agonistic, reference to some esteemed prototype serving not only as a witness to the ambition of the present but also as a measure of the difference between the model and its reflection. In this case the achievements of the past become a foil for the originality of the present and, in turn, a measure of the challenge raised to the future. The historical reference becomes evidence of the lesson of history having been mastered and incorporated into a new and surpassing synthesis.

Perhaps the point of view I suggest is obvious, yet it seems to me the only angle from which essential aspects of the Renaissance uses of the past can be fully grasped. Certainly this approach can help to obviate a fundamental fallacy that besets the recent vogue for explaining Renaissance art criticism in terms of classical rhetoric. Many practitioners of this powerful analytic technique make one basic, but to my mind, quite unnecessary assumption. Because Renaissance criticisms of art were full of stock motifs, topoi appropriated from ancient writers, such statements must signify nothing but an empty rhetoric devoid of sincere meaning. It is argued by Michael Baxandall (1933–2008) in his *Giotto and the Orators* (1971), for example, that we should not take as a considered opinion Filippo Villani's claim that Giotto is to be preferred to the artists of antiquity, because Filippo (1325–1407) also claimed that Pagolo de'Dagomari surpassed all ancient and modern astronomers, and he even compared the modern comedian Gonella with those of antiquity.[4] Yet, it is precisely the passage about

7

comedians, read in its context, that demonstrates Villani's seriousness. He disarms the opposite possibility at the outset by saying explicitly that, although it might seem ridiculous to include comedians among the great men of Florence, the example of the ancients bears witness to the wonder and nobility of the comic art. The reference to the classical model, far from undermining the sincerity of Villani's opinion, serves on the contrary to sanction his expressing a considered judgment in a matter that might at first thought seem unworthy of such consideration. The classical appreciation of comedians also serves to confirm the validity of Villani's appreciation of his own contemporaries.[5] Failure to perceive the positive, inner connection between reference to the past and definition of the present has created a glaring historical and conceptual void that needs to be filled.

MY PURPOSE IN THIS SERIES is to explore the possibilities of this alternate view of the Renaissance attitude toward the past by focusing on a disparate series of episodes in a narrow but, I trust, incisive field of reference where the two extremes of the paradox — revival and innovation — touch, that is, the idea of commemoration. By its very nature commemoration is a sort of time capsule that envelops some particular element of the past, labels its significance for the present, and sends it off into the future. In particular, I shall study a number of commemorative forms developed in antiquity, either neglected or transformed in the Middle Ages, and revived in the Renaissance to carry a new message. The themes to be discussed are but scattered fragments selected from the large corpus of material and ideas relevant to the theme; a few more or less isolated pieces from a large jigsaw puzzle, most of which is still in the box. What I hope ultimately to offer is a survey of visual modes of commemoration, the histories of which embody the kind of relationship here advocated between memory and imagination, between retrospection and innovation.

We may begin to do so, I think, by considering the very notion of memory, since it focuses explicitly on humanity's understanding of its relationship to the past, and since its history in some respects runs parallel to my own argument. I am concerned with memory itself,

CHAPTER 1 ※ MEMORY AND THE SENSE OF SELF

needless to say, not with memory technique, the theme admirably studied by Frances Yates (1899–1981) in her seminal book, *The Art of Memory*: the art of memorization impinges on the art of commemoration only tangentially, since history may provide the content of mnemonics but not the subject.[6]

The essence of the relationship between memory and personal identity that Hinks ascribed to the ancient Greeks is expressed in a story told by Diogenes Laertes about Pythagoras, who traced his lineage back through a series of reincarnations to the god Hermes. Hermes offered his son Aethalides, the ancestor of Pythagoras (579 BCE to 500–490 BCE), any gift except immortality. Aethalides chose the next best thing, to retain the memory of his experiences through life and death. In this way, Aethalides was able to establish his identity and preserve it in succeeding generations, so as to achieve the kind of cumulative immortality that is conferred on humans alone by their awareness of their own past.[7]

The idea of an existence before and after death that underlies Pythagoras' story was a basic determinant in Plato's view of memory. Physical reality is but the shadow of the realm of pure and abstract ideas that are eternal and instilled in every human when the soul enters the body, but are forgotten at birth. For Plato (428/7–348/7 BCE), then, the process of learning or knowing and that of remembering are virtually the same. Human self-awareness, the Socratean motto, "know thyself," is a matter of re-apprehending the innate prototypical ideas. Plato is careful to distinguish between simple memory, that is, a record imprinted on the passive soul by sense perceptions, and recollection or reminiscence, which is a higher act of the spirit.

Aristotle (384–322 BCE) took up the distinction between memory and recollection but shifted it to an entirely new context. For Aristotle, there are no innate ideas, and humanity's only source of knowledge is through the senses. Not only memory but thought itself is based on images formed in the mind by perceptions from the outside world. Aristotle conceives of memory as one of four powers of the soul. The *common sense* is the capacity of the soul to receive and conjoin perceptions derived from the various physical senses into a common image.

The *imagination* is the capacity to store, recall, reconstruct, or distort images derived from the senses. Memory at its lower level involves the capacity humans shares with animals to relate the image imprinted in the imagination to the original perception: at its upper level, unique to humans, memory is the power of reminiscence, that is, the capacity to recall and relate past images consciously and purposefully. The fourth and highest power of the human soul, still derived from sense perceptions, is reason. The physician Galen (c.130–c.210 CE) adapted the definitions of Aristotle and took an important step by attributing the powers to the brain, partly to its substance and partly to its three main cavities, the ventricles.

It has been said that there took place during the Middle Ages a merger of traditions concerning memory stemming from different strains of classical thought about human nature: philosophical, psychological, physiological, religious, and ethical. The merger brought three major developments in the interpretation of memory that may be described as internalization, localization, and moralization. The first involved the distinction between the external and the internal senses. The external senses — vision, hearing, touch, etc. — derive from the organs through which the stimuli of the outer world are perceived. The inward senses, a term first used by St. Augustine (354–430 CE) are the functions of the soul that process these perceptions by performing the three basic functions of receiving, digesting, and storing the information transmitted by the external senses.

It was another Christian author of the mid-fourth century, Bishop Nemesius of Emesa (fl. c.390), who first propounded the theory of localized brain functions that was to provide the basic framework for psychological speculation for centuries to come. Nemesius confined the faculties entirely to the ventricles, thus completing the process of internalization and, it might be said, spiritualization of human mental processes.

In its simplest form the localization theory, partly based on the experimental evidence of brain damage, distributed sensation, reason, and memory respectively to the front, middle, and rear ventricles. In its most complete form, the theory incorporated the distinctions and refinements of the Islamic physicians Avicenna (c. 980–1037) and

CHAPTER 1 MEMORY AND THE SENSE OF SELF

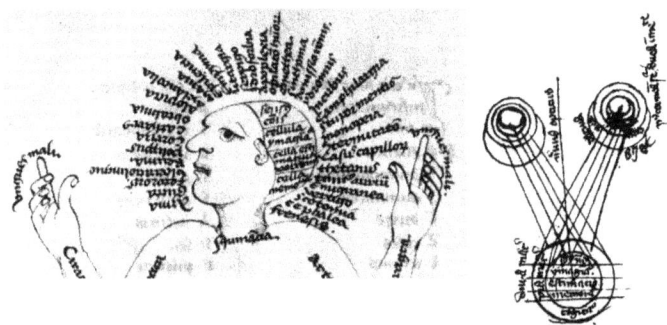

Fig. 1.5 (L). "Disease man," with diagram of the brain cells (sensus co[mmun]is, cellula ymagi[n]a[iv] a, cella estimativa vel r[ati]onis, cella memo[rati]va), c.1400. Paris, Bibliothèque nationale de France, Ms. Lat. 11229, fol. 37v. After Clarke and Dewhurst, An Illustrated History of Brain Function, Fig. 34. Fig. 1.6 (R). Diagram of perception and brain function (s[ensu]s c[ommu]nis, ymagi[na]t[iv]a, Estimacio, memoracio, cogitacio, pia mater, dura mater), 1367. John Pecham, Perspectiva communis. Vienna, Oesterreichische Nationalbibliothek, Ms. 5210, fol. 56v. After Clarke and Dewhurst, Fig. 57.

Averroes (1126–1198) and defined a total of six internal senses [Figs. 1.5 and 1.6]. The *common sense* merged information coming from the external senses into a coherent image. *Imagination* retained the incoming perceptions and made them available for combination with other perceptions in order to form images not actually perceived. This latter, combinatory capacity was sometimes called the *fantasy*. A fourth faculty was known usually as the *estimative power* in reference to the soul's capacity to grasp the "intention" or meaning of an image, as the sheep grasps the fearsomeness of the wolf and runs away. In this respect the estimative faculty was a form of judgment. The fifth power of the soul was that of *memory proper*, which stores the images together with their intentions and makes them available to reminiscence. Finally, there was the *motive power*, which effected the action to be taken in response to the stimuli.

The third, moral or ethical aspect of memory also had its origins in antiquity. It might be said that Plato's interest in memory was primarily metaphysical since it provided a link between everyday experience and the prototypical ideas that constitute the ultimate reality. Aristotle, instead, thought of memory primarily in psychological terms, as part of the functional mechanism of the mind. The most important

Roman thinker on the subject of memory was Cicero (106–43 BCE). While he followed Plato's views in his *Tusculan Disputations* on philosophical themes, in his works on rhetoric, the *De Oratore* and the *De Inventione*, Cicero introduced a fundamental shift in emphasis. Here memory is considered in an essentially practical context as a tool of the orator and is included as one of the five parts of rhetoric, along with invention, disposition, elocution, and pronunciation. Memory in this sense is part of a technique that involves retaining the main points or even the very words of a speech. Memory forms part of the orator's persuasive equipment and hence acquires a strong ethical component. In a famous passage in the *De Inventione* on the purposes of oratory, Cicero defines the parts of virtue, namely: prudence, justice, fortitude and temperance, the cardinal virtues in the Middle Ages. Memory, as the faculty of the mind that recalls the past, is defined as one of the three parts of the virtue of *providencia* (foresight), along with intelligence, the faculty of ascertaining the present, and prudence, the faculty of predicting the future. In this way, Cicero links humanity's relation to the past to a moral code.[8]

There can be little doubt that Cicero, or at least the Platonic tradition to which he adhered, was a major source for the interpretation offered by St. Augustine. Augustine's conception of memory is theological and results from his conception of the soul itself as a reflection of the Trinity. The soul, he says, possesses three powers: memory, understanding, and will. Memory contains the images of sense perceptions, of all knowledge, and the affections of the mind. Hence it holds the key to self-knowledge. Augustine thus extends the function of memory to self-consciousness itself and ultimately to God. When Augustine looked into his memory, he said, he found God there, since knowledge of the divine is innate.[9]

The moral nature of memory is apparent, especially in Augustine's conception of Christian eloquence, which he sharply distinguished from pagan rhetoric. The latter was concerned primarily with logic and the emotional appeal of language. Christian eloquence, instead, was defined as the exposition of the truth of the Bible. In this way, too, memory, insofar as it is part of rhetoric, takes on a

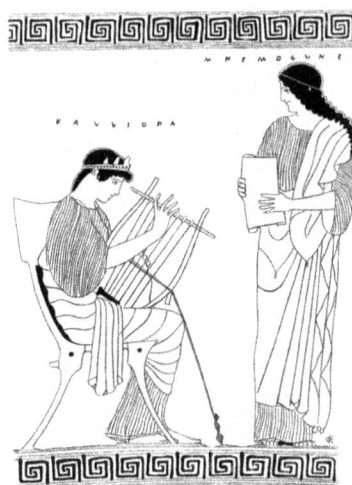

Fig. 1.7. *Mnemosyne and Calliope.* White ground *lekythos*. After Monumenti antichi. Universitätsbibliothek Heidelberg 17 *(1906), pl. XXVI.*

moral cast far more specific and concrete than in Cicero, in that it becomes a primary instrument for the salvation of souls. Finally, as we shall see, Augustine also adapted the tradition of ventricular localization to his own theory, placing perception at the front, memory in the middle, and emotion in the rear cavity.[10]

The shift in emphasis from the ancient conception of memory as an essentially metaphysical and psychological mental capacity to the medieval notion of memory as a powerful moral force is evident in the form and context in which the personification of memory was represented. A rare ancient instance of a depiction of memory, in which the figure is identifiable through an inscription, occurs on a white ground *lekythos*, where Mnemosyne stands holding a *rotulus* next to one of her daughters, Calliope, who is shown seated playing a lyre [Fig. 1.7]. In other words, memory is portrayed strictly as the recorder of the past and in her capacity as mother of the muses, whose activities depend on her. At the opposite end of the spectrum is the role given to memory in one of the great works of allegorical literature of the late Middle Ages, Guillaume de Degeuileville's (1295–c.1358) *Pèlerinage de la vie humaine,* a composition whose very title indicates its basic concern with human nature in relation to its purpose.[11] The section involving memory describes how the soul arms itself against the deceitful attacks of the devil that will assail it in the course of its journey to the heavenly Jerusalem. Grace Dieu, the soul's guide, offers the armor of virtue: the mailed

IRVING LAVIN & THE ART OF COMMEMORATION

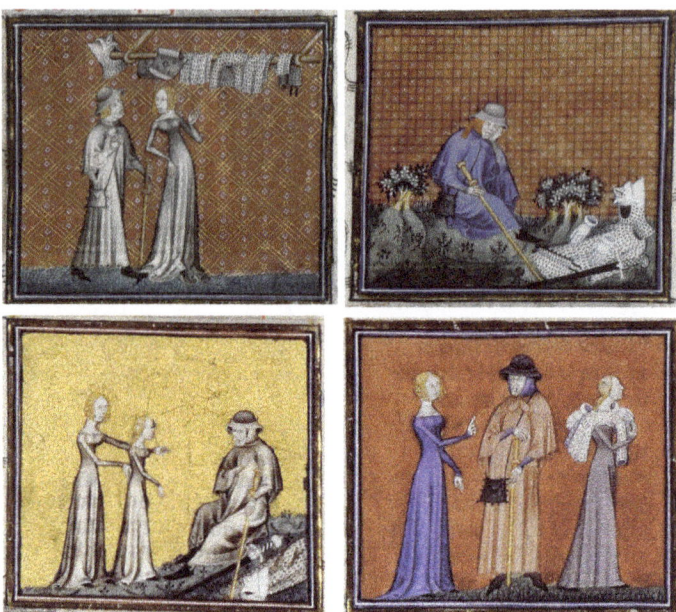

Guillaume de Deguilville, Pelerinage de vie humaine. Paris, Bibliothèque nationale de France, Ms. Fr. 823, 1393. Fig. 1.8. *Grace Dieu shows the pilgrim a suit of armor, fol. 27r. After Kolve, Chaucer, Fig. 25. Fig. 1.9. The pilgrim throws off his suit of armor. , fol. 34r. Kolve, Fig. 28. Fig. 1.10. Grace Dieu introduces Lady Memory to the pilgrim, fol. 34v. Kolve, Fig. 29. Fig. 1.11. Lady Memory takes up the pilgrim's armor, fol. 35v. Kolve, Fig. 30.*

coat of fortitude, the helmet of temperance, the scabbard of humility, the shield of prudence, etc. [Fig. 1.8]. The pilgrim balks at having to carry such heavy equipment on his journey [Fig. 1.9], and Grace of God comes to his rescue by summoning Memory [Fig. 1.10]. Lady Memory, portrayed in a late fourteenth-century manuscript as an elegant young woman with eyes at the back of her head, then proceeds to accompany him through life as his armor bearer [Fig. 1.11]. Thus memory, as the repository of the virtues vested in the soul by God's grace, vouchsafes the salvation of humanity.

The role of memory in salvation is also illustrated in an early fifteenth-century manuscript of a mythological treatise by John Ridewall (d. after

CHAPTER 1 ❧ MEMORY AND THE SENSE OF SELF

Fig. 1.12. Juno–Mercury, early fifteenth century. John Ridewall, Fulgentius Metaforalis. *Rome, Biblioteca Apostolica Vaticana, Ms. Pal. Lat. 1066, fol. 223v. After H. Liebeschütz,* Fulgentius Metaforalis. *Leipzig: B. G. Teubner, 1926, pl. II.*

1340), which provides a Christian allegorical interpretation of classical mythology [Fig. 1.12].[12] Ridewall associates the gods with Christian virtues based on Cicero's description of prudence as consisting of memory,

15

intelligence, and foresight. Juno is identified with memory and given many attributes. Her primary role, however, is in the recollection of sin, which leads to repentance and thus to reconciliation with God.

It will have become evident that the process of moralization entailed a conception of memory as an active force in the scheme of salvation, rather than simply a passive repository in the life of the mind. This species of activated memory actually had a physiological counterpart in the one deviant strain that may be discovered in the dominant medieval localization theory described earlier — quantitatively minor, but doggedly persistent, and in the end of great importance. In his commentary on Genesis, Augustine speaks of a medical theory that the three ventricles of the brain contain, in the first, *sensations*, in the second, the *memory*, and in the third, *motion*. The latter two faculties are thus reversed with respect to the norm. Augustine explains this distribution by observing that motion *follows* sensation, and humans must therefore be able to relate what they are about to do to what they have done in the past. In this way, memory is given a central and active role in the mental processes. Memory becomes a determining factor in the formulation of the soul's response to its environment.[13] Augustine's account was almost completely eclipsed during most of the Middle Ages, but his formulation was taken up again at the turn of the fourteenth century with the great Augustinian revival centered in the Order of Augustinian Hermits. The best known member of the group was Egidius Romanus (Gilles of Rome, 1247–1316), general of the order and friend of Pope Boniface VIII. Gilles sought to reconcile Augustine's views with those of Avicenna by dividing the functions of the third ventricle into two parts and locating memory in the front of that cavity, with the motive power in the rear. In this way, Gilles was able to include the memory in the third ventricle and yet retain its intermediate position between the other senses and the motive power.[14] Gilles' influence passed into the heart of the Renaissance through his later namesake and editor, Gilles of Viterbo (1472–1523), the close associate and advisor of Popes Julius II and Leo X. The arrangement the first Gilles described was illustrated two centuries later in a printed edition of a tract by the Augustinian

CHAPTER 1 ❧ MEMORY AND THE SENSE OF SELF

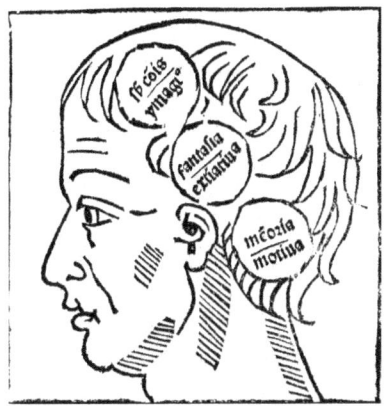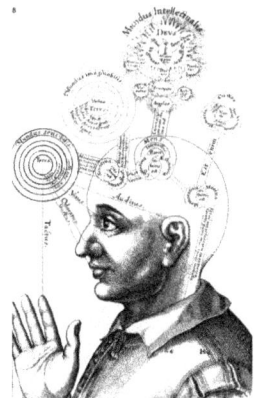

*Fig. 1.13 (L). The ventricles of the brain (s[ensu]s co[mmun]is/ymagi[nativ]a, fantasia/ extimat[iv]a, me[m]oria/motiva). Agostino Trionfo, Opusculum de cognitione animae. A. Achillini, ed. Bologna, 1503, sig. f.[viii]. After Clarke and Dewhurst, Fig. 34.
Fig. 1.14 (R). Diagram of brain functions and cosmology (sensitiva/imaginativa, cogitativa/aestimativa, memorativa/motiva). R. Fludd, Utriusque cosmi maioris scilicet et minoris, metaphysica, physica atque technica historia. 2 vols. Oppenheim: De Bry, 1617–21, II.1:217. After Clarke and Dewhurst, Fig. 57.*

Hermit Agostino Trionfo of Ancona, published in Bologna in 1503 [Fig. 1.13].[15] The same tradition is illustrated in England in the early seventeenth century by Robert Fludd (1574–1637, Fig.1.14).[16]

I can offer no better illustration of the profound change in the conception of memory that occurred in the Renaissance than to cite two poems, one by Petrarch, the other by Michelangelo. Both poems embody nearly all the themes involving memory and self-definition with which I am preoccupied in these essays. The sonnet by Petrarch is one of his best known, since it is thought to have been addressed to Cola di Rienzo, whom Petrarch for a time regarded as the potential savior of Rome. The poet invokes that noble spirit *(spirto gentil)* who, he hopes, will awaken Italy from her long slumber and raise her again to her ancient glory. In the first stanza the spirit is said to rule the limbs *(membra)* of that gallant lord. Two stanzas later the word *membra* becomes part of a play on words with "remember": the ancient walls, which the world still remembers, the stones that contained the members of famous men, all await salvation.

17

*Spirto gentil, che quelle membra reggi
Dentro a le qua' peregrinando alberga
un signor valoroso, accorto a saggio,
L'antiche mura ch'ancor teme et ama
E trema 'l mondo, quando si rimembra
Del tempo andato e'n dietro si rivolve,
E i sassi dove fûr chiuse le membra
Di tal che non saranno senzo fama
Se l'universo pria non si dissolve....*[17]

O gentle spirit who those members rule
Inside which like a pilgrim dwelt and trod
A gallant lord, discerning and wise
The ancient walls that the world fears and loves
Still, and trembles, recalling to its mind
The time that was, turning to give a glance
And the stones where were closed in and confined
The limbs of some of whom honor approves,
Unless the universe fall to mischance....[18]

The evocation of the past through its once glorious monuments and heroes, as well as the exhortation of the ideal ruler to fulfill his destiny by emulating the past — the very process whereby society may be redeemed — is couched in terms of memory, whose operation is mimicked by the echo of the rhyming words for disparate parts *(membra)* and recollection *(remembra)*. In Petrarch's sonnet this interplay between meaning and sound on the theme of memory is dispersed and largely immersed in a series of complex metaphors that make up the whole, eight-stanza work.

Two centuries later Michelangelo Buonarroti (1475–1564), doubtless inspired by Petrarch's poem, realized the potential latent in the same pun, which he brought into focus, distilled, and compressed into just eight lines of verse (English italics mine):

*Molto diletta al gusto intero a sano
l'opra della prim'arte, che n'assembra
i volti a gli atti, a con piu vive membra,
di cera o terra o pietra un corp'umano.
Se po' 'l tempo ingiurioso, aspro a villano*

CHAPTER 1 ⚜ MEMORY AND THE SENSE OF SELF

la rompe o storce o del tutto dismembra,
la beltà che prim'era si rimembra,
e serba a miglior loco il placer vano.[19]

There is much joy and perfect taste
In work of the first art, when it *assembles*
From gestures, face, and the liveliest *members*,
A human body in stone or clay or wax.
If time thereafter, hurtful, harsh and base,
Breaks it, or twists, or thoroughly *dismembers*,
The beauty earlier there he still *remembers*,
And keeps the vain joy for a better place.[20]

Time is again the villain, memory is the savior, and the goal is an ideal future. There are two important differences, however, apart from Michelangelo's brilliant sequence of images related by both rhyme and meaning, crammed into a few verses. Michelangelo's train of thought reflects the Platonic–Augustinian tradition of memory as a recollection of the realm of innate ideas, in this case the idea of beauty, to which the soul may return in the afterlife. Equally important in our context, however, is the role given to the memory through the sequence of puns: memory reassembles, as it were, the *disjecta membra* left by the ruinous passage of time. To a far greater degree than in Petrarch, memory has been transformed from a passive receptacle into an active participant in the creative working of the mind.

Subsequently this sense of memory as an essential part of a vital process came almost to undermine some of the traditional distinctions among the faculties. Thomas Hobbes (1588–1679), for example, emphasized that imagination, in its original meaning as the impression left by sensations when they reach the common sense, is really the same thing as memory. If we focus on experience itself, we refer to the imagination; if we focus on the pastness of experience, we call it memory.[21] In the eighteenth century that eccentric but deeply prophetic premodernist Giambattista Vico (1668–1744) drew this line of thought to its logical conclusion by virtually identifying memory and imagination: All images are based on the senses and we neither imagine without remembering, nor do we remember without the images produced by the senses. The Latins, Vico said, referred to the

faculty by which we create images as memoria and what the Greeks called fantasy the Italians called imagination. In fact, Vico says, the Italian *"immaginare"* corresponds to the Latin *"memorare."* Elsewhere, he observes that fantasy is nothing more than memory, either extended or composite, an efflorescence of reminiscences.

These psychological considerations are of fundamental importance to Vico's historical sense. In primitive times, he says, before the invention of writing and the development of abstract thought, the principle concern was with memory, which was the primary operation of the mind. Hence, the ancients were correct in referring to memory as the mother of the Muses. Vico emphasizes this argument especially in the section of his *Nuova Scienza* dealing with the discovery of the true Homer.[22] Poetry at this early stage was not separable from history. Poetry preserved in the memories of the people that the nations became conscious of their own past and hence of their identities. In part, Vico is here clearly borrowing from the close association between memory and the Muses (inspiration) in the traditional evocations of the epic poets Virgil, who asks the Muse to remind him of the causes of the fateful events he describes; and Dante, who links to the Muses his own *"alto ingegno"* and his memory in describing the Inferno. Yet, Vico seems to have gone beyond this relationship and incorporated as well the role of memory both as a simple evocation of past events and as a source of imaginings and ideas in the manner described by Shakespeare (1564–1616) in the passage in *Love's Labor's Lost* with which I shall conclude these preliminary ruminations. I might have quoted the passage at the outset, but then there would have been no point in writing this essay:

> *This is a gift I have simple: simple, a foolish extravagant spirit,*
> *full of forms,*
> *figures, shapes, objects, ideas, apprehensions, motions, revolutions.*
> *These are*
> *begot in the ventricle of memory, nourished in the womb of Pia*
> *Mater, and*
> *delivered upon the mellowing of occasion. (IV, II, 81f.)*

CHAPTER 1 ~ MEMORY AND THE SENSE OF SELF

NOTES

1. R.P. Hinks, *Myth and Allegory in Ancient Art* (London: Warburg Institute, 1939).

2. R. Klibansky, E. Panofsky, and F. Saxl, *Saturn and Melancholy: Studies In the History of Natural Philosophy, Religion and Art* (London: Nelson, 1964), passim.

3. J. Burckhardt, *Civilization of the Renaissance in Italy* (London: Phaidon, 1944). See also K. Meyer, *Jacob Burckhardt: Ein Portrait* (Munich: Wilhelm Fink Verlag, 2009).

4. M. Baxandall, *Giotto and the Orators: Humanist Observers of Painting in Italy and the Discovery of Pictorial Composition, 1350–1450* (Oxford: Oxford University Press, 1971), 72; R. Preimesberger, *Paragons and Paragone: Van Eyck, Raphael, Michelangelo, Caravaggio, and Bernini* (Los Angeles: Getty Publications, 2011).

5. Baxandall, *Giotto*, 146–48, citing Filippo Villani, *De origine civitatis Florentie et de eiusdem famosis civibus*. See also C. Ginzburg, *Jean Fouquet: Ritratto del Buffone Gonella* (Modena: F.C. Panini, 1996).

6. F.A. Yates, *The Art of Memory* (Chicago: University of Chicago Press, 1966), 397 (index reference).

7. C.B. Avery, *The New Century Handbook of Greek Mythology and Legend* (New York: Appleton-Century-Crofts, 1972), 27.

8. Cicero, *De Inventione*, Loeb Classical Library 386 (Cambridge, MA: Harvard University Press, 1960), 326–27: Memoria est per quam animus repetit illa quae fuerunt; intellegentia, per quam ea perspicit quae sunt; providentia, per quam futurum aliquid videtur ante quam factum est.

9. St. Augustine, *S. Aurelii Augustini Opera Omnia*, Patrologia Latina 42, *De Trinitate libri quindecim* X.11.17: Memoria, intellegentia, voluntas. Remotis igitur paulisper ceteris, quorum mens de se ipsa certa est, tria haec potissimum considerata tractemus, memoriam, intellegentiam, voluntatem 33. In his enim tribus inspici solent etiam ingenia parvulorum cuiusmodi praeferant indolem. [Putting aside, then, for a little while all other things, of which the mind is certain concerning itself, let us especially consider and discuss these three — memory, understanding, will]. Cited in Yates, *Art of Memory*, 47–49.

10. St. Augustine, *De doctrina christiana*, IV.1–31.

11. Marco M. Nievergelt and S.A. Viereck Kamath Gibbs, *The Pèlerinage Allegories of Guillaume de Deguileville: Tradition, Authority and Influence* (Cambridge: D.S. Brewer, 2013), 157–66.

12. H. Liebeschütz, ed., *Reginon Prumiensis Abbas en De Harmonica Institutione, el tercer Mitógrafo Vaticano, John Ridewall en Fulcientius metaforalis* (Leipzig: B.G. Teubner, 1926), 87–93.

13. St. Augustine, *Genesi ad literam,* VII.18 (Creation of the human soul), "The three parts of the brain connected with sensation, motion and memory of motion."

14. Egidius of Rome, *Tractatus aureus Egidii Romani De formatione corporis humani in utero ... cum Tractatu ejusdem De archa Noe, correctus ... per ...Johannem Benedictum Moncetum de Castelione Aretino* (Paris: Poncet Le Preux, 1515).

15. *Opusculum perutile de cognitione animae et eius potentiis Augustini de Anchona cum quadam questione Prosperi de Regio ... Augustinus,* in Clarke and Dewhurst, 27f.

16. *Utriusque cosmi maioris scilicet et minoris [...] historia* 2 (1619), I.1.X, *De triplici animae in corpore visione,* in Clarke and Dewhurst, 39.

17. Lines taken from *Canzoniere (Rerum Vulgarium Fragmenta),* "Rime in vita di Madonna Laura," 53, in Francesco Petrarch, *Sonnets & Songs,* A.M. Armi, trans.; T.E. Mommsen, intro. (New York: Pantheon Books, 1946), 84.

18. *Petrarch Sonnets,* 85.

19. *Rime e lettere di Michelangelo Buonarroti,* A. Corsaro and G. Masi, ed. (Milan: Bompiani , 2016), no. 237.

20. *Complete Poems and Selected Letters of Michelangelo,* C. Gilbert and R. Linscott, ed. and trans. (Princeton, NJ: Princeton University Press, 1980), no. 235, p. 132.

21. J. Lemetti, "Imagination and Diversity in the Philosophy of Hobbes," (Ph.D. Diss., University of Helsinki, 2006), 22–23.

22. T.G. Bergin and M.H. Fisch, trans, *The New Science of Giambattista Vico* (Ithaca, NY: Cornell University Press, 1970), 258–60.

2. ON THE SOURCES AND MEANING OF THE RENAISSANCE PORTRAIT BUST[1]

INDEPENDENT PORTRAIT SCULPTURE was revived around the middle of the fifteenth century in three main forms: the equestrian monument, the bust, and the medal. Equestrian monuments are over-life-size, they were made by public decree, and were displayed in public places. Sculptured busts are life-size, were privately commissioned, and were displayed on private property. Medals are small in scale, they might be commissioned officially or privately, and they were intended for a selected audience that did not include the public at large but extended beyond the sitter's personal domain.[2]

None of these classes of portraiture had actually disappeared during the Middle Ages, but when they occurred they were included within some physical and conceptual context, such as church and tomb decoration, or ordinary coinage.[3] The Renaissance portrait categories cannot be regarded only as revivals, however, for, not to mention questions of style and form, their meaning was profoundly different from what it had been in classical times. With equestrian monuments and medals, the difference is illustrated readily. In antiquity the former were the exclusive prerogative first of the nobility, then of the emperor himself;[4] medallions were restricted to the imperial family.[5] In the Renaissance anyone might be honored by an equestrian monument if he deserved it, and anyone might commission a medal if he could afford it. The change in both cases can be explained partly, but only partly, by what became of equestrian and numismatic portraiture in the Middle Ages.

THIS ESSAY IS CONCERNED with the characteristic Renaissance bust type.[6] The purpose is to analyze its relation to its predecessors, ancient as well as medieval, and to define the significance of its particular form and content. It will appear that the early Renaissance type was more or less equally indebted to classical and medieval traditions, and that in certain fundamental respects it was a new creation.

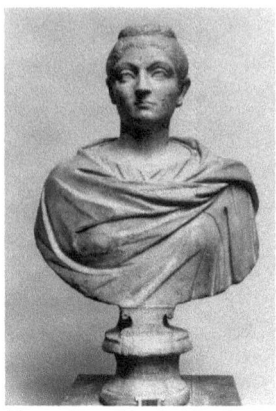
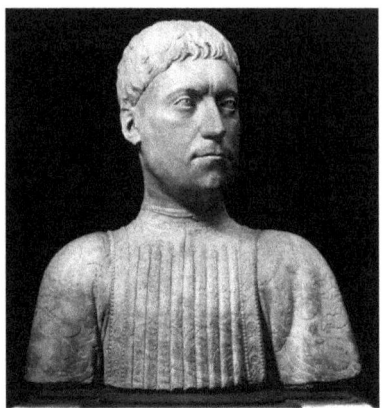

Fig. 2.1. Bust of Aurelia Monnina. 3rd c. Staatliche Museen, Berlin. *Fig. 2.2. Mino da Fiesole, Bust of Piero de' Medici, 1453. Museo Nazionale del Bargello, Florence.*

We begin by comparing as to form and function two representative busts from antiquity and the Renaissance. The classical bust [Fig. 2.1] is rounded at the bottom, hollowed out at the back, and set up on a base. It has an inscription on the front saying it was dedicated to the deified spirits of the dead by the parents of the girl named Aurelia Monnina, who died at age eighteen.[7] It probably formed part of her tomb or stood in a niche in her family's house along with other portraits of her ancestors. The Renaissance bust [Fig. 2.2] is cut straight through just above the elbow, it is carved fully in the round, and it has no base. It has an inscription on the underside saying that it represents Piero de' Medici at the age of thirty-seven and was made by the sculptor Mino da Fiesole. Thus it was carved in 1453, sixteen years before the sitter died, and is, incidentally, the first dated portrait bust of the Renaissance. This bust and others of Piero's wife and brother, also by Mino, stood in semi-circular pediments above doorways in the Palazzo Medici in Florence.[8]

Before exploring the comparison, it must be emphasized that the difference in the treatment of the backs is related to the special and perhaps unexpected way in which the Renaissance bust manifested its independence. Neither of these sculptures was meant to be seen from all sides. In antiquity and in the early Renaissance, busts (as

CHAPTER 2 ※ THE RENAISSANCE PORTRAIT BUST

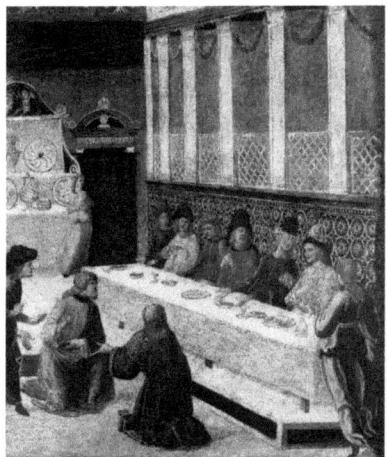

Fig. 2.3 (L). Jacopo del Sellaio, Scene from the Story of Esther, detail. Galleria degli Uffizi, Florence.
Fig. 2.4 (R). Jacopo del Sellaio, Scene from the Story of Esther, detail, Banquet of Vashti. Galleria degli Uffizi, Florence.

distinguished from herms) were normally set in recesses or on consoles projecting from an architectural member. The idea of the bust as a "freestanding" monument with a columnar pedestal reaching to the ground was a late development in both periods, early Christian in the former, sixteenth century in the latter.[9] The Renaissance bust, however, as is indicated by two companion paintings attributed to Jacopo del Sellaio [Figs. 2.3 and 2.4, above the doorways], might be displayed in profile as well as head-on;[10] and this equivalence of front and side views made the quattrocento bust independent in effect, although it was not so in fact.

Visually the classical work is a self-contained, abstract form, conceived only from the front and set apart by a base from its support. The Renaissance work is an arbitrarily cutoff, incomplete form, conceived in three dimensions and not isolated from the support. It could be deduced from their forms alone that both objects were created by rational beings, but whereas it might be concluded that the classical work is purely an artifact, it would be evident that the Renaissance work represents part of a whole. The classical bust is an

ideal form, the Renaissance bust is a deliberate fragment. The locations of the inscriptions are also significant: the dedicatory formula on the classical portrait, D<iis> M<anibus>, is in this case cut into the torso itself, emphasizing that the bust is an object. The inscription on the bottom of the Renaissance portrait serves purely as documentation, since it is ordinarily invisible, and it does not interfere with the suggestion that the bust is part of a human being.[11] From each artist's point of view the other's creation is grotesque, in the one case because the bust appears like an amputated body, in the other because a human being is made into an inanimate thing.

The visual contrast is paralleled on the functional level. Classical sculptured portraits may be grouped into two broad categories. One group consists of official, honorific portraits displayed publicly. They depict persons, living or dead, who by virtue of rank or achievement merited recognition. They were set up in open fora, in temples, libraries, and baths. The second group consists of private ancestral portraits. They represented deceased persons of no special distinction, and were displayed on the tomb or within the home as part of the family cult.[12] There is no literary or epigraphical evidence that portraits of living friends or members of the family were displayed privately.[13] The classical bust, therefore, was never just a record of an individual. In all its uses it was basically an idol, a cult image — for ruler or hero worship in the case of public portraits, for ancestor worship in the case of private portraits.[14]

Most Renaissance busts, by contrast, are neither honorific nor are they family ghosts.[15] Moreover, they were not only displayed on tombs or inside the house, but on the facade of the dwelling as well; they were private, but might be seen by one and all.[16] And they had no role in religious cults, whether of the hero, though the sitters might be alive, or of ancestors, though they might represent members of the family.

CHAPTER 2 ❧ THE RENAISSANCE PORTRAIT BUST

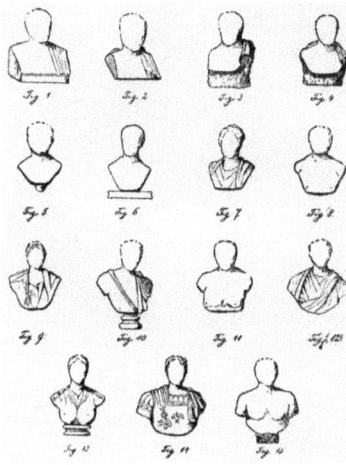

Fig. 2.5. *Development of Roman Bust Forms, after Bienkowski.*

Fig. 2.6. *Votive Terracotta from the Temple of Vignale. 2nd c. BCE. Falerii Veteres, Museo Nazionale di Villa Giulia, Rome.*

Antiquity

THE CLASSICAL PORTRAIT BUST, in all its forms, transforms the body into an abstract, ideal shape. The development of the "canonical" type of Roman bust may be defined as follows: starting from the head, the torso increased in width and length to include the shoulders and arms, while the back was hollowed out, the bottom rounded off, and the base introduced [Fig. 2.5].[17]

The horizontally cut bust, with or without base, does occur throughout the Roman period, in two contexts.[18] It occurs when the body is fully articulated but the whole bust is not included. This is the case with the herm, where the shoulders and arms are sliced off vertically, and with certain votive terracottas, where the shoulders are included but the trunk is severed at the breast line or above [Fig. 2.6].[19] The horizontal cut also occurs in portraits where more of the bust is included but the body is not fully articulated. Such is the

27

Fig. 2.7 (above). Roman Tomb Monument. 1st c. BCE. Cloister, S. Giovanni in Laterano, Rome.
Fig. 2.8a–b (below). Bust from a tomb at Palestrina (front and side). 2nd c. BCE. Museo Etrusco Gregoriano, Vatican Museums. Rome.

case with portraits in relief [Fig. 2.7][20] or with freestanding busts that are flat or merely roughed out at the back [Fig. 2.8a–b].[21] Busts of this kind were regularly framed by an aedicule or set in a base, so that the lower part of the figure did not appear to have been cut off but hidden.[22] Such is the case also with various types of funerary terracottas and cinerary urns that have no frames or bases [Figs. 2.9a–b and 2.10]. Here the arms are not articulated (that is, the bust is a simple rectangle, circle or oval in plan), the back is flat or unworked, openings are left in the sides or back.[23]

Thus, if the Renaissance bust was inspired by classical models, they were transformed both physically and conceptually. Physically, by lengthening the abbreviated type, or by executing the partially articulated type fully in the round. Conceptually, the portrait was transformed from an idol or cult image into the representation of a private living person. Antiquity did not create portraits of individuals, pure and simple, and it did not create a complete bust form for the portrait, that is, a human protome, including head, trunk of the body,

CHAPTER 2 ⁂ THE RENAISSANCE PORTRAIT BUST

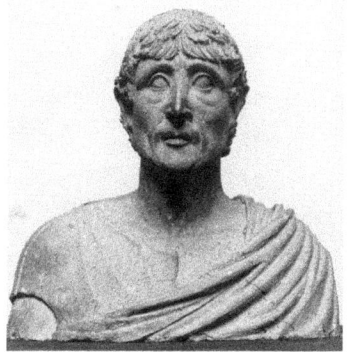 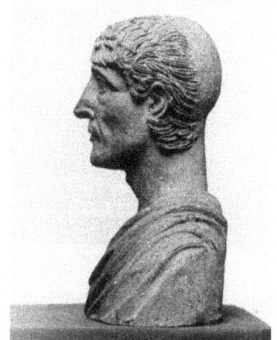

Fig. 2.9a–b. (above). Terracotta Bust of a Man (front and side). 2nd c. BCE. Staatliche Museen, Berlin.
Fig. 2.10 (below). Terracotta bust of a Man. 1st c. BCE. Museo Nazionale delle Terme, Rome.

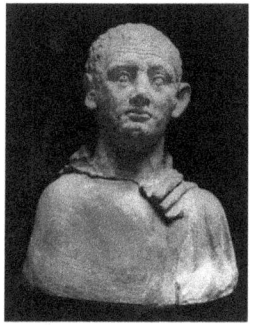

shoulders and upper arms, and worked fully in the round.

These formulations have linguistic counterparts. There is no equivalent in classical Latin for the word "individual" used as a substantive noun in reference to a human being. The parent word *individuus* occurs only as an adjective, or as a neuter noun referring to inhuman entities (atoms).[24] Other terms, such as *persona* or *homo*, or *privatus*, were applied to human beings, but these did not focus, as does "individual," on the quality of uniqueness.[25] Similarly, antiquity had no name for the bust in the sense of a complete human protome. *Truncus* meant, as do our words "trunk" and "torso" (from *thyrsus*, stalk), the main stem of the body, excluding head and arms. *Herma* or *imago clipeata* (that is, the shield portrait) might be used for abbreviated likenesses, but these terms do not refer to the protome as such.[26] *Bustum* (from *urere*, to burn) was used in the context of funeral rites to mean the place of incineration, the ashes or bones left from the pyre, the tumulus of earth on the tomb; but it was never used for the human protome.[27] It has been suggested, on the basis of the anthropomorphic funerary urns just

29

Fig. 2.11 (L). Workshop of Peter Parler. Bust of Wenceslaus I, c.1375. Cathedral, Prague.
Fig. 2.12 (R) Bust of a Man. Mid-13th c. Cathedral, Acerenza.

mentioned, that the later use of *bustum* was a linguistic extension, from the place where the body was burned, to the urn in which the ashes were kept.[28] This hypothesis finds support in the fact that in late classical Latin *bustum* was used to mean brazier.[29] *Bustum* was first used with the connotation of human protome by medieval writers, who also applied it to containers for holy relics.[30] The ancient cinerary urn was, after all, a sort of reliquary.

The Middle Ages
IN THE MIDDLE AGES the horizontal cut was the canonical form for the portrait bust.[31] It occurs both in relief and in the round. An example of the former is the portrait of Wenceslaus I [Fig. 2.11] that forms part of a series of busts by Peter Parler and his workshop set in niches in the triforium of Prague Cathedral (around 1375).[32] An example of the latter is a thirteenth-century bust in the classicistic style of the period of Frederick II [Fig. 2.12] that crowned the tympanum of the cathedral of Acerenza, which is left unfinished at the back.[33] Such busts are generally seen without separate frames or bases, so there is no suggestion that the lower body is hidden, as was the case with their classical antecedents; rather there is implied an inner continuity between the torso and its architectural matrix.

CHAPTER 2 ❧ THE RENAISSANCE PORTRAIT BUST

Fig. 2.13. Reliquary Bust of a Saint. 14th c. Church of St. Ursula, Cologne.

The horizontal cut occurs in the late Middle Ages in one class of independent monuments, namely, bust reliquaries [Fig. 2.13].[34] These often include the whole bust, and they are worked fully in the round. This is a form we could not find in antiquity. The bust reliquaries differ from the Renaissance portrait in three respects: they are normally

Fig. 2.14. Donatello, Reliquary Bust of St. Rossore, c.1424. Museo di S. Matteo, Pisa.

isolated from the support, either by a base or necking or a lip around the lower edge; being portable, they are completely free of their environment; and they represent distinguished, dead people.

The medieval reliquary was functionally related to the ancient cinerary urn, and this relationship seems to have become explicit in the genealogy of the term *bustum*. Both were cult images and served as containers for the remains of a venerated person. The difference is that in antiquity this honor might be accorded to any one: it was, so to speak, a "death right." In the Middle Ages the honor was accorded only to a sanctified few. In this respect the reliquary is comparable to the pagan idol. The difference here is that, as with the Byzantine icon, the worship was not accorded to the object itself, but to what it represented.[35] The image was not the deity, it merely represented the

CHAPTER 2 ❦ THE RENAISSANCE PORTRAIT BUST

Fig. 2.15. Donatello(?), Bust of a Youth, c. 1440.
Museo Nazionale del Bargello, Florence.

deity. The icon and the reliquary allude, in a way the pagan idol does not, to a reality beyond that which is actually represented.

If the Renaissance bust was inspired by the medieval reliquary, the model was again transformed physically and conceptually; physically, by taking the bust off its base and connecting it to a setting; conceptually, by making it into a representation of a living, private individual.

The Transition to the Renaissance Bust

TWO WORKS seem consciously to mediate between the independent, bust-length portrait of antiquity and the medieval bust-reliquary on the one hand, and the Renaissance portrait-bust on the other. One of these is Donatello's reliquary of St. Rossore, of around 1424 [Fig. 2.14]. Here the realistic treatment is obviously intended to suggest an individual likeness: there is no horizontal band or lip, and there was evidently no base.[36] By a striking illusionistic device, however, Donatello made it clear that the St. Rossore is not really half a human being. The bottom edge of the drapery spills out onto the underlying surface, so that while the figure appears amputated, the bust appears as an object resting on its support.

An analogous device is seen in the much-discussed bust of a youth in the Bargello, often attributed to Donatello, in which case it must date from around 1440 [Fig. 2.15].[37] In that it is worked in the round and is not a reliquary, it anticipates the portrait busts that appear a decade later. But in that it has a rim at the base, on which the drapery rests, it is again an object, not half a man. There is a specific reference to the reliquary tradition in the oval relief at the front: it has been

33

observed by Wittkower that this recalls the jewels that often decorate the breasts of bust reliquaries; but it also recalls the openings in the breast that often provided a glimpse of the relic inside. The relief depicts Plato's image, described in the Phaedrus, of the human soul as a two-horsed chariot and driver, which appears here as if it were the relic. The interplay between medallion and view of the soul is a perfect visual counterpart of the Platonic relationship between visible form and the idea behind it. The bust thus represents Humanity, whether it portrays a particular person or not.

Both the *St. Rossore* and the *Bust of a Youth* break radically with tradition: in the former a reliquary appears as if it were a portrait, in the latter what appears to be a portrait is given the character of a reliquary. Both involve an existential pun in which generic notions — Saint/ Human — and concrete things — reliquary/portrait — are fused.

CONCLUSION

THE INGREDIENTS from which the Renaissance bust was created had all existed in the classical and medieval past. The Renaissance bust itself, however, is something that had never existed before, conceptually and visually: an independent portrait of a living, private individual, and a full human protome, horizontally cut, without a base. This unprecedented portrait form creates a three-dimensional illusion that the full-length figure, by its very nature, cannot achieve and that the shaped, hollowed bust inevitably contradicts. The arbitrary amputation specifically suggests that what is visible is part of a larger whole, that there is more than meets the eye. By focusing on the upper part of the body but deliberately emphasizing that it is only a fragment, the Renaissance bust evokes the complete individual — that sum total of physical and psychological characteristics that make up the "whole man."[38]

"*Tòtus homo*," the whole man, was in fact a Renaissance expression. Though used in various contexts, and never precisely defined, the concept of the *totus homo* occurs widely in the writings of Renaissance thinkers. It has been studied only in the case of Martin Luther, but it first appears, so far as I can discover, in the famous

CHAPTER 2 ❧ THE RENAISSANCE PORTRAIT BUST

Fig. 2.16. Antonio Rossellino, Bust of Matteo Palmieri, 1468. Museo Nazionale del Bargello, Florence.

treatise *On the Dignity and Excellence of Man* written in 1451–52 by Giannozzo Manetti, the Florentine statesman and historian.[39] Having considered the body and soul separately, Manetti devotes the third book to the "whole man." His main theme here is the uniqueness of human nature, the qualities of which are shared, he says, by no other of God's creatures, not even the angels.

From Manetti it was but a short step to the view of the human being as a free and independent being midway between heaven and hell, a concept which is one of the principal glories of Florentine humanist thought in the second half of the fifteenth century. This forms the basis of the long poem on the significance of human life, the *Città di Vita,* written in the 1450s and 1460s by the life-long friend of Cosimo and Piero de' Medici, Matteo Palmieri. His bust, dated 1468 by Antonio Rossellino, now in the Bargello, stood above the entrance to Palmieri's house in the Via de' Pianellai [Fig. 2.16].[40] Palmieri formulated the heretical theory that humanity was descended from those archangels who remained neutral at the time of the rebellion, when Michael sided with God and Lucifer fell. In humanity, according to Palmieri, the neutral archangels are given a second opportunity to choose their destiny. I will only mention the passionate hymn to the uniquely indeterminate nature of humanness in Pico della Mirandola's *Oration on the Dignity of Man* of 1486.[41] Neither Palmieri nor Pico use the term, but thereafter *totus homo* became intimately linked to the problem of the freedom of the will. It entered into the dispute on this subject between Desiderius

35

Erasmus and Luther; its connotation here has been defined as that of a "neutral" concept of human personality, a sheer self-awareness that participates in, but is essentially independent of, body and soul, good and evil, salvation and damnation.[42]

I do not pretend that the Renaissance idea of the "whole man" and the peculiar form of the Renaissance portrait bust were specifically related. But they were specifically correlated, historically in the sense that both emerged at the same time in the same close-knit ambience of Florentine humanism, and ideologically in the sense that both embody a notion of human nature as a totality that can be reached only by implication and allusion.[43]

They are also analogous in that they belong to the unarticulated premises rather than the explicit deductions of Renaissance culture. For just as none of the writers ever says what he means by *totus homo*, so one cannot cite external evidence for the significance of the bust form as such. Fifteenth-century references to portrait busts are, in fact, exceedingly rare, and, except for a number of poems, limited to bare notations of their existence.[44] The poetical evocations are deeply revealing, however, because they create in words the same effect as do the portraits in marble. This is true of the earliest poem on a portrait bust I have found so far,[45] which contains, incidentally, the word "bust" for the first time to my knowledge with its modern meaning.[46] It is one of a series of Latin epigrams by Alessandro Bracci, a member of Marsilio Ficino's Platonic academy and friend of Angelo Poliziano and Lorenzo de' Medici, eulogizing Albiera degli Albizzi, who died betrothed in 1472, at the age of fifteen.[47] The epigram, which is on a lost or as yet unidentified portrait of Albiera,[48] reads in translation as follows:

To the Marble Bust
Albiera, whose noble form is to be admired, asks, o passerby,
That you stop a little and consider
Whether Polykleitos' or Praxiteles' deft hand
Ever made such visages from Parian marble.
But lest there be on earth any lovelier than the goddesses,
Death, at the command of the deities, carried me off.

CHAPTER 2 ❧ THE RENAISSANCE PORTRAIT BUST

Works of art that speak are, of course, commonplace in the classical literary tradition of ekphrasis and in medieval accounts of miraculous holy images. Inscriptions on tombs and commemorative statues are often couched in the first person. But Bracci's epigram is remarkable in two respects. It is the earliest case of such elocution I know that involves a portrait bust. The second point concerns the structure of the poem. The title tells us that we are confronted by a portrait. In the first four lines Albiera is represented as asking us to compare her noble form with faces by famous sculptors. Were it not for the title, we would assume the living woman was asking to be compared to a work of art. In the last two lines there is a crucial grammatical shift from indirect to direct discourse, and Albiera says she is dead. The difference between life and death is therefore deliberately conjured up, and dismissed, for it is impossible to know in either case which is speaking, Albiera or her counterfeit. The verbal equivalent of the horizontal cutoff is the title: in an arbitrary way, since it is not part of the poem, it calls attention to the material and the incompleteness of the object. In the text, however, the words "form" and "visage" are used, and these refer not to an object but to an image and a person. Thus, because the title addresses a marble bust and the text alludes to a human being, on reading the epigram we inevitably think of what can only be described as the whole individual.

APPENDIX

Chronological checklist of inscribed Florentine portrait busts of the Quattrocento

1. Mino da Fiesole, Piero de' Medici, Museo Nazionale del Bargello, Florence

Inside hollow at front:

PETRVS. COS. F

Inside hollow at back:

AETATIS. ANNO. XXXVII [1453]

Under right arm:

SCVLTORIS

Under left arm:

OPVS. MINI

2. Mino da Fiesole, Niccolo Strozzi, Staatliche Museen, Berlin

Inside hollow at back:

NICOLAVS. DESTROZIS INVRBE. A. MCCCCLIIII.

On underside of rim at front:

OPVS. NINI

See F. Schottmüller, *Die italienischen und spanischen Bildwerke der Renaissance und der Barock* 1. *Die Bildwerke in Stein, Holz, Ton und Wachs*, 2d ed. (Berlin: De Gruyter, 1933), 55, no. 96.

3. Mino da Fiesole, Astorgio Manfredi, National Gallery of Art, Washington, DC

Inside hollow at back:

ASTORGIVS. MANFREDVS. SECVNDVS. FAVENTIE. DOMINVS

On underside of rim at right side:

ANNO. XLII. ETATIS. SVE

Under right arm:

1455

Under left arm:

OPVS. NINI

4. Antonio Rossellino, Giovanni da San Miniato, Victoria and Albert Museum, London

Inside hollow, inscribed within the slightly hollowed base:

MAGISTER IOHANES MAGISTRI. ANTONII DE SANCTO MINIATE DOCTOR ARTIVM ET MEDICINE. M.CCCCLVI

In the center:

OPVS ANTONII.

See J. Pope-Hennessy, assisted by R. Lightbown, *Catalogue of Italian Sculpture in the Victoria and Albert Museum*, 3 vols. (London: Victoria and Albert Museum, 1964), 1:124.

5. Mino da Fiesole, Alessandro Mini di Luca, Staatliche Museen, Berlin

On the plinth at the front:

ALEXO DI LVCA MINI 1456

Inside hollow at back:

MCCCCLXV

See Schottmüller, 56, no. 2186.

6. Mino da Fiesole, Rinaldo della Luna, Museo Nazionale del Bargello, Florence

Around front lower edge beginning behind right shoulder:

RINALDO. DELLA. LVNA. SVE. ETATIS. ANNO. XXVII.

Around back lower edge beginning behind left shoulder:

OPVS. MINI. NE CCCCLXI.

7. Antonio Rossellino, Francesco Sassetti, Museo Nazionale del Bargello, Florence

Inside hollow at back:

FRAN. SAXETTVS FLORENT. CIVIS AETATIS. ANN. XLIIII [1464]

8. Mino da Fiesole, Dietisalvi Neroni, Musée du Louvre, Paris

On base:

+AETATIS. SVE. AN AGES. LX TYRC ... FACIV. DVM.L CVRAVIT. DIETISALVIVS. OPVS. MINI MCCCCLXIIII.

See A. Venturi, *Storia dell'arte italiana*, 11 vols. (Milan: Hoepli, 1901–39], 6:640, n. x.

9. Antonio Rossellino, Matteo Palmieri, Museo Nazionale del Bargello, Florence

Inside hollow at back:

MATTHEO PALMERIO SAL. AN. MCCCCLXVIII

Inside hollow at front:

OPVS ANTONII GHAMBERELLI

10. Benedetto da Maiano, Pietro Mellini, Museo Nazionale del Bargello, Florence

Inside hollow above a banderole at back:

AN 1474

Inside hollow on a banderole at the back:

PETRI. MELLINI. FRANCISCI. FILII. IMAGO. HEC

On underside of rim at front:

BENEDITVS. MAIANVS. FECI

11. Benedetto da Maiano, Filippo Strozzi (died 1491), Musée du Louvre, Paris

On interior of base:

PHILIPPVS. STROZA. MATHEI. FILIVS. BENEDICTVS. DE. MAIANO. FECIT

See Babelon, "Un medaillon de cire du Cabinet des Medailles: Filippo Strozzi et Benedetto da Majano," *Gazette des Beaux-arts* 5th ser. 4 (1921): 204, n. 2.

12. Antonio Pollaiuolo (?), Portrait of a Man, Museo Nazionale del Bargello, Florence

Inside hollow on tabula ansata at back:

MCCCCLXXX.XV.

CHAPTER 2 ❧ THE RENAISSANCE PORTRAIT BUST

NOTES

1. Previously published in *The Art Quarterly* 33 (1970): 207–26. Reprinted with additions in *Looking at Italian Renaissance Sculpture*, Sarah Blake McHam, ed. (New York: Cambridge University Press), 1998, 60–78.

2. The most useful survey of the kinds of Renaissance portrait sculpture remains that of J. Burckhardt, "Skulptur der Renaissance," in *Jacob Burckhardt Gesamtausgabe* 13 (Stuttgart: Deutsche Verlags-Anstalt, 1934), 302–17. See further the articles "Bildnis" (P.O. Rave), "Büste" (H. Keller), and "Denkmal" (H. Keller), in *Reallexikon zur deutschen Kunstgeschichte* (Stuttgart: Metzler, 1937-73), 2:639–79, 3:255–74, 1257–98; and H. Keutner, *Sculpture Renaissance to Rococo* (London: M. Joseph, 1969), 27–29. On the medal, G.F. Hill, *Medals of the Renaissance* (Oxford: Clarendon Press, 1920). The isolated standing portrait monument did not appear until the sixteenth century. See H. Keutner, "Über die Entstehung und die Formen des Standbildes im Cinquecento," *Münchner Jahrbuch der bildenden Kunst* 7 (1956): 138–68; although a columnar monument with a seated figure of Borso d'Este was erected at Ferrara in the mid-fifteenth century. See W. Haftmann, *Das italienische Säulenmonument*, Leipzig: B.G Teubner, 1939), 146–47. The honorific papal portrait statue, which emerged in the late Middle Ages, forms a category apart. See W. Hager, *Die Ehrenstatuen der Päpste* (Leipzig: Poeschel & Trepte, 1929).

3. On the medieval portrait, see H. Keller, "Die Entstehung des Bildnisses am Ende des Hochmittelalters," *Römisches Jahrbuch für Kunstgeschichte* 3 (1939): 227–356.

4. See H.W. Janson, "The Equestrian Monument from Cangrande della Scala to Peter the Great," in *Aspects of the Renaissance, A Symposium, Austin, Texas* (Austin: University of Texas Press, 1967), 75, 77.

5. See Hill, *Medals of the Renaissance*, 15.

6. For a survey of Renaissance bust types and bases, see W. von Bode, "Die Ausbildung des Sockels bei den Büsten der italienischen Renaissance," *Amtliche Berichte aus den preuszischen Kunstsammlungen* 40 (1918–19): 100–120.

7. C. Blümel, *Staatliche Museen zu Berlin: Römische Bildnisse* (Berlin: Verlag für Kunstwissenschaft, 1933), No. R118.

8. The busts of Piero and Lucrezia are mentioned by Giorgio Vasari, *Le Vite dei più eccelenti pittori scultori ed architettori*, G. Milanesi, ed., 9 vols. (Florence: Sansoni, 1878-1906), 3:123: "fece [Mino] il ritratto di Piero di Lorenzo de' Medici e quello della moglie, naturali e simili affatto. Queste due teste

stettono molti anni sopra due porte in camera di Piero, in casa Medici, sotto un mezzo tondo." The busts of Piero and Giovanni are listed in the inventory of the Medici Palace made in 1492: "Nella Camera della scala grande detta di Lorenzo — Una testa di marmo sopra l'uscio dell'antichamera della [i]mpronta di Piero di Cosimo. Nella chamera che risponde sulla via chiamata di Monsignore dove sta Giuliano — Una testa di marmo sopra l'uscio dell'antichamera di tutto rilievo ritratto al naturale di Giovanni di Cosimo de' Medici." See E. Müntz, *Les collections des Médicis au XVe siècle* (Paris: Librairie de l'art, 1888), 62, 84–85. In general, on the placement of family portraits, Vasari's phraseology is significant: "onde si vede in ogni casa di Firenze, sopra i cammini, usci, finestre e cornicioni, infiniti di detti ritratti..." (*Le Vite*, 3:373).

9. On the modes of displaying classical busts, see M. Wegner, *Die Herrscherbildnisse in antoninischer Zeit* (Berlin: Mann, 1939), 289–91. Both in antiquity and in the Renaissance the freestanding bust monument seems to have been related to the conception of the bust form itself as a sign of veneration. The custom may be traceable to the imperial cult. Portrait busts are shown on altars, which may take cylindrical shape, from the later Republican period: cf. a gem attributed to Sulla, in M.L.Vollenweider, "Der Traum des Sulla Felix," *Schweizerische numismatische Rundschau* 39 (1958–59): pl.VII, no. 6, p. 24, n. 8, a reference for which I am indebted to Mr. Dawson Kiang. Related material was kindly brought to my attention by Professor Henri Seyrig: H. von Fritze, *Die Münzen von Pergamon* (Berlin: de Gruyter, 1910), 90; F. Imhoof-Blumer and P. Gardner, *A Numismatic Commentary on Pausanias* (reprinted from *The Journal of Hellenic Studies*, 1885, 1886, 1887), 94, pl. S, fig. XVIII. See also a coin of Caracalla, C.Vermeule, *Roman Imperial Art in Greece and Asia Minor* (Cambridge, MA: Harvard University Press, 1968), frontispiece. See also *The Museum Year, 1968: The Ninety-Third Annual Report of the Museum of Fine Arts, Boston* (Boston: MFA, 1969), 33. Subsequently, busts are shown placed on columns in scenes of Nebuchadnezzar ordering the three youths to worship his image, and on an ivory representing a poet and his model. See Wegner, *Herrscherbildnisse*, 290; H. Kruse, *Studien zur offiziellen Geltung des Kaiserbildes im römischen Reiche* (Paderborn: Schöningh, 1934), 84–89. Related phenomena are imperial portrait busts set on moveable stands and surmounting scepters. See Kruse, 101–2, 106–9; A. Alföldi, "Insignien und Tracht der römischen Kaiser," *Mitteilungen des deutschen archaeologischen Instituts, Römische Abteilung* 50 (1935): 116–17. In the Renaissance, busts were not put on separate supports until the sixteenth century, along with the revival of the "canonical" form of the classical bust. See A. Sciaparelli, *La casa fiorentina e i suoi arredi nei secoli XIV e XV* (Florence: Biblioteca storica del rinascimento, 1908), 194.

CHAPTER 2 ⚜ THE RENAISSANCE PORTRAIT BUST

10. Alinari photos 307167. I am indebted to Professor Ulrich Middeldorf for referring me to these paintings. See P. Schubring, *Cassoni* (Leipzig: Hiersemann, 1923), 307.

11. I know of no Renaissance bust inscribed on the body of the sitter, and in most early examples the inscription appears on the underside. I include as an appendix to this chapter, with no claim to completeness, a chronological checklist of inscribed Florentine portrait busts of the Quattrocento. Where no reference is given I have copied the inscription myself.

12. For a survey of the Roman uses of portrait statuary, see L. Friedlaender, *Darstellungen aus der Sittengeschichte Roms in der Zeit von Augustus bis zum Ausgang der Antonine*, 4 vols. (Leipzig: S. Hirzel, 1919–21) 3:57–78. For the types and placement of ruler portraits, see Wegner, *Herrscherbildnisse*, 100–122. For portraits of philosophers and poets, T. Lorenz, *Galerien von griechischen Philosophen und Dichterbildnissen bei den Römern* (Mainz: Philipp von Zabern, 1965), 35–44. For ancestral portraiture, see A.N. Zadoks and J. Jitta, *Ancestral Portraiture in Rome and the Art of the Last Century of the Republic* (Amsterdam: Noord-Hollandsche Uitgevers-Mij, 1932). An intermediate group might include votive portraits displayed in a sanctuary to invoke the deity's beneficence, as in case of illness; for example, our Fig. 2.6, a terracotta portrait in the Villa Giulia, from the Tempio Maggiore at Vignale, Falerii Veteres. See below, n. 18. A passage in Pliny is often cited as evidence that ancestral portraits were displayed publicly on the outside of houses. More likely, it refers to the placement of such images around the door leading to the family record room: "Tabulina codicibus implebantur et monumentis rerum in magistratu gestarum. Aliae foris et circa limina animorum ingentium imagines erant...." *Historiae Naturalis*, 35.7. This passage may, nevertheless, have had considerable influence in the Renaissance. See below.

13. H. Jucker, *Das Bildnis im Blätterkelch* (Olten: URS Graf-Verlag, 1961), 136: "Devon aber, dass sich der Hausherr Porträts seiner noch lebenden Familienangehörigen oder Freunde machen liess, um sie bei sich aufzustellen, ist, so viel ich seine, weder in der Literatur noch in Inschriften je die Rede."

14. "Das Bildnis zeigt überall eine noch viel stärkere Kraft zur Vergegenwärtigung, es ist in intensiverem Masse stellvertretend für den Dargestellten, als wir im allgemeinen empfinden können." Jucker, *Bildnis im Blätterkelch*, 135.

15. All the busts listed in the Appendix above with the name of the sitter and his age or the date inscribed were made while the sitter was alive.

16. The bust of Matteo Palmieri (Fig. 2.16) stood until 1832 over the entrance to the Casa Palmieri in the Via de' Pianellai in Florence (see below). For a later Quattrocento example in Naples, see G.L. Hersey, *Alfonso II and the Artistic Renewal of Naples 1485–1495*, New Haven: Yale University Press, 1969), 29–30 n. 12. This custom, which became widespread in the sixteenth century, may have arisen from a misinterpretation of a passage in Pliny (cited in n. 12 above). I have found no classical instances of private portrait busts placed over exterior entrances.

17. On the development of this bust type, see P. Bienkowski, "Note sur l'histoire du buste dans l'antiquité," *Revue archéologique* 27 (1895): 29–37 (our Fig. 2.5 is Bienkowski, 294, fig. 1); H. Hekler, "Studien zur römischen Porträtkunst," *Jahreshefte des österreichischen archäologischen Institutes in Wien* 21–22 (1922–24): 172–202. Lorenz, *Galerien*, 54, notes that the first bust known to him that is set on a base is a portrait of Caligula.

18. For a brief discussion of the horizontal cut, see B. Schweitzer, *Die Bildniskunst der römischen Republik* (Leipzig: Koehler und Amelang, 1948), 31.

19. On the development of the portrait herm, see K. Schefold, *Die Bildnisse der antiken Dichter, Redner und Denker* (Basel: B. Schwabe, 1943), 196–97; Lorenz, *Galerien*, 54. For such portrait terracottas, G. von Kaschnitz-Weinberg, *Ausgewählte Schriften* (Berlin: Mann, 1965), 2:16–17, 51; R. Bianchi-Bandinelli, *Storicità dell'arte classica* (Florence: Electa, 1950), 100–130. Our Fig. 2.6 is M. Moretti, *Il museo nazionale di Villa Giulia* (Rome: Tipografia artistica, 1962), fig. 160. See above, n. 12.

20. Fig. 2.7 is Zadoks and Jitta, *Ancestral Portraiture*, pl. XVIIb, an interesting tomb relief in which certain of the figures are distinguished by the inscription "VIVIT."

21. M. Collignon, *Les statues funéraires dans l'art grec* (Paris: E. Leroux, 1911), 301–14; O. Vessberg, *Studien zur Kunstgeschichte der römischen Republik. Acta instituti romani regni sueciae* 8 (Lund: Gleerup, 1941), 189; A. Giuliano, "Busti femminili da Palestrina," *Mitteilungen des deutschen archaeologischen Instituts. Römische Abteilung* 60–61 (1953–54): 172–83. Our Fig. 2.8, Giuliano, pl. 71. See W. Helbig, *Führer durch die öffentlichen Sammlungen klassischer Altertümer in Rom*, 4th ed. (Tübingen: Wasmuth, 1963–72), 1:477–78, no. 618.

22. See O. Benndorf, "Bildnis einer jungen Griechin," *Jahreshefte des österreichischen archäologischen Institutes in Wien* 1 (1898): 1-8, at 8; J. Keil, "Hellenistische Grabstele aus Magnesia a. M.," *Jahreshefte des österreichischen archäologischen Institutes in Wien* 16 (1913): 178–82 at 181; Lorenz, *Galerien*, 54. Certain bust-length tomb figures from the Greek islands, set in aedicules

CHAPTER 2 ❧ THE RENAISSANCE PORTRAIT BUST

or on hollowed plinths on sarcophagus covers, are carved in the round, for example that from Thera in Athens. See S. Karovsov, *National Archaeological Museum: Collection of Sculpture. A Catalogue* (Athens: National Archaeological Museum, 1968), 190. These are not individualized portraits. I have found no classical example of a life-size portrait bust cut horizontally at the breast line or lower, worked fully in the round, and demonstrably not set in an aedicule or on a base.

23. See n. 19 above; S. Ferri, "Busti fittili di Magna Grecia e l'origine dell'erma," *Atti della Accademia nazionale dei Lincei. Rendiconti* 18 (1963): 29–42. Our Fig. 2.9 is Bianchi-Bandinelli, *Storicità*, 64, figs. 129, 130; our Fig. 2.10 is B.M. Felletti Maj, *Museo nazionale romano: I ritratti* (Rome: Libreria dello Stato, 1953), no. 48. There is a large hole in the back left side.

24. *Individuum* appears in writers of the early Christian period as a neuter substantive, meaning a person as a single member of the species: "Cum dico 'Cicero,' iam quiddam individuum certumque significo; cum dico 'homo,'... incertum est, quem significem." See "Martianus Capellus" *Thesaurus linguae latinae* (Leipzig: Teubner, 1900–1913), 7.1, col. 1208, ll. 68–72. The first instance cited in the dictionaries in which the word refers to a particular person without any notion of contrast to a class or group dates from the sixteenth century: "Dubitando che per qualche accidente e' non nascesse alcuna differenza tra queste due individui" (Agnolo Firenzuola, 1493–1543). See N. Tommaseo, *Dizionario della lingua italiana,* 4 vols. (Turin: UTET, 1861–79), 2.2:1456. A further extension occurred in the seventeenth century when the word was applied to the person's self: "Il peccato d'Adamo non solamente condannò l'uomo a conservare il suo individuo con tanta fatica, ma l'abbassò a mantener la sua specie con tanta deformità" (Pietro Sforza Pallivicino, 1607–77; ibid.). Compare the obsolete English usage, "As to what concerns my owne poore individuall" (E. Nicholas, 1655), in J.A.H. Murray, ed., *A New English Dictionary on Historical Principles,* 10 vols. (Oxford: Clarendon Press, 1888–1933), 5:224.

25. The Greek word ἰδιώτης focused on the private, as opposed to the public, nature of the person, but not on his uniqueness. Modern Greek has an equivalent for "individual," ἄτομο, undivided, an extension of the ancient word, which was not applied to persons: *Istorikon lexikon tes neas ellenikes* (Athens: Typographeion Estia, 1933–), 3:268.

26. On herm portraits, see Schefold, *Bildnisse*, 196f.; on the *imago clipeata*, H. Blank, "Porträt-Gemälde als Ehrendenkmäler," *Bonner Jahrbücher* 168 (1968): 4–12; and R. Winkes, *Clipeata imago* (Bonn: University of Bonn, 1969). The

45

same is a fortiori true of terms, such as *caput* and *vultus* (πρόσωπον), which do have anatomical reference, but not to the protome. It is also interesting that I have found no Renaissance use of *vultus* to mean portrait image, as in antiquity, and no real classical equivalent for the Renaissance use of *caput (testa)* in reference to portrait busts (e.g., the Medici inventory quoted in the Appendix above and the documents concerning Paolo Romano's bust of Pius II in the Vatican. See E. Müntz, *L'art à la cour des papes pendant le XVe et le XVIe siècle*, 3 vols. (Paris:Thorin, 1879–82), 1:276.The Greek word προτομή was applied to portraits, but it refers as much to the "front" as to the "upper" part of the body and seems to have been used thus only after the Roman bust type had been developed. See H. Stephanus, *Thesaurus graecae linguae*, 10 vols. (Paris: Didot, 1816–28), 6:20–71; H.G. Liddell and R. Scott, *Greek-English Lexikon* (Oxford: Oxford University Press, 1953), 1536–37; and L. Robert,"Recherches épigraphiques," *Revue des études anciennes* 72 (1960): 320, a reference I owe to Henri Seyrig.

27. Gullini,"Busti fittili," 42.

28. Ibid.

29. H. Chirat, *Dictionnaire latin-français des auteurs chrétiens* (Turnhout: Brepols, 1954), 120.

30. C. du Cange, *Glossarium mediae et infimae latinitatis*, 10 vols. (Niort: Favre, 1883–87), 1:793; and O. Prinz, ed., *Mittellateinisches Wörterbuch bis zum ausgehenden 13. Jahrhundert* (Munich: C.H. Beck, 1967), 1:1629. Further on the word below, n. 46.

31. On the revival of the bust form in Italy in the thirteenth century, see H. Keller,"Der Bildhauer Arnolfo di Cambio und seine Werkstatt. 2 Teil,"*Jahrbuch der preussischen Kunstsammlungen* 56 (1935): 25–32; and idem,"Entstehung des Bildnisses," 269–84. For a tradition of half-length relief figures in niches, see O. von Kutschera-Woborsky,"Das Giovanninorelief des spalatiner Vorgebirges: Ein allgemeiner Beitrag zur Geschichte der Antiken Nachahmung," *Jahrbuch des kunsthistorischen Institutes der K. K. Zentralkommission für Denkmalpflege* 12 (1918): 1–43.

32. Fig. 2.11 is *Reallexikon zur deutschen Kunstgeschichte* 2:656, fig. 15. See K.M. Swoboda, *Peter Parler*, 2nd ed. (Vienna: A. Schroll, 1941).

33. G. von Kaschnitz-Weinberg,"Bildnisse Friedrichs II von Hohenstaufen," *Mitteilungen des deutschen archäologischen Instituts, Römische Abteilung* 62 (1955): 48–49. For a view of the bust in its original location, see R. Delbrück,"Ein Porträt Friedrich's II von Hohenstaufen," *Zeitschrift für bildenden Kunst* 14

CHAPTER 2 ❧ THE RENAISSANCE PORTRAIT BUST

(1903): 17, fig. 1; for a view of the back, Keller, "Entstehung des Bildnisses," 271, fig. 246. In fact, as far as I have been able to determine, none of the bust-length portraits of the period of Frederick II are worked fully in the round. The example formerly in the Brummer Gallery, now in the Metropolitan Museum, New York, is finished at the back, but the head and torso are two separate and different pieces of marble and may not be contemporary. See J. Deér, *Der Kaiserornat Friedrichs II* (Bern: A. Francke, 1952), 42, pl. XXII, 4.

34. See J. Braun, *Die reliquiare des christlichen Kultes und ihre Entwicklung* (Freiburg-i.-B.: Herder, 1940), 413–34; E. Kovàcs, *Kopfreliquiare des Mittelalters* (Budapest: Corvina, 1964). Our Fig. 2.13 is *Reallexikon zur deutschen Kunstgeschichte*, 3:279, fig. 5.

35. Ernst Kitzinger has called my attention to a remarkable passage in Mesarites' description of the church of the Holy Apostles at Constantinople, in which the bust-length image of the Pantocrator in the central dome is explained in three ways. These might be defined as metaphorical, the bust alluding to our partial knowledge of the whole divinity; illusionistic, the bust illustrating Christ's arrival from the heavens at the Second Coming; and physical, the bust representing the portion of the Father's anatomy in which the Son resides. In all three cases the bust is conceived as significant specifically because it refers to more than meets the eye. The passage is as follows: "This dome shows in pictured form the God-Man Christ, leaning out as though from the rim of heaven, at the point where the dome begins, toward the floor of the church and everything in it, but not with His whole body or in His whole form. This I think was very wisely done by the artist as he turned the matter over in his mind and revealed the very clever conclusion of his intelligence through his art to those who do not observe superficially, because for one thing, I believe, we now know in part as though in a riddle (αἰνίγματι), and in a glass, the things concerning Christ and in accord with Christ, and for another thing the God-Man will appear to us from heaven at the time of his second sojourn on earth, though the space of time until that coming has never yet been wholly measured, and because He himself dwells in heaven in the bosom of His father...." From G. Downey, "Nicolaos Mesarites: Description of the Church of the Holy Apostles at Constantinople," *Transactions of the American Philosophical Society*, n. s. 47.6 (1957): 869–70.

36. At least, a base for it is mentioned only in the sixteenth century, when a woodcarver was paid for making one. See H.W. Janson, *The Sculpture of Donatello* (Princeton, NJ: Princeton University Press, 1957), 569.

37. Janson, *Sculpture*, 141–43; and R.Wittkower, "A Symbol of Platonic Love in a Portrait Bust by Donatello," *Journal of the Warburg Institute* 1 (1937–38): 260–61. On the bust, see E. Panofsky, *Renaissance and Renascences in Western Art* (Copenhagen: Almqvist & Wiksells, 1960), 189; P.H. von Blanckenhagen, "Two horses and a Charioteer," in J. Cropsey, ed., *Ancients and Moderns* (New York: Basic Books, 1964), 92; U.Wester and E. Simon, "Die Reliefmedaillons im Hofe des Palazzo Medici in Florenz," *Jahrbuch der Berliner Museen* 7 (1965): 72–73; and C. De Tolnay, "Nuove osservazioni sulla cappella medicea," *Accademia nazionale dei lincei: Problemi attuali di scienza e di cultura* 130 (1969): 7 n. 10. A variation of the drapery device appears in Mino da Fiesole's profile relief bust of Bernardo Giugni (d. 1466) in the Badia of Florence. See J. Pope-Hennessy, *The Portrait in the Renaissance* (London: Phaidon, 1966), 79, fig. 81.

38. Oddly enough, leaving function and meaning aside, the closest precedent I know for the Quattrocento type of portrait bust — life-size, cut in a straight horizontal through chest and arms, fully articulated and finished in the round — is a limestone bust of Akhnaton in the Louvre, a sculptor's model presumably made in preparation for a full-length statue. See H. Fechheimer, *Die Plastik der Ägypter* (Berlin: B. Cassirer, 1923), pls. 85–86. In general, see W.S. Smith, *A History of Egyptian Sculpture and Painting in the Old Kingdom* (London: Oxford University Press, 1946), 38-39;W.Wolf, *Die Kunst Aegyptens* (Stuttgart: W. Kohlhammer, 1957), 150–51, 456; B. von Bothmer, *Egyptian Sculpture of the Late Period 700 B.C. to A.D. 100: The Brooklyn Museum* (New York: The Brooklyn Museum, 1960), 85–86. The obvious parallel for this sculptured type in Quattrocento painting is the bust-length profile portrait, which is also without real precedent in antiquity. Both the front and the back of the figure are shown, yet it is manifestly incomplete. See J. Lipman, "The Florentine Profile Portrait in the Quattrocento," *The Art Bulletin* 18 (1936): 54–102; R. Hatfield,"Five Early Renaissance Portraits," *The Art Bulletin* 47 (1965): 315–34.

39. Manetti's treatise, published at Basel in 1532, is extensively analyzed in G. Gentile, *Il Pensiero italiano del Rinascimento. Opere complete* 14 (Florence: Sansoni, 1968), 901–13; W. Zorn, *Gianozzo Manetti: Seine Stellung in der Renaissance* (Freiburg: University of Freiburg, 1939), esp. 22–30; and C.Trinkhaus, *In Our Image and Likeness*, 2 vols. (London: Constable, 1970), 1:230–58. Book IV, the best known part, is published with an Italian translation in E. Garin, *Prosatori latini del quattrocento* (Milan: Ricciardi, 1952), 421–87; English translation in B. Murchland, *Two Views of Man* (New York: Frederick Ungar, 1966), 63–103. I quote the concluding sentences of Book III: "Nihil enim aliquid quicumque ei naturae, quam tam pulchram, tam ingeniosam et tam sapientem ac tam

CHAPTER 2 ※ THE RENAISSANCE PORTRAIT BUST

opulentam, tam dignam et tam potentem, postremo tam felicem et tam beatam constituerat, ad totem et undique absolutam perfectionem suam deesse putabatur, nisi ut ea per admixtionem cum ipsa divinitate, non solum coniuncta in illa Christi persona cum divine, sed etiam ut cum divina natura una et sola efficeretur, ac per hunc modum unica facta fuisse videretur. Quod neque angelis neque ulli aliae creaturae, nisi homini duntaxat, ad admirabilem quondam humanae naturae dignitatem, et ad incredibilem quoque eius ipsius excellentiam, datum, concessum et attributum esse novimus" (Ed. Basel, 1532, 173–74).

40. On Palmieri, see the literature cited concerning the painting commissioned by him, attributed to Botticini, in M. Davies, *National Gallery Catalogues: The Earlier Italian Schools*, 2nd ed. (London: National Gallery, 1961), 12–27.

41. E. Cassirer, P.O. Kristeller, J.H. Randall, Jr., eds., *The Renaissance Philosophy of Man* (Chicago: University of Chicago Press, 1948), 223–54.

42. R. Pfeiffer, *Humanitas Erasmiana*. Studien der Bibliothek Warburg 22 (Leipzig: Teubner, 1931), 19–20; E. Schott, *Fleisch und Geist nach Luthers Lehre unter besonderer Berücksichtigung des Begriffs* "totus homo" (Leipzig: A. Deichert, 1928), esp. 50–72.

43. Though in a different way, J. Pope-Hennessy has also seen the portrait bust as the creation of an interrelated group of Florentine humanists. See *The Portrait in the Renaissance*, 75–77.

44. As in the Medici inventories and documents concerning the bust of Pius II, cited in nn. 7 and 25 above.

45. For an example from near the end of the century in Naples, see E. Pèrcopo, "Una statua di Tommaso Malvico ed alcuni sonetti del Tebaldeo," *Napoli nobilissima* 2 (1903): 10–13. See Hersey, *Alfonso II*, 35 and n. 24.

46. *Busto* appears as part of the body, not as a sculpture, in Dante, *Inferno*, XVII.8. The first instance of the latter use listed in the Italian dictionaries is from A.M. Salvini, 1735. See S. Battaglia, *Grande dizionario della lingua italiana* (Turin: UTET, 1961–), 2:465. In fact, I do not find it defined thus in the editions of the *Vocabolario della Crusca* before Salvini.

47. A. Perosa, ed., *Alexandri Bracci Carmina* (Florence: Bibliopolis, 1944), 108–9. I am indebted to Ulrich Middeldorf for bringing the poem to my attention.

AD BUSTUM MARMOREUM

Albiera, insigni forma spectanda, viator,
Ut paulum sistas aspiciasque rogat,
Duxerit e Pario tales si marmore vultus
Docta Polycleti Praxitelisve manus.
Ne tamen in ferris formosior ulla deabus
Esset, mors iussu me rapuit superum.

I adopt the title from the Turin manuscript of eulogies by various authors on Albiera, which was compiled by her fiancé Sigismondo della Stufa and which gives the earliest versions of Bracci's epigrams to her. See Perosa, x and the references cited there. In subsequent manuscript collections of Bracci's poems the more elegant but less precise title AD EIUS MARMOREAM EFFIGIEM is substituted. On Bracci, who is mentioned among the academicians in 1473, see B. Agnoletti, *Alessandro Braccesi* (Florence: G. Passeri, 1901); and A. Della Torre, *Storia dell'accademia platonica di Firenze* (Florence: Carnesecchi, 1902), 656, 806–7.

48. The bust is presumably identical with portraits of Albiera mentioned in poems by Poliziano, Ugolino Verino, and Mabilio Novato (who names a certain "Morandus" as the artist). See F. Patetta, "Una raccolta manoscritta di versi e prose in morte d'Albiera degli Albizzi," *Atti della R. Accademia della Scienza di Torino* 53 (1917–18): 290–94, 310–28.

3. ON ILLUSION AND ALLUSION IN ITALIAN SIXTEENTH-CENTURY PORTRAIT BUSTS[1]

AMONG THE MOST NOTABLE achievements of the Italian Renaissance in art was to have revived the classical tradition of the independent portrait bust.[2] The sculptured portrait did not actually disappear during the Middle Ages, but when it occurred it was included within some physical and conceptual context, notably as part of the decoration of churches and tombs. To say that the Renaissance revived the classical portrait is only a partial truth, however, for in their basic structure Renaissance busts differ profoundly from their ancient predecessors. The typical Roman bust [Fig. 2.1] is rounded at the bottom, hollowed out at the back and set up on a base; its Renaissance counterpart [Fig. 2.2] is cut straight through just above the elbow, it is carved fully in the round, and it has no base. Visually the classical work is a self-contained, abstract form, conceived only from the front and set apart by a base from its support. The Renaissance work is an arbitrarily cut off, incomplete form, conceived in three dimensions and not isolated from the support. From each artist's point of view, the other's creation is grotesque, in the one case because the bust appears like an amputated body, in the other because a human being is made into an inanimate thing. The ancient work is an ideal form, the Renaissance bust is a deliberate fragment, the effect of which is to create an illusion that is entirely new in the history of art. The arbitrary amputation specifically suggests that what is visible is part of a larger whole, that there is more than meets the eye. By focusing on the upper part of the body, but deliberately emphasizing that it is only a fragment, the Renaissance bust evokes the complete individual — that sum total of physical and psychological characteristics to which contemporaries already referred as the "whole man."[3]

This development occurred in Florence around the middle of the fifteenth century. During the second half of the century, measures were taken to heighten the illusion of a complete, living human being. One of these involved the introduction of motion, both implied and actual. In a *Bust of a Lady* attributed to Antonio Rossellino,

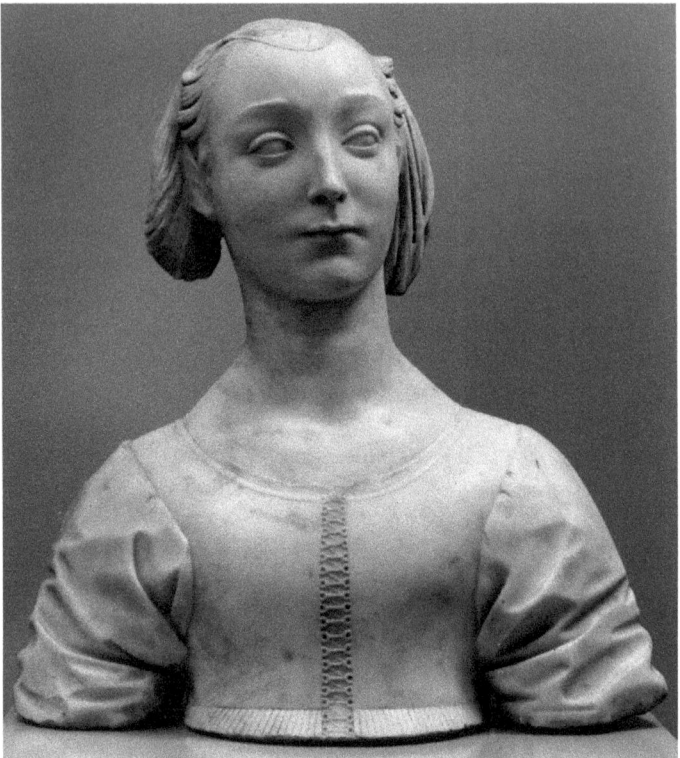

Fig. 3.1. Attributed to Antonio Rossellino, or Desiderio da Settignano. Bust of a Lady, 1470s. Staatliche Museen, Berlin.

dating from the 1470s [Fig. 3.1], the arms are separated from the body so that they may function, at least by implication, independently of the torso.[4] Furthermore, a subtle and complicated series of departures from the strict horizontal and vertical axes to which the earlier bust had adhered, is introduced. The head turns slightly to the right and tilts slightly to the left; and the left shoulder is slightly higher than the right. The kind of motion seen here is different from that found in any ancient work. In classical busts the head may look up or down, or turn to one side or the other: but a strict vertical axis is always discernible running through the body, neck, and

CHAPTER 3 ❧ ITALIAN 16TH-CENTURY PORTRAIT BUSTS

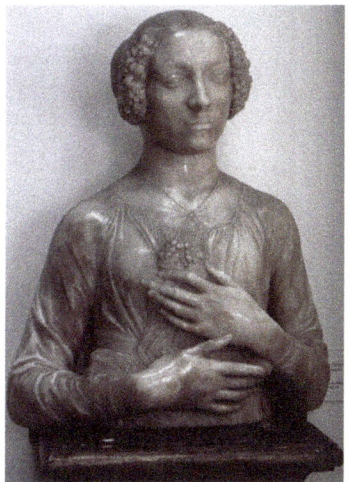 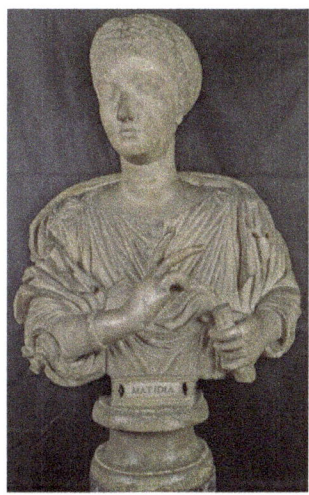

Fig. 3.2 (L). Andrea del Verrocchio, Bust of a Lady holding Flowers, 1475–80. Museo Nazionale del Bargello, Florence.
Fig. 3.3 (R). Bust of "Matidia" (Vibia Sabina), 3rd c. Galleria degli Uffizi, Florence.

head, and the shoulders remain on a horizontal line. In other words, the ancient bust has an inviolable, inner structure, for which the Renaissance artist substitutes a more pervasive mobility.

In the next decade, Andrea del Verrocchio took another bold step. His *Portrait of a Lady* [Fig. 3.2] echoed a relatively rare bust type in which both arms are shown in their entirety.[5] But comparison with a Roman work of this kind [Fig. 3.3] reveals differences no less striking than the similarities. The basic structural contrast we noted before is again present; and now also Verrocchio includes a zigzag of motion through the head, neck, chest, and abdomen. The result is a forceful illusion, not only of the whole person, but also of live action. The classical figure seems inhibited by a spinal column in which the vertebrae have fused.

The second contribution of the late fifteenth century is in the realm of expression. To be sure, ancient portraitists explored a wide range of emotions. But there is nothing from classical times to compare

53

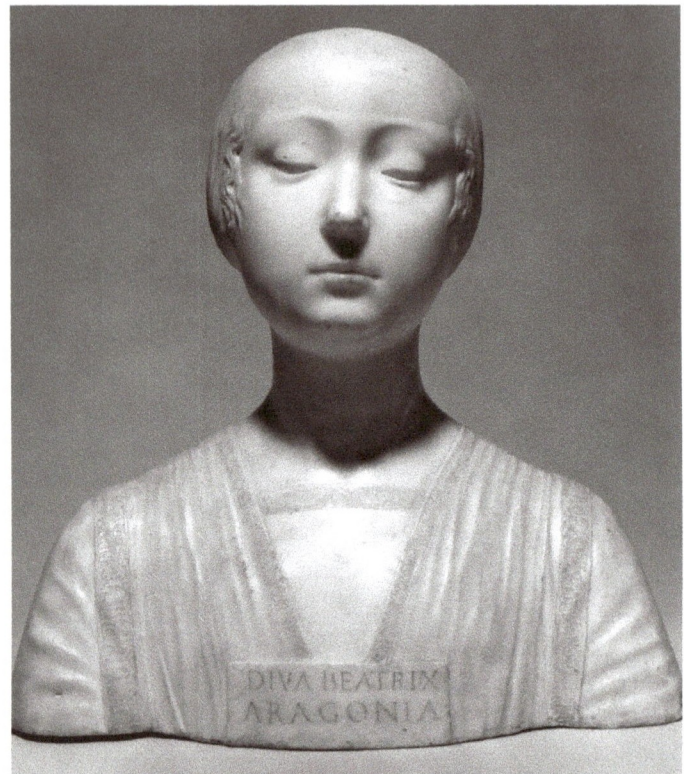

Fig. 3.4. Francesco Laurana, Bust of Beatrice d'Aragona, 1475. Frick Collection, New York (formerly collection of John D. Rockefeller, Jr.).

with the bust of Beatrice d'Aragona by Francesco Laurana [Fig. 3.4], whose inclined head and downcast eyes express a perfect demureness. And nothing from antiquity compares with Verrocchio's bust of Giuliano de' Medici [Fig. 3.5], in which the proud bearing and the faint smile help to create a sense of genial self-confidence. It should be emphasized that neither of these images would have been possible without the intervening personifications of Christian virtue — the chaste maiden on the one hand, the noble knight on the other. In fact, it might be said that the Renaissance achievement consisted largely in

CHAPTER 3 ❧ ITALIAN 16TH-CENTURY PORTRAIT BUSTS

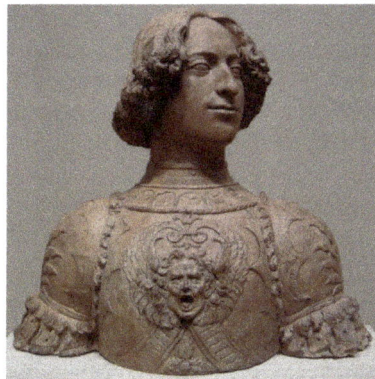

Fig. 3.5 (L). Andrea del Verrocchio, Bust of Giuliano de' Medici, 1475. National Gallery of Art, Washington, DC.
Fig. 3.6 (R). Francesco da Sangallo, Bust of Giovanni delle Bande Nere, c.1520. Museo Nazionale del Bargello, Florence (Photo Alinari).

having assimilated the medieval concept of human morality to the classical notion of human individuality.

While this is an important contribution to the portrayal of character, nevertheless there is something curiously discreet and unassuming about these early Renaissance works. The artist was evidently concerned to give an external description of the sitter, of whose inner personality we are made aware implicitly by an abrupt psychological truncation analogous to the treatment of the bust form itself. This relative objectivity has a functional counterpart in the fact that, as far as we can tell from the sources, such portraits served an essentially documentary purpose, as family records. They were made for the private home, to whose architecture they were physically attached over doorways, mantelpieces, and the like; and there is no evidence for one of the most conspicuous uses of bust portraits in antiquity, namely, as civic monuments.

In the sixteenth century all this changes. The portrait bust becomes a consciously designed object — no longer simply half a human being, with a consciously conceived expressive purpose — no longer simply a record of the individual. A first critical move in a new direction was taken in the late 1520s in a bust by the Florentine sculptor Francesco da Sangallo [Fig. 3.6], representing Giovanni delle Bande Nere, the father

of Cosimo I de' Medici, the first grand duke of Tuscany. It follows the example of Rossellino in the horizontal cut-off with the arms separated from the torso, in the turn and tilt of the head, and in the differing level of the shoulders. It follows the example of Verrocchio in that the body is cut off low at the waistline. The arms continue just below the elbows, and the elbows are shown bent. So far as I can discover, this is the first instance of a bust with severed arms in which the arms are shown in motion. Sangallo thus combined the illusionism of the bust type with the dramatic action of the half-figure type. Another innovation is that the two arms are not symmetrical. While the right arm hangs vertically, the left moves slightly forward, breaking through a heretofore impenetrable plane facing the spectator. In addition, the character of the pose and the defiant expression give the portrait a distinct quality of aggressiveness.

Sangallo also introduced two ingenious devices in designing the amputation of the figure. The torso is cut off in such a way that the bottom line coincides with the lower edge of the armor plate. The amputation is thus dissimulated, so we cannot properly say that the figure is "cut off" at all. On the one hand, the object appears complete and self-contained; on the other hand, nothing prevents us from conjuring up Giovanni delle Bande Nere "in toto." Furthermore, this is the first instance I know in which a severed surface — that of the left arm — is visible from the front.[6] There was only one context in which such visible amputation had occurred before, in actual fragments of ancient statuary. And this is certainly what Sangallo had in mind. The great men of antiquity were in fact known to the Renaissance (as indeed they are to us) largely through the broken remains of honorific statues, and the visibly severed arm suggests not only that the bust is part of a larger figure but that Giovanni delle Bande Nere was like the venerable heroes of classical times.[7]

The aggressive quality of the pose and expression, the element of self-containment in the design, and the explicit reference to antiquity — these features are new, and they coalesce in a new conception of the portrait bust, which is no longer simply a record but a mode of exaltation of the individual as well. The sense of this exaltation becomes clear when we recall that Giovanni delle Bande Nere

CHAPTER 3 ❧ ITALIAN 16TH-CENTURY PORTRAIT BUSTS

Fig. 3.7 (above). Michelangelo, Bust of Brutus. Museo Nazionale del Bargello, Florence.
Fig. 3.8 (below). Bust of Caracalla, 212 CE. Museo Nazionale Archeologico, Naples.

played a key role in the political transformation of Florence from a republic into the grand duchy that became the model for the system of absolute monarchies of the seventeenth century.

For the early Christians the portrait bust became a symbol of pagan idolatry,[8] a stigma so potent that the familiar classical bust type — rounded at the bottom, hollowed at the back and raised on a base — was not fully revived on a monumental scale until the second quarter of the sixteenth century, and even so in a work that cannot really be called a portrait. About 1539–40 Michelangelo made a bust of Brutus, which is the first monumental marble sculpture of this class since antiquity [Fig. 3.7]. Michelangelo adopted not only the form, but also the pose, expression, and costume of a well-known portrait of the Emperor Caracalla [Fig. 3.8], assimilating to it the depictions of Brutus on Roman gems and coins.[9]

Apart from its form and expressive content, two points concerning the bust should be noted. One is that, although the work does not represent a contemporary personage, the time and circumstances of its execution show that it did have a contemporary political significance, reflecting the republican sentiment in Florence in favor of the assassination of a potentially tyrannical member of the Medici

57

Fig. 3.9. Baccio Bandinelli, Bust of Cosimo I de' Medici, 1544. Museo Nazionale del Bargello, Florence.

family. Hence, while the bust depicts the antagonist of Caesar, it also embodies an abstract idea, that of the noble tyrannicide. From the very moment of its revival, therefore, the classical bust type carried a heavy burden of meaning. It was a kind of visual metaphor, serving to raise the person represented to a higher plane of existence. The second point concerning the Brutus is that it moves in a way no earlier bust moved. Much of its powerful effect depends upon the fact that the left shoulder is thrust strongly forward with respect to the right (not just a movement of the arm, as in the Sangallo bust). In previous portraits, including ancient ones, the shoulders adhered to a frontal vertical plane. The movement gives the Brutus bust a strong suggestion of life and vitality underlying the abstract form and content, a counterpart to the "living" relevance of its subject.

Following Michelangelo's lead, the final act in the creation of a new portrait form took place in Florence a few years later, under very different circumstances. The first busts of the ideal type representing a contemporary personage were made toward the middle of the sixteenth century by two arch rivals who were vying for the favor of the despotic ruler of Florence, Cosimo I de' Medici. In his marble bust of Cosimo of about 1544 [Fig. 3.9], Baccio Bandinelli perpetrated what would heretofore have been considered virtually an act of idolatry: an independent, honorific bust of a living individual in the mode of pagan antiquity. Cosimo is treated literally as though he were a Roman

CHAPTER 3 ❧ ITALIAN 16TH-CENTURY PORTRAIT BUSTS

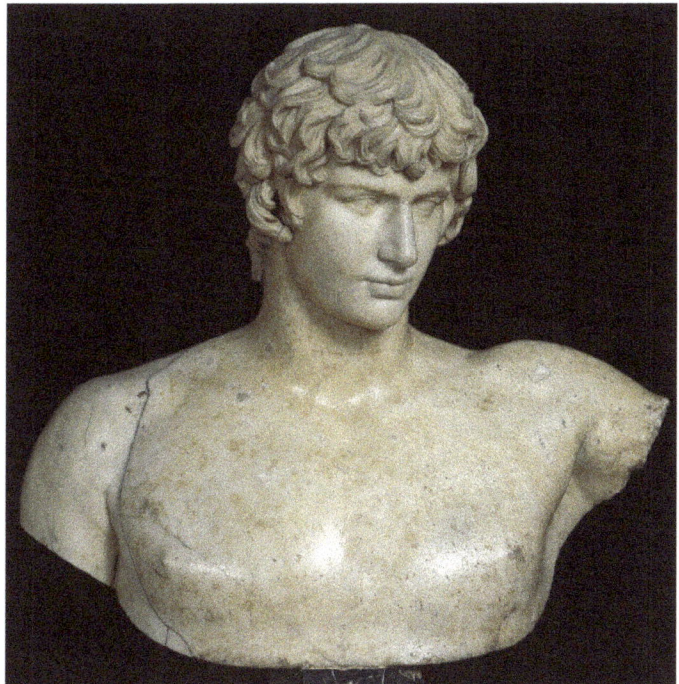

Fig. 3.10. Bust of Antinous., 131–32 CE. Museo del Prado, Madrid.

emperor, in the form of the bust itself, in the armored cuirass he wears, and in its adulatory function. The conception of the portrait bust as an explicit political statement initiated by Michelangelo is here turned completely about, so that from a symbol of republicanism it becomes the visual herald of modern absolutism.

The underlying modernity of the bust is evident visually, as well. In following classical precedent, Bandinelli selected the one notable type from antiquity that suggests that it is part of a larger whole. This occurs in busts of Antinous, the favorite of the Emperor Hadrian, who caused him to be divinized and worshiped as a god [Fig. 3.10]. They are smooth and regular in outline, but asymmetrical, with the head turned to the side and slightly downward and one arm raised. The design deliberately hints that the bust is cut from a whole statue, and in

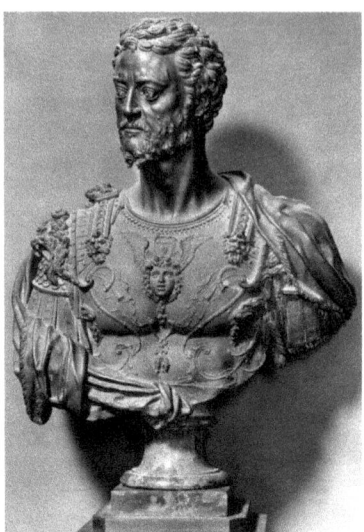

Fig. 3.11. Benvenuto Cellini, Bust of Cosimo I de' Medici, 1546–47. Museo Nazionale del Bargello, Florence (Photo Alinari).

fact the pose is derived from full-length statues of gods and heroes. The purpose clearly was to assimilate the portrait of Antinous, an ordinary mortal, to the idea of Antinous as a deity.

In suggesting that the bust is part of a statue Bandinelli shows his indebtedness to Sangallo, but he takes the significant step of referring explicitly to the outstanding classical prototype that accomplished the same thing. Bandinelli's bust differs from the ancient model, however, in two essential ways. The head and neck are tilted slightly off the vertical axis, the right shoulder is slightly higher than the left, and the raised left arm is cut free of the body. Once again, the figure has the independence and continuity of movement of a living human being. The second difference is in the treatment of the arms, where Bandinelli adopts a variation of the principle of dissimulation introduced by Sangallo. The cut of the arms corresponds to the ends of the epaulettes of the cuirass.[10] Hence the arms are not actually amputated, and their forceful action is continued in the mind's eye. Bandinelli's bust involves a two-fold visual pun. Insofar as it appears cut off it suggests part of a larger whole, namely a complete statue. Insofar as it is dissimulated it also suggests part of a larger whole, a complete human being. In the end, the bust can only be described as a new art form, at once independent and self-contained, yet through a combination of illusion and allusion, infinitely evocative.

Bandinelli's great antagonist, Benvenuto Cellini, also did a bust of Cosimo at this time, a colossal bronze [Fig. 3.11]. The scale itself is a measure of the element of personal aggrandizement.[11] The classical

CHAPTER 3 ❧ ITALIAN 16TH-CENTURY PORTRAIT BUSTS

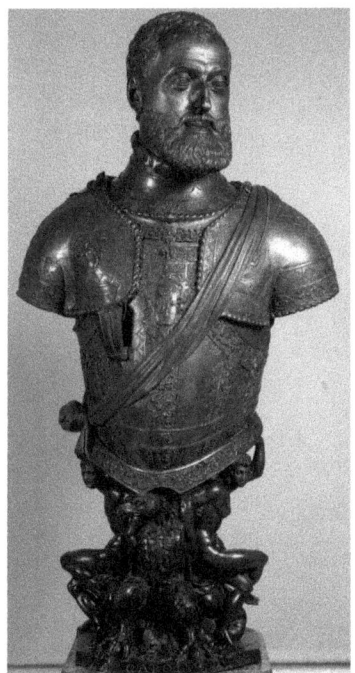

Fig. 3.12. Leone Leoni, Bust of Charles V, 1549. Museo del Prado, Madrid (Photo MAS).

convention is referred to in the form of the bust, but again it is modernized in pose and design. Now for the first time both arms move, one forward, the other back, so that a veritable counterpoint is introduced, giving the figure a spatial content and a continuity of action it had never had before. Furthermore, Cellini comes to grips in a new way with the problem posed by the classical bust form, with its raised, curved outline. Bandinelli, following Sangallo, had dissimulated the edges by making them coincide with the edge of a garment or of a cut out statue. For the left arm of his figure Cellini adopts the same device, but in addition he throws a cape over the shoulders which is draped around the right half of the figure in a special way.[12] It covers the lower edge and is arranged so that it appears folded, rather than cut off. The drapery acts as a kind of proscenium, hiding the severed edge, yet self-contained and therefore not cut off itself. As a result, only the short edge at the lower right remains to remind us that this is not Cosimo himself, but a bust of Cosimo — an essential element if the work is to carry visually its honorific message.

These Florentine busts set the pattern for the entire future development of the genre. In the course of the century three major branches grew from this central Italian trunk. The Tuscan tradition was raised to new heights, particularly at the hands of Leone Leoni, whose portraits of the Hapsburg family actually brought the bust into the imperial service. In his bronze *Charles V* (1553–55, Fig. 3.12] the breast and shoulder

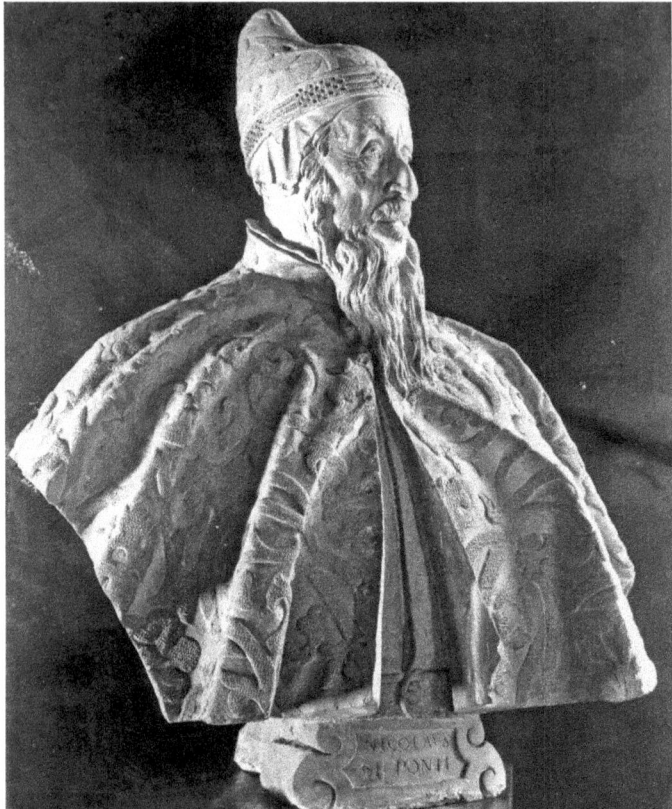

Fig. 3.13. Alessandro Vittoria, Bust of Doge Nicolò da Ponte, 1585. Seminario Patriarcale, Venice (Photo Böhm).

plates of a suit of armor completely dissimulate the amputation of torso and arms; and this empty shell, which the mind fills with the spirit of the man, does not rest on an abstract base but is carried aloft in apotheosis by the imperial eagle and two allegorical figures.

Another mode developed in Venice. In the portraits of Alessandro Vittoria [Fig. 3.13], drapery plays a role equivalent to the armor in Leoni's. It falls in ample folds that hide the body beneath, and it is cut in irregular shapes so as to create the effect of an apron or screen before a void, which the imagination ineluctably fills up. The

CHAPTER 3 ※ ITALIAN 16TH-CENTURY PORTRAIT BUSTS

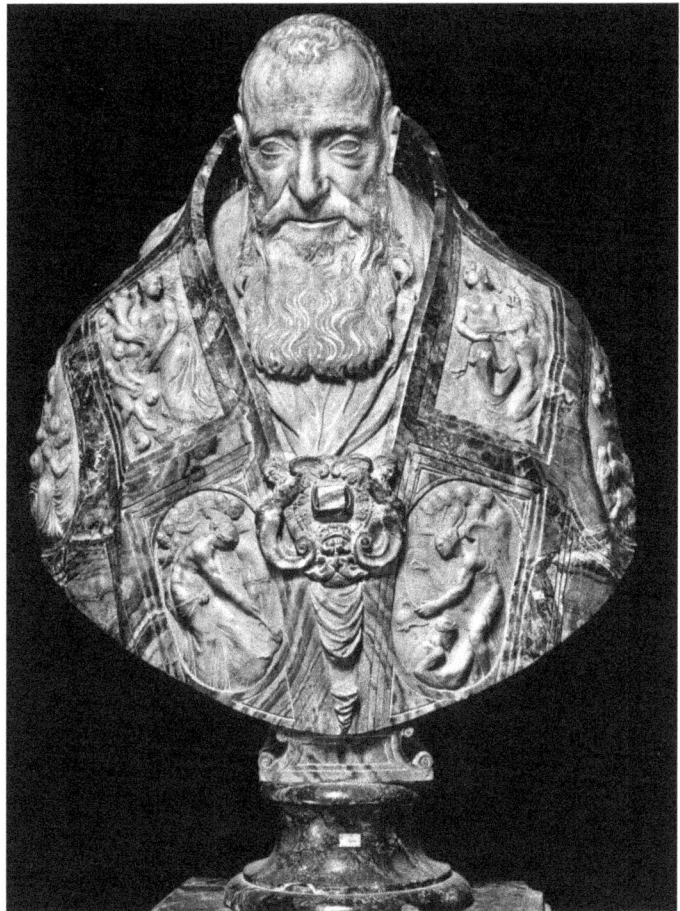

Fig. 3.14. Guglielmo della Porta, Bust of Pope Paul III, 1547. Museo Nazionale di Capodimonte, Naples (Photo Anderson).

torsos, moreover, tend to be vastly inflated so that the figures appear larger than life —regardless of their scale. Finally, they never have the strident tone and allegorical paraphernalia of the Medicean works. Rather, Vittoria's busts display a pompous gravity and lofty concern, expressive of the ideals of Venetian republicanism.

The third major off-shoot was in Rome, where a very different formula emerged. The tone was set by Guglielmo della Porta in a portrait of Pope Paul III (1546–47, Fig. 3.14). The drapery again submerges the body, but instead of loose and ample folds, it forms a sort of cocoon around the figure. The body has none of the movement of the Florentine works. The outline is closed and regular, and the eyes look out from the heavy, patriarchal head with an almost accusative air. The robe is decorated with reliefs explaining in symbolic terms the secular and religious mission of the pope. Paul III, it will be remembered, initiated a period of aggressive self-scrutiny in the church that blossomed into the great movement of spiritual elevation known as the Counter-Reformation.

These three great expressive conventions — modes of characterization, to be more precise — the Florentine imperial, the Venetian republican, and that of the Roman Counter-Reformation, constitute the main achievement of Italy in the sixteenth century in this domain. They fuse three essential elements: the illusion of a living presence in the bust, the allusion to classical antiquity, and the elevation of the individual represented to an ideal. A symptom of their differences from the Renaissance type is the consciousness with which the fusion was achieved. We have comments by both Bandinelli and Cellini in letters to Cosimo de' Medici, which show that the artists were fully aware of what they were about.[13] Cellini speaks of his portrait as being "in accord with the high manner of the ancients," and "having the bold movement of life." Bandinelli says of another of his busts of the duke that it is "as if to see Octavian or Pompey the Great extend his arm to pacify the people." Even more striking is a further passage in which he says that if the duke should prefer a whole statue, arms and legs could easily be added — a frivolity perhaps, yet clearly indicative of the implied wholeness with which he conceived the work. Above all, busts of this period seem far more imposing — "surpassing everything ideal and pathetic" was Jacob Burckhardt's phrase for them[14] — than their Renaissance predecessors, both visually and psychologically. Here, too, the effect had a functional counterpart. They might be displayed on pedestals of their

CHAPTER 3 ❧ ITALIAN 16TH-CENTURY PORTRAIT BUSTS

own and, no longer confined to the sitter's home, they acquired a new "public" significance.[15]

In sum, they are pieces of monumental rhetoric, and as such they confront us with a remarkable paradox. We tend to think of the portrayal of human nature as an analytical process of stripping away convention. Instead, the development of the portrait bust since the Renaissance suggests an opposite view — that character and convention are inseparable, the one expressed through the other. In the process we have traced, the individual and the heroic emerged together as the compound product of one creative synthesis.[16]

NOTES

1. Prepared for and delivered to American Philosophical Society, Nov. 14, 1974, and published in its *Proceedings* 119.5 (1975). The present essay is presented in a version updated in 2014.

2. This paper is the second of three projected essays on Italian portrait busts from the fifteenth through the seventeenth century. The opening paragraph recapitulates in part the first of the series: I. Lavin, "On the Sources and Meaning of the Renaissance Portrait Bust," *The Art Quarterly* 33 (1970): 207–26. I have anticipated some of the observations made here in various publications: "Five New Youthful Sculptures by Gianlorenzo Bernini and a Revised Chronology of His Early Works," *The Art Bulletin* (1968): 226 f., 239 and n. 107; "Duquesnoy's 'Nano de Crequi' and Two Busts by Francesco Mochi, *The Art Bulletin* 52 (1970): 134 ff., 139 ff.; "Bernini's Death," *The Art Bulletin* 54 (1972): 176 ff. Valuable surveys of sixteenth-century bust portraiture will be found in J. Burckhardt, "Randglossen zur Skulptur der Renaissance," in *Jacob Burckhardt Gesamtausgabe* 13:314 ff.; J. Pope-Hennessy, *Italian High Renaissance and Baroque Sculpture,* 2nd ed., (London: Phaidon, 1970), 93 ff.; H. Keutner, *Sculpture Renaissance to Rococo,* 27 ff.

3. See chapter 2, p. 34.

4. The work has also been ascribed to Desiderio da Settignano and Bernardo Rossellino by J. Pope-Hennessy, *Italian Renaissance Sculpture,* 2nd ed. (London: Phaidon, 1971), 282, and sometimes identified as Marietta Strozzi. See Valerie Niemeyer Chini, *Stefano Bardini e Wilhelm Bode: Mercanti e connaisseur fra Ottocento e Novecento* (Florence: Polistampa, 2009).

5. G. Passavant, *Verrocchio* (London: Phaidon, 1969), 33, 180 f.

6. Seen only faintly in our reproduction.

7. An interesting passage in this context, brought to my attention by Phillip Foster, occurs in Poggio Bracciolini's dialogue *De Nobilitate* (c.1440), where the ancient custom of decorating the home with ancestral portraits is ironically connected with the modern vogue for collecting fragments of classical statuary. See G. Holmes, *The Florentine Enlightenment, 1400–1450* (New York: Oxford University Press, 1969), 228. In northern Italy at this period, "incomplete" figure sculptures began to be made deliberately in imitation of ancient fragments. See L. Planiscig, *Venezianische Bildhauer der Renaissance* (Vienna: Anton Schroll, 1921), 335 f.; H. Ladendorf, *Antikenstudium und Antikenkopie* (Berlin: Akademie-Verlag, 1953); M. Perry, "A Greek Bronze in Renaissance Venice," *Burlington Magazine* 117 (1975): 204 ff. For a possible influence of such fragments on bust design, see

CHAPTER 3 ⁂ ITALIAN 16TH-CENTURY PORTRAIT BUSTS

Sarah Wilk (McHam), "Tullio Lombardo's 'Double Portrait' Reliefs," *Marsyas* 16 (1972–73, publ. 1974): 77.

8. See E. Becker, "Protest gegen den Kaiserkult und Verherrlichung des Sieges am Pons Milvius in der christlichen Kunst der konstantinischen Zeit," in F.J. Dölger, ed., *Konstantin der Grosse und seine Zeit. Römische Quartalschrift.* Supplementheft 19 (Freiburg i. B.: Herder, 1913), 155–90.

9. See C. de Tolnay, *The Tomb of Julius II* (Princeton: Princeton University Press, 1954), 76 ff., 131 ff.. For depictions of Brutus on gems, see M.L. Vollenweider, *Die Porträtgemmen der römischen Republik* (Mainz: Von Zabern, 1972), 139ff. Further to the background in D.J. Gordon, "Giannotti, Michelangelo and the Cult of Brutus," in D.J. Gordon, ed., *Fritz Saxl, 1890–1948: A Volume of Memorial Essays from His Friends in England* (London: Thomas Nelson & Sons, 1957), 281–96, and N. Rubinstein, "Political Ideas in Sienese Art: The Frescoes by Ambrogio Lorenzetti and Taddeo di Bartolo in the Palazzo Pubblico," *Journal of the Warburg and Courtauld Institutes* 21 (1958): 195, 198, 207. For the antecedents to Michelangelo's innovation, see W. von Bode, "Die Ausbildung des Sockels bei den Büsten der italienischen Renaissance," *Amtliche Berichte aus den preussischen Kunstsammlungen* 40 (1918–19): 112 ff., to which should be added the actual copies and restorations of ancient Roman busts made in North Italy. See H.J. Hermann, "Pier Jacopo Alari-Bonacolsi, genannt Antico," *Jahrbuch der kunsthistorischen Sammlungen des allerhöchsten Kaiserhauses* 28 (1909–10): 276 ff. See also Keutner, *Sculpture*, 28. A bust of Pius II in the Vatican by Paolo Romano, was placed above a doorway, which, however, I suspect had no base. See R. Olitzky Rubinstein in F.A. Gragg, trans., and L. C. Gabel, ed., *Memoirs of a Renaissance Pope: The Commentaries of Pius II. An Abridgement* (London: George Allen & Unwin, 1960), 11, note on Fig. 1; and A.M. Corbo, L'attività di Paolo di Mariano a Roma," *Commentari* 17 (1966): 200, 213, Doc. 74.

10. Precedents for the device may be seen in Donatello's reliquary bust of *St. Rossore* (Fig. 2.14) and Verrocchio's *Giuliano de' Medici* (Fig. 3.5).

11. 110 cm high, excluding base; Verrocchio's *Giuliano de' Medici*, 61 cm.; Michelangelo's *Brutus*, 74 cm. excluding base.

12. Cellini is here also evidently indebted to Donatello's *St. Rossore*.

13. D. Heikamp, "In margine alla 'Vita di Baccio Bandinelli' del Vasari," *Paragone* 191 (1966): 57f. On Bandinelli's and Cellini's busts of Cosimo, see further the illuminating study by K.W. Forster, "Metaphors of Rule: Political Ideology and History in the Portraits of Cosimo I de' Medici," *Mitteilungen des kunsthistorischen Institutes in Florenz* 15 (1971): 65–104, esp. 76.

14. *Gesamtausgabe* 13:314.

15. The revival in the sixteenth century of the full length pedestal for portrait busts was noted by Schiaparelli, *La casa fiorentina*, 194. Surveys of the many Medicean busts that begin now to populate the façades of public buildings and the houses of the rulers' friends in Florence will be found in *L'illustratore fiorentino* 6 (1909): 59; and K. Langedijk,"De Portretten van de Medici tot omstreeks 1600" (Diss., Amsterdam, 1968), 66, 91, 99f. A Florentine law of 1571 prohibited the removal or defacement of such works displayed on public and private buildings. See D. Heikamp,"Die Bildwerke des Clemente Bandinelli," *Mitteilungen des kunsthistorischen Institutes in Florenz* 9 (1959–60): 130 f. The reference is evidently to the *Legge contra chi rimovesse, o violasse armi inscritioni, o memorie esistenti apparentemente nelli edifitii cosi publici, come privati...*, Florence, May 30, 1571. Copy in Biblioteca Nazionale Centrale, Florence, cited by L. Manzoni, *Bibliografia statutaria e storica italiana*, 3 vols. (Bologna: Romagnoli, 1876–93), 1.2:200. As early as 1514 in Mantua, busts of the Quattrocento type representing illustrious Mantuans were privately commissioned to decorate an ancient city gate. See H. Keller, *Das Nachleben des antiken Bildnisses von der Karolingerzeit bis zur Gegenwart* (Freiburg i. B.: Herder, 1970), 97 n. 3.

16. For a remarkable study of the development of character portrayal in Florentine historiography and rhetoric of the sixteenth century, see H. Gmelin, *Personendarstellung bei den florentinischen Geschichtschreibern der Renaissance* (Leipzig: Teubner, 1927), a reference for which I am indebted to Professor Felix Gilbert. Related also are the development of biographical theory, for example, G.A. Viperano, *De scribenda virorum illustrium vitis* (Perugia: Valentum Panutium, 1570). See B. Weinberg, *A History of Literary Criticism in the Italian Renaissance*, 2 vols. (Chicago: University of Chicago Press, 1961), 1:43, 297 f. For a theory of portraiture in art, see M. Jenkins, *The State Portrait: Its Origin and Evolution*. Monographs on Archaeology and Fine Arts, Archaeological Institute of America and the College Art Association of America 3 (New York: College Art Association, 1947), 34 ff. See also G.A. Paleotti, *Discorso intorno alle imagini sacre e profane* (Bologna: Benacci, 1582), cited in P. Barocchi, *Trattati d'arte del cinquecento fra manierismo e controriforma*, 3 vols. (Bari: Laterza, 1960–62), 2:30 ff. A relationship between portraiture and physiognomical theory at this period has been suggested by P. Meller, "Physiognomical Theory in Renaissance Heroic Portraits," in *Acts of the Twentieth International Congress of the History of Art. New York, 1961*, 4 vols. (Princeton: Princeton University Press, 1963), 2:53–69.

4. GREAT MEN PAST AND PRESENT[1]

I MUST PREFACE MY REMARKS by forewarning you that this will be a most peculiar and visually austere essay on the history of art, since not one of the works to be discussed exists in its original form. They were either destroyed or redone virtually to the point of extinction. Partly for this reason, moreover, those of you who have the misfortune not to be professional art historians will probably never have heard of them. Apart from a few illustrations that reflect them more or less inadequately, the only compensation I can offer is that, as I hope to convince you, they were among the most important works of art ever made.

OWING TO THE ACCIDENTS of preservation, our comprehension of early Renaissance painting generally, and of the contribution of Giotto di Bondone (1266/76–1337) in particular, is terribly skewed. We are blinded by the great religious fresco decorations that still bedazzle the viewer in the churches of Assisi, Florence, and Padua. We forget that a whole segment of the memory of Giotto's imagination has been lost through the destruction of his secular decorations, much more subject than religious works to the vicissitudes of time and politics. Furthermore, his secular decorations were created after he had established his reputation as a religious painter and became greatly in demand by princely patrons. These largely forgotten works were therefore the chief products of Giotto's mature and late years.

Indeed, although the fact is little appreciated today, a radical new departure in the history of European culture may be discerned in the scant remaining records of a work executed by Giotto for King Robert of Anjou (1275–1343) during the artist's five-year stay in Naples from 1328 to 1333. A room in the Castel Nuovo frescoed with a series of depictions of famous men was already mentioned in the early fifteenth century by Lorenzo Ghiberti (1381–1455), in the brief survey of the history of art since antiquity — the first of its kind — appended to his treatise, *I Commentari*. Ghiberti's report was followed by later writers, including Giorgio Vasari (1511–74), but

Fig. 4.1. *Achilles and Polixena, after Giotto.*, mid-15th c. Florence, Biblioteca Medicea Laurenziana, Ms. Strozzi 174, fol. 1r.

CHAPTER 4 ❧ GREAT MEN PAST AND PRESENT

the cycle was destroyed in the sixteenth century and fell from the consciousness of all but specialists in the field of early Italian painting.

Two critical pieces of evidence survive to indicate something of the decoration's content and appearance. One of the sources is a group of nine Italian sonnets recorded in several manuscripts, in one of which it is tantalizingly reported that the poems were "composed by (the name is omitted), who saw these famous men painted in the 'sala of Robert' and dedicated a sonnet to each of them." The nine personages so honored were Alexander, Solomon, Hector, Aeneas, Achilles, Paris, Hercules, Samson, and Caesar. Several of the poems include allusions to the women associated with the heroes, Polixena with Achilles, Penthesilea with Hector, etc.

One of the manuscripts, and this is the second piece of evidence, includes next to the sonnet on Achilles a miniature of a warrior who stands on a pedestal holding a spear [Fig. 4.1] magnificently attired in pseudo-classical armor, a flowing cape and an enormous hat. Standing below, beside the pedestal, is an equally fashionably dressed lady who returns his gesture. In all likelihood the miniature offers a pale but useful reflection of Giotto's fresco cycle, which differed from any known predecessor and started a chain reaction that has never ceased. Giotto's Naples frescoes were, it seems, the first series of ancient heroic individuals depicted on a monumental scale and isolated from any narrative context. The subjects chosen were no less remarkable than the basic conception of the series. The characters came either from the Old Testament or from pagan antiquity. They were evidently not presented in chronological sequence, and there was a notable absence of Christian heroes. The focus was clearly on persons from the distant past.

There was, of course, a long tradition stemming from antiquity of depictions of secular heroic subjects in palace decorations. So far as we know, however, they were narrative cycles and if they included portraits, these depicted the family line of the patron. Perhaps the best known medieval instance was the decoration of the Palace of Charlemagne at Ingelheim, described in a famous eulogy by the court poet Nigellus.[2] The cycle followed the pattern established

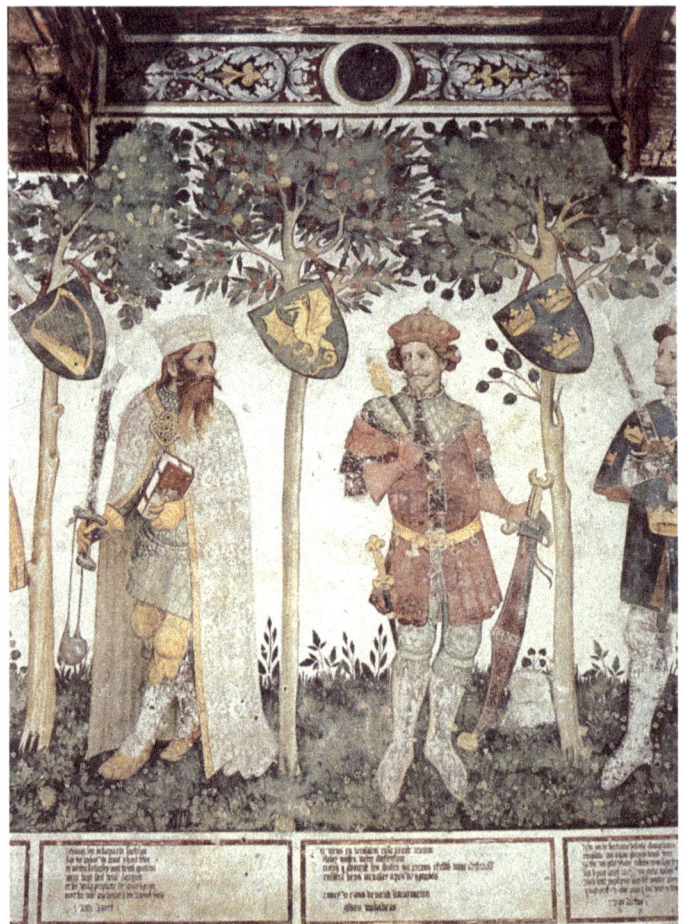

Fig. 4.2. The Nine Worthies, fresco, 1430s. Palace of the Marquis of Saluzzo, La Manta (Piedmont).

in the fifth century by Paulus Orosius (c.375–c.420), who viewed the *History of the Pagans,* as he titled his work, as the prelude to Christianity.[3] Narratives from pagan history appeared on one side of the palace hall, while on the other side, by way of contrast, deeds of Christian rulers were shown, culminating in those of the Frankish kings and Charlemagne himself.

CHAPTER 4 ❧ GREAT MEN PAST AND PRESENT

In some respects Giotto's series also seems indebted to the tradition of world chronicles, in which, following St. Augustine's division of time into three phases — before the law (Adam to Moses), under the law (Moses to Christ), and under Grace (since Christ) — history was organized to illustrate Christianity's succession to Judaism and paganism. This program was ultimately distilled into the theme of the Nine Worthies (Hector, Alexander, Caesar, Joshua, David, Judas Maccabeus, King Arthur, Charlemagne, Godefroi de Bouillon) as formulated in a French poem, *Voeux du Paon*, the Oath of the Peacock, composed around 1312.[4] The poem recites the deeds of three triads of heroes — three Hebrews, three pagans, and three Christians — who correspond in part to the nine chosen by Giotto. The Naples decoration may well have been inspired from this quarter — Robert of Anjou was French, after all. But if so, the cycle was transformed and interpreted in a new way, by restricting the choice of subjects to pre-Christian heroes only, and by treating them as independent figures. This later arrangement may in turn have influenced the earliest portrayals of the Nine Worthies, of which the best known is a fresco decoration of the 1430s in the palace of La Manta of the marquises of Saluzzo in the Piedmont, where the noble knights appear as so many saints aligned in a holy phalanx [Fig. 4.2]. Giotto's decoration established a tradition of great men cycles that proliferated endlessly thereafter. The theme as such, however — great men of the past as exemplars of moral behavior — is commonly traced to Petrarch (1304–74), whose famous series of biographies of classical heroes, the *De viris illustribus*, revived the legacy of Plutarch and other ancient biographical compilers. Petrarch began the *De viris* only a few years after Giotto's sojourn in Naples, and the fresco cycle has in fact been linked to the writer, who was a close friend and protégé of Robert of Anjou, whom he visited in Naples in 1341.[5] I suspect a relationship did exist, but with Giotto, not Petrarch, as the originator of the idea. Robert certainly possessed in his library, before Petrarch's treatise was written, the text of another work, we do not know the author, also called *De viris illustribus*, which previously must have been available to Giotto as well. Iconoclastic though the thought may seem, to my mind Giotto is the person most likely to have been responsible for

73

the fundamental innovations of the Naples cycle, that is, the emphasis on ancient characters and their treatment in heroic isolation. Indeed, he subsequently went much further in exploiting the historicism and individualism implicit in those monumental figures from the distant past.

After Giotto left Naples he went to Milan to work for Azzone Visconti (1302–39), who had recently become signore of the city and was building a palace. In 1335, four years before his death, Giotto executed a fresco in the palace that is described in the sources variously as an allegory of vain or mundane glory accompanied by "gentile princes of the mundane world, including among other Aeneas, Attila, Hector and Hercules, plus a single Christian, Charlemagne, and Azzone Visconti himself." The change from the Neapolitan cycle is striking. The Old Testament figures are replaced by Attila so that the ancient heroes are now uniformly pagans. Charlemagne was clearly included as the Frankish king who restored the Christian empire, and it was from the Longobard kingdom that Visconti derived his title and indeed his surname. Azzone is thus conceived as successor to Charlemagne and a worthy match for the secular heroes of antiquity. The Visconti of this period were, in fact, extraordinarily imaginative and ambitious genealogically, and I should not be surprised to learn that Giotto had actually been aware of Nigellus' eulogy of Charlemagne's palace at Ingelheim.

At any rate, the great men theme here acquires new cohesiveness and focus and, above all, a new motivation. Perhaps the major innovation of the decoration at Milan is that the great men theme is subsumed within a larger context, that of glory, which now appears as the ultimate goal of human action.

A strong case can be made for believing that Giotto's fresco is reflected in a number of manuscript illuminations that depict a comparable subject and can be connected with the theme on independent grounds. The miniatures occur as the frontispieces in three manuscripts of the most important work of historical biography since antiquity, none other than Petrarch's *De viris illustribus*. The manuscripts are themselves significant. The earliest, now in the

CHAPTER 4 ※ GREAT MEN PAST AND PRESENT

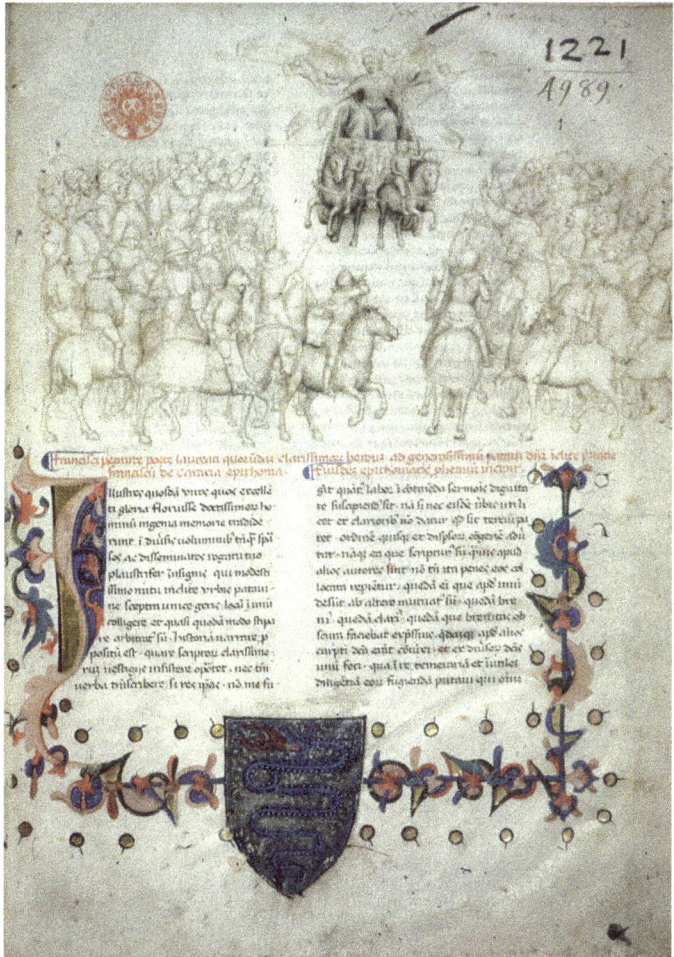

Fig. 4.3. Petrarch, De viris illustribus, *frontispiece, 1379. Paris, Bibliothèque nationale de France, Ms. Lat. 6069 F.*

Bibliothèque nationale de France, was presented in 1379 to Francesco I of Carrara, the patron of Petrarch, by the author's literary executor, Lombardo della Seta [Fig. 4.3]. The second manuscript, also in the Bibliothèque nationale and originally in the Carrara library

75

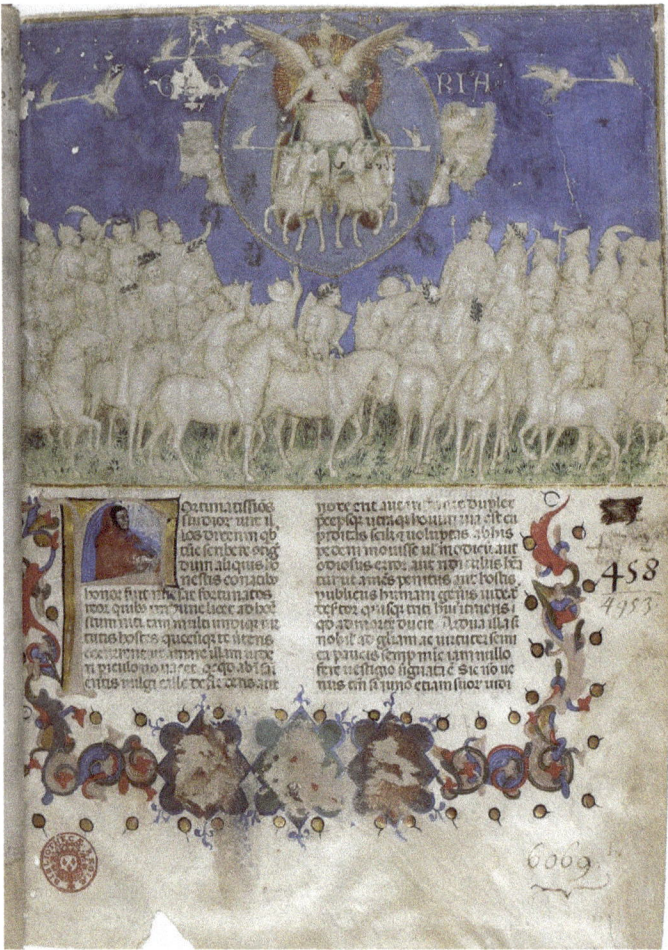

Fig. 4.4. "Gloria," Petrarch, De viris illustribus, frontispiece, before 1388. Paris, Bibliothèque nationale de France, Ms. Lat. 6069 I.

in Padua, dates before 1388 [Fig. 4.4]; the third, in Darmstadt, is the first Italian version of the treatise, dated about 1400 [Fig. 4.5]. The miniatures, the second of which bears an inscription identifying the subject as *Gloria*, differ in detail but agree in presenting a

CHAPTER 4 ❧ GREAT MEN PAST AND PRESENT

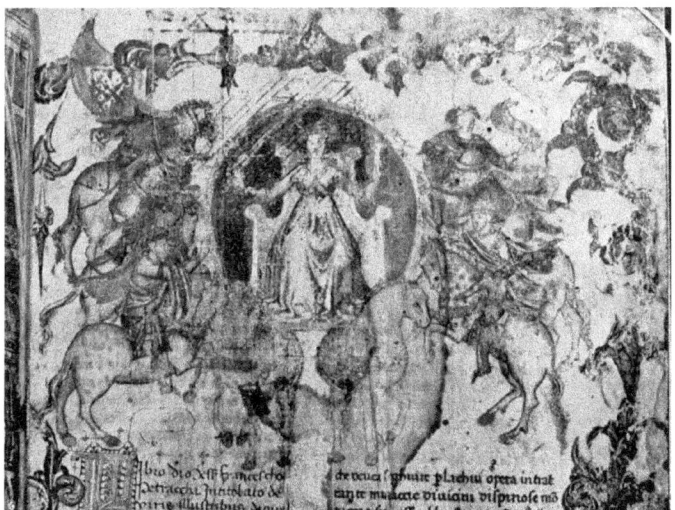

Fig. 4.5. Petrarch, De viris illustribus, *frontispiece, c.1400. Darmstadt, Universitäts- und Landesbibliothek, Ms. 101.*

grandiose, unified composition including the personification in the center, seated in a horse-drawn chariot with troops of mounted warriors in armor ranged below. The facts that one of the miniatures is inscribed "Gloria" and that they are used to illustrate Petrarch's text glorifying famous men, are clear indications that the Milan fresco of similar subject matter must have been the model.

The second miniature in the series, often attributed to the great Veronese mural painter, Altichiero (Aldighieri da Zevio, c.1330–90), is also remarkable for its technique and color. The basic composition is a common form of drawing in pen and bistre, but in this case color has been added in special ways: blue for the background, green for the foliage on the ground and for the laurel wreaths worn by the figures, who are themselves given highlights in white; the rays surrounding Glory are gold. There can scarcely be any doubt that in this respect, too, the miniature is following the lead of Giotto's fresco, which one of the sources describes as being picked out with gold, blue and green *(figure ex auro azurro et smaltis distincte),* "with

77

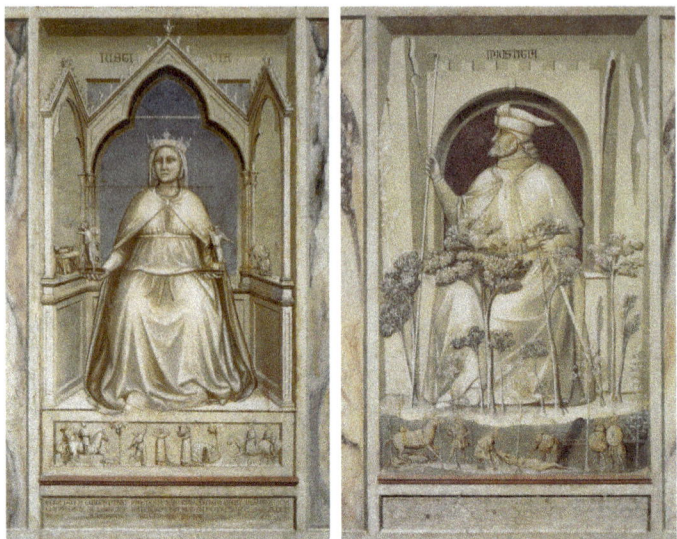

Fig. 4.6. Giotto di Bondone, Justice and Injustice. Fresco, 1302–5. Scrovegni Chapel, Padua.

such beauty and subtle artifice as may not be found in the whole world" *(contingeret reperiri)*. It is clear that the fresco was not painted in the ordinary way with full polychromy, but was rather a kind of "colored" grisaille, that is, a modified version of the technique of white monochrome painting that Giotto had used twenty-five years earlier for the personifications of virtues and vices in the dado of the Scrovegni Chapel at Padua [Fig. 4.6]. The obvious purpose there was to distinguish these abstract ideas by treating them as if they were sculptured relief, as distinct from the living figures of polychrome flesh and blood that populate the narrative scenes of the life of Christ above.

At Milan the grisaille technique was given a specific historical significance. An essential element of the allegorical theme was its historical content. The notion of glory involved almost, by definition, reference to the more or less remote past, and grisaille served not only to distinguish levels of reality, but to suggest the appearance of ancient sculpture. The reference to sculpture in turn was not simply a matter of suggesting a distant past and the medium in which ancient figurative art was most

CHAPTER 4 ❧ GREAT MEN PAST AND PRESENT

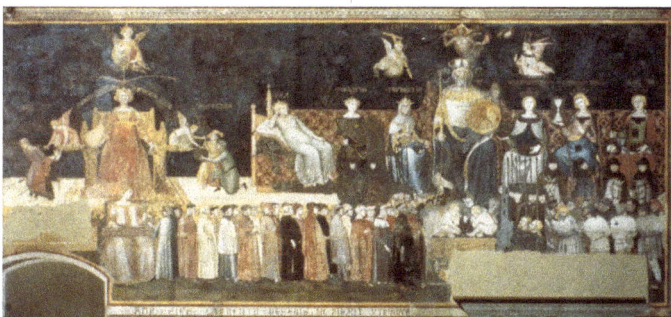

Fig. 4.7. Ambrogio Lorenzetti, Justice and Good Government, 1338–39. Palazzo Pubblico, Siena.

familiar. It also serves to reiterate the commemorative nature of classical sculpture generally. We shall discuss presently the antiquarian flavor both of the composition and the technique, but it should be emphasized here that the mixture of grisaille and color seems to express the mixture of ancient and modern represented by the heroes themselves. The grandiose, hierarchical composition in turn suggests the overarching moral principle by which the historical component is organized.

The Milan fresco was Giotto's second great achievement in the latter part of his life. Perhaps intended to recall the triumphal paintings carried by the Romans in their victory processions, it must have been the first monumental, unified composition of a secular allegorical theme since antiquity. The unity and cohesiveness of the design matched that of the allegory itself, in which the heroes of the past were assimilated to the heroes of the present and thence in turn to the heroic ideal of glory. The Milan fresco, like that in Naples, also spawned a continuing tradition of secular allegories with more or less explicit political implications. I will mention only one of the earliest and best known: the great allegories of *Good and Bad Government* painted by Ambrogio Lorenzetti in the Palazzo Pubblico of Siena [Fig. 4.7], beginning in 1337, just two years after Giotto executed his Milan fresco. Although many changes have been introduced in the transfer from the princely to the republican domain, Giotto's work provides the nearest precedent for the scale, the design, and the kind of allegorical content illustrated by Lorenzetti.

Important further steps were taken almost simultaneously in the 1360s at two neighboring courts in northern Italy, that of the Scaliger at Verona and that of the Carrara at Padua. Cansignorio della Scala is said in a contemporary chronicle to have built and decorated his palace at Verona in 1364. The decorations are first described a century later in a poem, by Francesco Corna da Soncino written before 1476: "Among other things," he says, "there is a room all painted with great figures. It has stories of Titus and Vespasian and is so rich with gold and painting (colors) and the figures are so natural that its like has not been seen in all Italy."[6]

In the second edition of his *Lives* (1568), Vasari notes that Cansignorio commissioned Altichiero to depict in the Scaliger palace

> the War of Jerusalem according to what is written by [Flavius] Josephus... [portraying]... a scene on each wall with a single ornament (frame) enclosing the whole. In the upper portion of this frame there are many medallions with what are thought to be illustrious men of that time, especially members of the Scaliger family, but this is not certain.... Among many portraits of great men and writers is that of Francesco Petrarca.

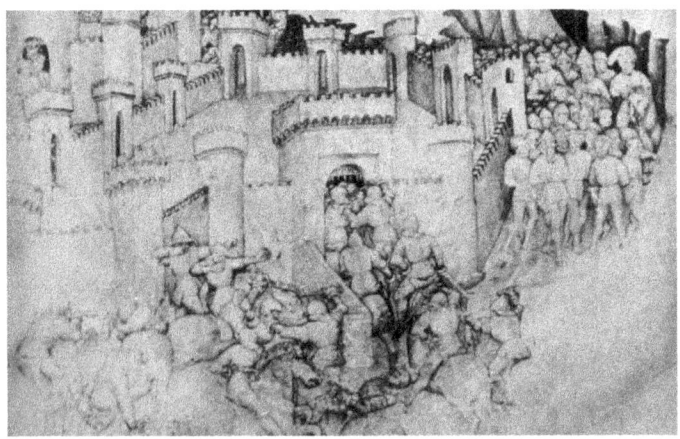

Fig. 4.8. After Altichiero, War of Jerusalem: Troops Entering the City. *Drawing. Paris, Museé du Louvre, Coll. Rothschild 848v.*

CHAPTER 4 ❧ GREAT MEN PAST AND PRESENT

After Altichiero, War of Jerusalem: *Fig. 4.9 (above). Troops Entering the City. Drawing. Prato, Coll. Loriano Bertini.*

Fig. 4.10 (below). Triumphal procession of Vespasian and Titus. Drawing. Paris, Museé du Louvre, R. F. 28 899.

Vasari goes on to say that Altichiero's collaborator, and in this case competitor, Iacopo Avanzi, painted below the frescoes of Altichiero "two most beautiful triumphs so well that Andrea Mantegna was reported to have admired them greatly."[7] Once again the decoration was destroyed, in the eighteenth century.

Two of the scenes are known from early drawings that copy them. One composition, copied in two drawings of the early fifteenth century, depicted the army entering the city and a troop of prisoners outside the walls [Fig. 4.8]. The second drawing of this scene has an inscription identifying it with the Verona decoration [Fig. 4.9]. Another drawing, of the early sixteenth century, shows a triumphal procession of the two rulers, Vespasian and his son Titus, who jointly celebrated the victory over the Jews [Fig. 4.10].

What is striking about these decorations, and what particularly struck Vasari in them, was again the great unified compositions, which may also have had a particular significance for the Scaliger. *The Jewish Antiquities*

81

of Flavius Josephus, in which the Roman victory over the Jews is described, was a popular work that found great resonance in the chivalric-crusader spirit of the later Middle Ages. At Verona, however, the scenes must also have alluded specifically to what was once a conspicuous tradition concerning the origin of the city. Verona was said to have been founded by Shem, the son of Noah, after the Flood; so the town was frequently referred to as Verona Minor Jerusalem. This ancient tradition was known to a remarkably learned chancellor of the Scaliger during the second quarter of the fourteenth century, Benzo d'Alessandria. Benzo refers to the Jewish origin of Verona in a chronicle he wrote around 1320 that concludes precisely with the destruction of Jerusalem, based on Flavius Josephus. A direct line can be traced from Benzo to Petrarch, whose portrait Vasari reported seeing in the Scaliger palace, through their mutual friend Guglielmo da Pastrengo, another important Veronese proto-humanist. Pastrengo mentions Benzo's treatise in a work of his own, written in 1337–50, in which he chronicled the lives of famous men and notable human achievements. Pastrengo was a close friend and correspondent

Fig. 4.11. Medallions in Window Embrasures, Loggiato of the Sala Grande, 1364. Palace of the Scaliger, Verona.

CHAPTER 4 ❧ GREAT MEN PAST AND PRESENT

of Petrarch who, in turn, had originally conceived of his treatise on Roman history, the same that ultimately became the *De viris illustribus*, as beginning with Romulus and culminating with none other than Emperor Titus. Petrarch thought of Titus, the conqueror of Jerusalem, as God's unwitting henchman, chosen by Christ to avenge the blood of the martyrs, of the Apostles, and of Himself. This sequence makes it tempting to imagine that Petrarch formulated the program for the Scaliger palace. Whether it was Petrarch's suggestion or not, however, Cansignorio's motive for having the Josephus stories and triumphs depicted on the family palace walls seems clear: the narratives created an allegory of the Scaliger reign as the salvation of the city, just as the ancient Jerusalem had been saved for Roman and hence Christian rule by Emperor Titus.

Fig. 4.12. Altichiero, *Marcus Antoninus Bassianus*, detail of Fig. 4.11.

This theme may have been implicit in the second and if anything, more noteworthy, feature of the Verona decoration: the frieze of medallions containing what Vasari thought might have been portraits of contemporaries, the Scaliger themselves, and Petrarch in particular. A series of profile heads of Roman imperial personages was uncovered in restorations of the Scaliger palace after World War II, on the soffits of the arches of the exterior Loggiato [Fig. 4.11]. The heads are painted in grisaille and framed by quatrefoils [Fig. 4.12], and in some cases retain identifying inscriptions. There can be little doubt that the rediscovered series must be closely related to those mentioned by Vasari, even though Vasari locates the series of portrait medallions in the audience hall and mentions portraits of contemporaries, whereas

83

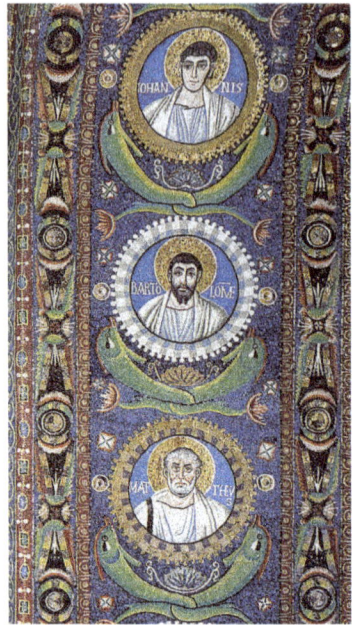

Fig. 4.13 (above). Mosaic medallions of saints. Intrados, begun 547 CE. S. Vitale, Ravenna.

Fig. 4.14 (below). Roman Coin: Maximinus I Thrax (Flavius Magnus Maximus Augustus), Emperor 235–38.

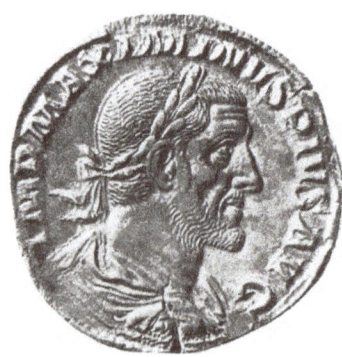

all the identifiable people here are ancients.

The basic idea for such rows of framed bust portraits came from the *imagines clipeatae*, images of military heroes that adorned ancient votive temples. Adapted to display the ranks of Christian saints, whose names might be inscribed, the motif became one of the most familiar forms of medieval church decoration [Fig. 4.13]. The Verona images are different from any prototype I am aware of, however, in two respects: the busts are shown in profile rather than full face, and they are painted in grisaille rather than in full polychrome. The artist has transformed a millennial decorative tradition by assimilating it to images derived from a totally alien tradition, namely numismatics, since it is clear that both the profile form and the grisaille technique are intended to invoke the sculptured portraits of Roman emperors on coins and medals [Fig. 4.14]. They must have been based, in fact, on a collection formed early in the century by still another notable Veronese antiquarian, Giovanni Mansionario.

CHAPTER 4 ❧ GREAT MEN PAST AND PRESENT

Fig. 4.15. Drawing after Roman Coins. Mansionario Codex, 1313–20. Rome, Biblioteca Apostolica Vaticana, Ms. Chig. I, VII, 259.

Between 1313 and 1320, Mansionario wrote a book of imperial history, from Augustus to Charlemagne, which he intended to continue down to his own time, introducing a series of pen drawings after the ancient coins, as illustrations of the biographies to which his text is mainly devoted [Fig. 4.15]. Mansionario is best known for having been the first to distinguish between the elder and the younger Pliny, realizing that the name belonged not to one but to two authors. We

should realize that these were not simply antiquarian matters. The coins, for example, were not particularly of interest from a properly numismatic point of view, that is, for what they reveal about economics and trade in antiquity. Rather, they made it possible to give faces to the names and deeds familiar from the written sources, and so gave life, as it were, to the moral order with which antiquity was imbued.

Petrarch actually articulated this point in a passage in one of his biographical works concerning Vespasian himself, saying the he found the image of the emperor given in the sources quite similar to that provided by coins. The exemplary role of numismatic portraiture is made explicit in a famous letter Petrarch wrote in 1355, in which he tells of giving his precious collection of ancient coins to Emperor Charles IV:

> I gave him as a gift some gold and silver coins bearing the portraits of our ancient rulers and inscriptions in tiny and ancient lettering, coins that I treasured, and among them was the head of Caesar Augustus, who almost appeared to be breathing. "Here, O Caesar," I said, "are the men whom you have succeeded, here are those whom you must try to imitate and admire, whose ways and character you should emulate: I would have given these coins to no other save yourself. Your prestige has moved me; for although I know their ways and names and deeds, it is up to you not only to know but to follow their example; it was thus fitting that you should have these." Giving a brief summary of each man's life, I intermingled my words as much as possible with goads intended to make him imitate their valor and zeal.... [8]

Above all, this physiognomical concern — like the concern to distinguish between the elder and younger Pliny — reflected an interest in the individual and his personality. At Verona this interest extended, if we follow Vasari, to include contemporaries — the Scaliger family, other great men, and writers, including Petrarch. The past was thus associated with the present through a heightened awareness of personal identity, just as the narrative scenes were

CHAPTER 4 ⚜ GREAT MEN PAST AND PRESENT

Fig. 4.16. Sala dei Giganti (originally painted by Altichiero?, 1367–79). Palace of Francesco il Vecchio da Carrara, Padua.

linked to the present through the political implications of the taking of Jerusalem and the imperial triumphs. Finally, these contemporary resonances in content have visual counterparts in the thorough modernization to which the classical references have been subjected. The cityscapes and costumes in the Jerusalem scenes are wholly recent in design, and the circular frames of the medals have become "gothic" quatrefoils. Such features are often taken merely as lingering medievalisms, remnants of outmoded traditions, whereas they are better regarded as advertisements of the living relevance of the themes they represent.

From 1367 until his death in 1374 Petrarch lived in Padua as the guest of Francesco il Vecchio da Carrara, with whom he developed a close friendship. Between 1367 and 1379 Francesco had the walls of the great hall of his palace [Fig. 4.16] covered with frescos, perhaps by the same Altichiero who executed the decorations at Verona and, presumably, the miniature version of Giotto's *Gloria* mural at Milan [Fig. 4.4]. The subject was a series of famous men closely related to Petrarch's series of biographies of them, the *De viris illustribus* [Fig. 4.17].[9] Petrarch dedicated a

87

Fig. 4.17. *Sala dei Giganti, Domenico Campagnola and Stefano dall'Arzere. Fresco, 1539–40. Palace of Francesco il Vecchio da Carrara, Padua.*

version of his work to Francesco, and in all probability provided the program of the decoration, as I suspect he must have done at Verona. At one end of the room portraits were added a few years later of Petrarch himself and Lombardo della Seta, his literary executor who completed the text after his death. The room was severely damaged by a fire around 1500, and was repaired

Fig. 4.18. Petrarch, De viris illustribus, *Scenes from Roman History. Darmstadt, Universitäts- und Landesbibliothek, Ms. 101, fols. 4v, 6v.*

CHAPTER 4 ❧ GREAT MEN PAST AND PRESENT

toward the middle of the sixteenth century; in this form it serves today as the assembly hall of the University of Padua. The original decoration included figures of thirty-six ancient heroes from Romulus to Trajan, all of whom were Roman except three: Alexander, Pyrrhus, and Hannibal. The figures were painted in color, while below there were grisaille narrative scenes illustrating the lives of the heroes.

Some notion of the narratives is provided by the miniatures in the manuscript in Darmstadt, of the first vernacular translation of Petrarch's *De viris illustribus,* the same manuscript that includes one of the depictions of *Gloria* mentioned earlier. The scenes are portrayed in what might be called a contemporary classical mode, that is, the figures wear modern costumes and the settings mix modern buildings with references to ancient monuments in the episodes located in Rome [Fig. 4.18]. The episodes seem almost to have been cut from a continuous strip of marble relief sculpture like the Roman triumphal columns, which had also fascinated the painter — Giotto or whoever it was — of the upper church at Assisi [Fig. 4.19].

Fig. 4.19. Giotto di Bondone (?), St. Francis Liberating the Repentant Hermit, 1290–96. S. Francesco, Upper Church, Assisi.

The designer of the Padua cycle evidently sought to unite the predominant features of the earlier decorations at Naples, Milan, and Verona — joining the monumental, isolated figures of the first to the narratives of the third, and using the mixture of polychromy and grisaille of the second as a kind of tertium quid in the combination.

In part, the idea may have been inspired from Giotto's Arena Chapel not far away in Padua where, we remember, grisaille figures of virtues and vices appeared as footnotes to the polychrome

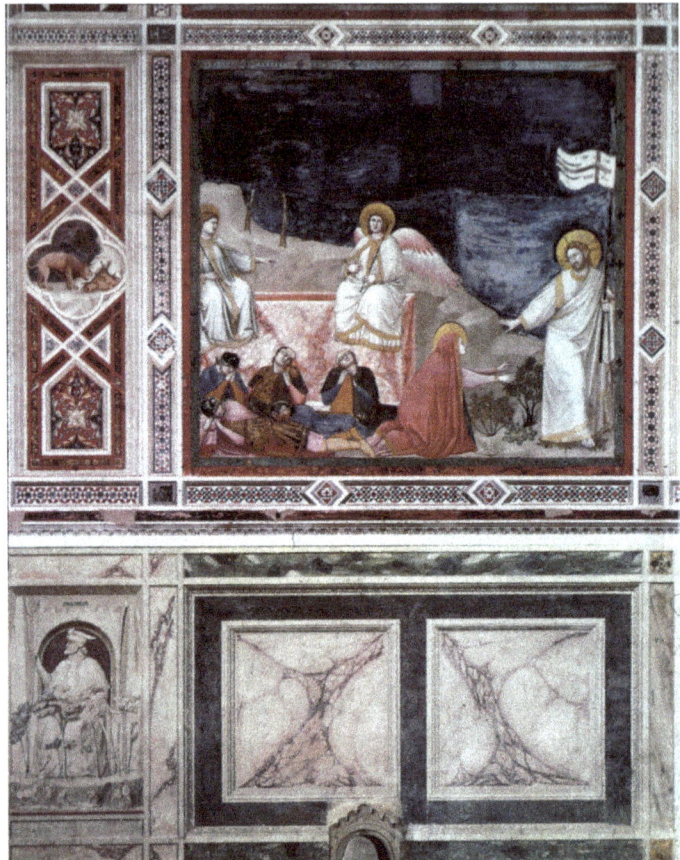

Fig. 4.20. Giotto di Bondone, Section of North Wall. Scrovegni (Arena) Chapel, Padua.

narrative scenes above [Fig. 4.20]. The central allegories of justice and injustice at Padua even provided a model for the idea of a monumental figure explicated by the representative narrative scene [Fig. 4.6]. This formulation was portentous, becoming a classic mode of expressing the idea of an heroic ideal, like the altarpiece with a saint above the predella or the niche statue with a relief below [Fig. 4.21].

CHAPTER 4 ❧ GREAT MEN PAST AND PRESENT

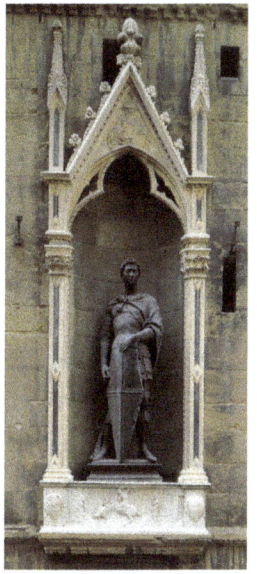

Fig. 4.21 (above). Donatello, St. George, *bronze copy after original, 1410–15. Or San Michele, Florence.*

Fig. 4.22 (below). Altichiero, *Petrarch in his Study, c.1400. Sala dei Giganti, Palace of Francesco il Vecchio da Carrara, Padua.*

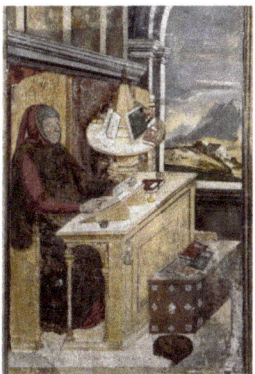

Of particular interest, finally, is the important role given to the portraits of Petrarch [Fig. 4.22] and Lombardo della Seta. They are shown not as part of a subsidiary frieze of medallions but in isolated and conspicuous positions at the end of the room; and they appear in their studies as authors of the historical work on which the decoration is based. They serve not only to elevate two contemporary literary figures to the ranks of the great men of antiquity — "culture heroes," as it were — but also to place the whole decoration into an explicitly historical context. They provide figural and thematic quotation marks, guaranteeing that the great men of the past are to be understood in terms of those of the present.

I SAID AT THE OUTSET of this essay that I held Giotto's secular decorations responsible for a new departure in European culture. I intended the latter phrase to echo beyond the domain of the visual arts, to which his contribution, however much appreciated, is normally restricted. I shall devote the time that remains to staking out this claim.

In a fundamental study of the ancient Roman idea of fame, or glory, conceived as a spur to noble actions, Ulrich Knoche, showed that it was above all a social idea, with two essential and complementary characteristics.[10] The quality of glory was inextricably related to the estimation and

appreciation of men; and, conversely, it was a property exclusively attributable to human beings. The idea of glory as a basic motive for human action had the effect of assuring the concept a universal reach, and hence of relating it to notions of triumph and victory. The triumph of glory is conceived ironically in a passage in one of Horace's *Satires* that is based, significantly, on a distinction among social classes: "Glory drags all bound to her glittering chariot, the obscure as well as the high-born." Nothing could illustrate the mundane, social nature of the concept more strikingly than the simple fact that in the entire range of pre-Christian Latin literature the term *gloria* is applied to a deity only once, in a passage in Ovid's *Metamorphoses*, where Amor says to Apollo, "Your glory is greater than mine." But it is the exception that proves the rule, since the whole sense of the phrase involves the transfer of a value system from the society of humans to that of the gods. Knoche also showed that Christianity, partly from Greek and partly from Old Testament sources, turned the pagan Roman notion completely about. Glory came to be identified with illumination, and illumination was divine. All true glory was a reflection of the glory of God. "Glory must be sought from God, not men," Tertullian says, and any glory not derived from God was vain: "Despise glory and you will be glorious," says early Christian St. John Chrysostom. [11]

Considering these alternatives — a purely mundane glory having to do with human intercourse, or a celestial glory as an exclusively divine attribute — it is no wonder that neither in antiquity nor in the Middle Ages does glory seem to have been given the status of an independent personification with a visual image of its own. This achievement occurred only in the early years of the fourteenth century, not at the hands of a professional artist but at those of the Tuscan poet Francesco da Barberino (1264–1348). Before 1318, Francesco composed a long allegorical poem, or rather cycle of poems, entitled *Documenti d'Amore*.[12] The poems are grouped under the headings of various moral concepts: docility, industry, constancy, patience, hope, prudence, glory, justice, innocence, gratitude, eternity, concluding with a treatise on love. Francesco was also a draughtsman of some ability and provided models for many illustrations to the poems, to be followed by a professional illuminator. The manuscript with

CHAPTER 4 ❧ GREAT MEN PAST AND PRESENT

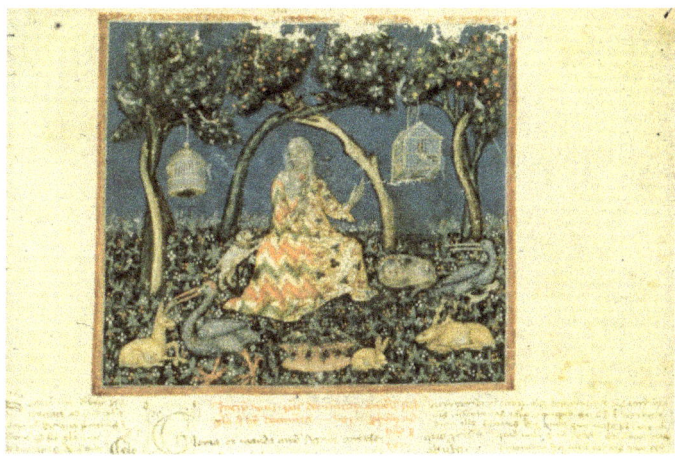

Francesco da Barberino, Documenti d'Amore: Gloria. *Fig. 4.23 (above). Rome, Biblioteca Apostolica Vaticana, Ms. Barb. Lat. 4076, fol. 85r.*
Fig. 4.24 (below). Rome, Biblioteca Apostolica Vaticana, Ms. Barb. Lat. 4077, fol. 74r.

Francesco's own designs is preserved [Fig. 4.23], as is that with the professional's copies [Fig. 4.24]. The illustration for the section on glory represents a beautiful young maiden seated in a flower garden with a variety of forest animals listening to the delectable paeans of praise sung by the birds (in gilded cages). To be sure, the presence of

Fig. 4.25. Francesco da Barberino, Documenti d'Amore: Amor. Rome, Biblioteca Apostolica Vaticana, Ms. Barb. Lat. 4076, fol. 99v.

animals, not humans, suggests that the satisfaction is strictly personal and private, but so far as I am aware, Francesco's illumination is the first anthropomorphic visualization of glory as an independent concept. No less significant in our context, however, is the illustration of the section on love. The figure of Amor — a flower-bedecked boy with wings and taloned feet — rides circus-style on a white horse and casts arrows down upon the representatives of various walks of life ranged in a register below [Figs. 4.25 and 26]: a monk, a nun, a maiden, a young woman, a widow, a husband and wife, a knight, a common man, a dead man and woman. In the tradition of "Amor Vincit Omnia," the idea of universal domain is here an essential part of the concept.[13]

CHAPTER 4 ❧ GREAT MEN PAST AND PRESENT

Fig. 4.26. Francesco da Barberino, Documenti d'Amore: Amor. *Rome, Biblioteca Apostolica Vaticana, Ms. Barb. Lat. 4077, fol. 88v.*

It has often been noted that Francesco's figure of Amor anticipates by no more than a year or two a figure with the same attributes that appears in the Giottesque frescoes of the lower church at Assisi, being chased away from the tower of chastity [Fig. 4.27]. Boccaccio, in turn, refers to Amor in this form in the *De genealogia deorum*.[14]

Of far greater importance than the figuration of Amor, however, is the fact that, as will already have become apparent, Francesco's illumination also anticipates Giotto's *Gloria* fresco at Milan [Figs. 4.3 and 4.4]: not only the basic idea of an abstract quality conceived as an allegorical figure distributing emblems of itself to an assembly of devotees, but also the vast hieratically organized compositional scheme in which the idea is couched.

In general, it might be said that Giotto conflated Francesco's two images: glory as an isolated female personification accompanied by the

95

Fig. 4.27. *Maestro delle Vele (?). Allegory of Divine Love, c.1320. Web of Crossing Vault. S. Francesco, Lower Church, Assisi.*

muse of praise, becomes a winged, airborne personification of a universal force, and love's rain of arrows upon all the people is transformed into glory's conferral of laurel crowns upon the virtuous few. What is above all novel to Giotto's image is the idea of triumph, and this he seems to have derived from a very particular classical source, the one form in which the idea of glory appears, not in isolation to be sure, but on the contrary, in a context of universality. I refer to a medallion representing the triumph of Emperor Probus [Fig. 4.28], who appears in a horse-drawn chariot accompanied by a winged personification of victory crowning him with laurel. The notion of universal glory is conveyed by the legend *Gloria Orbis* (Glory of the World). Giotto converted the universal military triumph into a universal moral triumph. It is possible that Giotto was inspired to transpose the idea into a monumental mural decoration by one of the great works of late antique art that decorated a basilica in Rome built by the consul Junius Bassus (prefect of the Roman Empire from 318 to 331), in Giotto's day the church of Sant'Andrea in Catabarbara

Fig. 4.28. *Silver medallon, Emperor Probus (276–82 CE), obverse; Triumph, reverse.*

CHAPTER 4 ❧ GREAT MEN PAST AND PRESENT

Fig. 4.29. *Charioteer from the Basilica of Junius Bassus, Opus Sectile, 318–30. Museo Nazionale Romano, Palazzo Massimo, Rome.*

[Fig. 4.29]. The composition, executed in a marble inlay technique that anticipates Giotto's vivid color contrasts, shows the two-horse consular chariot accompanied by a flanking row of equestrian figures.

It is clear in any case that Giotto's image, in contrast to Francesco da Barberino's, entailed at least a partial reclamation of the social content the idea of glory had in antiquity. On the other hand, it is not bestowed by one's fellows but by a high power. And it is not bestowed upon a single person but distributed almost as an act of grace to a population whose class is determined by their virtue. Although he did not realize that they depicted Giotto's lost fresco at Milan, Julius von Schlosser recognized long ago that the *Gloria* miniatures strikingly anticipated an imaginary palace wall decoration described by Boccaccio in his great allegorical poem *Amorosa Visione* of 1342.[15] The paintings are attributed in the poem to Giotto, and in one of the rooms was represented "Fame in the form of a Lady":

> ...Among the throng
> Appeared a Lady there, comely and pure,
> Who seemed to have dominion o'er them all.
> Her head with gold and richest stones was crowned,
> ...
> Bravely she triumphed o'er the crowd around

Fig. 4.30. Giovanni di Ser Giovanni Guidi, Triumph of Fame, *birth tray, 1449. New York, The Metropolitan Museum of Art, acc. no. 1995.7.*

*And gazed at them while seated on her car
Bedecked with laurel leaves. A cleaving sword
She bore, with which, me thought,
She threatened all the world.
. . .
Her left hand held an apple of pure gold.
I saw her seated on a royal throne
And at her right, two steeds with mighty chests
Amid the august throng the chariot drew.
Another thing I noted with surprise:
The sov'reign Lady, enemy of Death,
Was with a mighty circle all enclosed
Which encompassed her complete from head to foot.
. . .*

CHAPTER 4 ❧ GREAT MEN PAST AND PRESENT

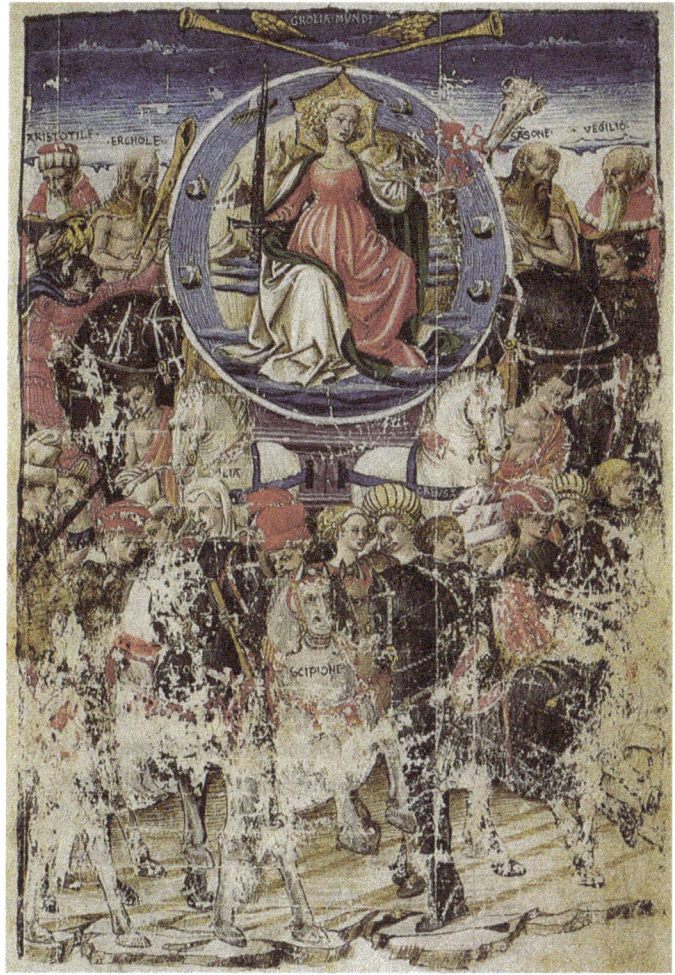

Fig. 4.31. Apollonio di Giovanni, Triumph of Fame, *1460–70. Florence, Biblioteca Ricciardana, Ms. 1129.*

*Above her head, and not in vain, was writ
A verse in which this noble legend ran:
'I am the Glory of Terrestrial Man'.*[16]

99

In Boccaccio's case the throng of glory's devotees was a long list of biblical, classical, and medieval greats. On purely literary grounds, Boccaccio's poem has, in turn, been defined as a major source for Petrarch's famous allegorical poem, *I Trionfi,* a work upon which he was engaged from 1356 until his death in 1374.[17] Petrarch's poem carries the reader through an ever more lofty and enduring series of conceptual triumphs from that of love through those of chastity, death, fame and time to that of divinity. From the beginning of the fifteenth century, the *Trionfi* became one of the most popular of all Renaissance texts for illustration, and the earliest illustrations of the *Triumph of Fame,* in particular, are clearly related to those in the manuscripts of the *De viris illustribus* [Figs. 4.30 and 4.31].

By and large it has been the tradition to give written texts precedence, to assume that writers lead the way. It has been suggested that Petrarch lay behind the monumental series of *Great Men* at Naples in the early 1330's, as well as those at Verona in the early 1360s and those at Padua in the later 1360s; and that Boccaccio inspired the *Gloria* mural at Milan in the late 1330s. All this despite the patent evidence to the contrary, the fact that Giotto's works at Naples and Milan were executed before the relevant literary texts were composed, and the fact that in executing the late works Altichiero was clearly following Giotto's lead.

Where had Francesco da Barberino received instruction in drawing? Cimabue and Giotto have been suggested. Hardly. But the suggestion is based on the fact that Francesco greatly esteemed the two founders of modern painting. He speaks of them both in the long commentary he composed to accompany and explain the *Documenti d'Amore,* in a passage, significantly, in which he argues the superiority of the pictures over the written word. Francesco was an active participant in the visual culture of his time, commissioning, as he reports, paintings of allegorical subjects at Florence, and in the episcopal palace at Treviso. Most important, he refers explicitly to the Arena Chapel frescoes by Giotto, in particular to the portrayal of Invidiousness, one of the vices painted in grisaille along the dado. Moreover, the painter he chose to execute the copies of his own illustrations of the *Documenti* was utterly imbued with

CHAPTER 4 ❧ GREAT MEN PAST AND PRESENT

the spirit of Giotto's style. Could it be that the pictures anticipate Giotto because he had inspired them in the first place?

References to Giotto in the works of Boccaccio and Petrarch are astonishingly frequent and enthusiastic: Boccaccio in the passage in the *Amorosa Visione* describing the palace's fresco decorations by Giotto regards the artist's hand as inspired by an *"ingegno"* apparent in every figure and second only to the divine.[18] Giotto and Dante are the only contemporaries Boccaccio includes among the wise men and ancient heroes who appear in the triumph of fame represented by the poem. Boccaccio makes Giotto the hero of a novella in the *Decameron*, where the painter is said to have brought back to light that art which had been buried for centuries by those who painted more to delight the eyes of the vulgar than to please the intellect of the wise. Petrarch urged a friend from Milan who was planning a trip to the Holy Land not to miss seeing the work in Naples of Giotto, "great monuments of the skill et imagination *[manus et ingenium]*" of "the outstanding painter *[princeps pictorium]* of our time," whose fame among contemporaries, he said, was immense. And when he drew up his testament in 1370, Petrarch left his most precious possession to his patron, Francesco da Carrara, a painting of the Virgin by Giotto, the beauty of which, he said, "the ignorant fail to understand while those who be masters of art are amazed."

These statements have been discussed primarily in the context of early Renaissance art criticism. They have sometimes been dismissed as purely conventional praise, or appreciated simply for the evidence they provide of his contemporaries' awareness of the new formal order Giotto inaugurated. I submit that the esteem they express may signify something more: an acknowledgement of a fundamental debt the writers owed to the painter who was evidently the leading spirit not merely in the formulation of a new canon of visual eulogy but also in the creation of a new, commemorative mode of thought. That mode entailed the paradoxical but essential link between allegory and history described by Roger Hinks: at once retrospective and augural, at once historical and relevant.

NOTES

1. This fourth essay was updated in 2014. It has not previously been published.

2. Ermoldus Nigellus (act. 824–30); poet at the court of Pippin (son of King Louis), so noted in Einard's *Lives*. See T.F.X. Noble, *Charlemagne and Louis the Pious: Lives by Einhard, Notker, Ermoldus* (State Park, PA: Pennsylvania State University Press, 2009), 174–76. From MGH *Poetae* 2:65–66.

3. Paulus Orosius, *Historiarum adversus paganos libri VII*. Translated Texts for Historians 54, A.T. Fear, trans. (Liverpool: Liverpool University Press, 2010), 13–25.

4. Jacques de Longuyon of Lorraine is the author of the chanson de geste, written for Thibaut de Bar, bishop of Liège in 1312. C. Gaullier-Bougassas, dir., *Les Vœux du paon de Jacques de Longuyon: Originalité et rayonnement* (Paris, Éditions Klincksieck, 2011).

5. Francesco Petrarca, *De viris illustribus*, in *Opere storiche: De Gestis Cesaris* 3.1–2, S. Ferrone, ed., G. Nanua, trans. (Florence: Le Lettere, 2003–12). See Ronald G. Witt, "The Rebirth of the Romans as Models of Character *(De viris illustribus)*," in Victoria Kirkham and Armando Maggi, ed., *Petrarch: A Critical Guide to the Complete Works* (Chicago: University of Chicago Press, 2009), 103–11; and Gur Zak, "Petrarch and the Ancients," in Albert Russell Ascoli and Unn Falkeid, ed., *The Cambridge Companion to Petrarch* (Cambridge: Cambridge University Press, 2015), 141–53.

6. Francesco Corna da Soncino, *Fioretto de le antiche de Verona e de tutti i suoi confini e de le reliquie che se trovano dentro in ditta citade* (Verona: Stamperia Valdonega, 1973), 3.4. "La Sala Grande": "tra le altre cose, egli dice, c'era una sala che per certano era tutta dipinto con grandi figure. Vi erano storie di Tito e Vespasiano ed era così ricca di oro e corlori e le figure così naturali che non se ne era vista nessuna uguale in tutta Italia."

7. William Gaunt, ed., *Giorgio Vasari: Lives of the Most Eminent Painters Sculptors and Architects, 1568,* 4 vols. (London: Dent, 1963), 2:138–39.

8. …[dunque, prendendo spunto da questa conversazione sugli uomini illustri], gli feci dono di alcune effigi, a me molto care, di nostri imperatori in oro e in argento, iscritte con lettere minutissime e antiche, tra le quali vi era anche il ritratto, quasi animato, di Cesare Augusto. "Ecco" dissi, "O, Cesare, coloro dei quali sei il successore, ecco coloro che tu devi

adoperarti a imitare e ammirare, al cui modello conformarti; a nessun altro, se non a te, li avrei potuti dare. È il tuo prestigio a spingermi; sta a me, infatti, conoscere i costumi, i nomi e le gesta di costoro, a te non solo conoscerle, ma anche seguirne l'esempio; a te, perciò, erano dovute." Quindi, tracciando molto brevemente l'essenziale della vita di ognuno, alle parole mescolai, per quanto mi fu possibile, stimoli alla virtù e all'emulazione; profondamente toccato, nulla parve essergli più gradito di quel piccolo dono. *Epistolae familiares* XIX.3, in Aldo S. Bernardo, "The Selection of Letters in Petrarch's Familiares," *Speculum* 35.2 (1960): 280–88. But see also the Latin (with facing Italian) text in Francisci Petrarce, *Familiarium Rerum Libri,* Vittorio Rossi and Umberto Bosco, ed.; Ugo Dotti, Italian trans. 5 vols. (Turin: Nino Aragno Editore, 2004), 4:2624–43, at 2634–35; and in English, Francesco Petrarch, *Letters on Familiar Matters,* Aldo S. Bernardo, trans. 3 vols. (New York: Italica Press: 2005), 3:77–82, at 79.

9. T.E. Mommsen, "Petrarch and the Decoration of the Sala Virorum Illustrium in Padua," *The Art Bulletin* 34.2 (June 1952): 95–116.

10. Ulrich Knoche, "Der römische Ruhmesgedanke," *Philologus* 89 (1934): 123.

11. Tertullian, "On the Veiling of Virgins," in *The Ante-Nicene Fathers: Translations of the Writings of the Fathers down to A. D. 325,* vol. 4, Alexander Roberts and James Donaldson, ed. (Grand Rapids, MI: Eerdmans, 1986), 3.2, p. 28; Chrysostom, Homily XXV, in *Homilies on Hebrews: A Select Library of Nicene and Post-Nicene Fathers,* First Series 14, Philip Schaff, ed. (Grand Rapids, MI: Eerdmans, 1979–83), 479.

12. Francesco da Barberino, *I documenti d'amore. Documenta amoris,* 2 vols. (Lavis: La finestra, 2008), 1:372–84, 2:493–507.

13. "Omnia vincit amor: et nos cedamus amori," a line from the last poem in Virgil's *Eclogues* 10.69.

14. *Genealogia deorum gentilium,* known in English as "On the Genealogy of the Gods of the Gentiles," is a mythography or encyclopedic compilation of the tangled family relationships of the classical pantheons of Ancient Greece and Rome, written in Latin prose from 1360 onwards by the Italian author and poet Giovanni Boccaccio (1313–75). The standard edition is by V. Zaccaria, in Giovanni Boccaccio, *Tutte le opere,* V. Branca, ed., 10 vols. (Milan: Mondadori, 1998), 7–8:1–1813. English translation by J. Solomon, *Genealogy of the Pagan Gods,* 2

vols. (Cambridge, MA: Harvard University Press, 2011–17). See also J. Simon, "Gods, Greeks, and Poetry *(Genealogia deorum gentilium),*" in *Boccaccio: A Critical Guide to the Complete Works,* Victoria Kirkham, Michael Sherberg, and Janet Levarie Smarr, ed. (Chicago: University of Chicago Press, 2013), 235–44.

15. Julius Schlosser, *Die Kunstliteratur: Ein Handbuch zur Quellenkunde der Neueren Kunstgeschichte* (Vienna: Schroll, 1985), 30–32.

16. *...quanto infra gran gente*
donna pareva lì leggiadra e pura.
Tutti li soprastava veramente,
di ricche pietre coronata e d'oro,
nell'aspetto magnanima e possente.

Ardita sopra un carro tra costoro
grande e triunfal lieta sedea,
ornato tutto di frondi d'alloro.
Mirando questa gente in man tenea
una spada tagliente, con la quale
che il mondo minacciasse mi parea.

Il suo vestire a guisa imperiale
era, e teneva nella man sinestra
un pomo d'oro, e 'n trono alla reale
vidi sedeva; e dalla sua man destra
due cavalli eran che col petto forte
traeano il carro fra la gente alpestra.
Ed intra 1'altre cose che iscorte
quivi furon da me intorno a questa
sovrana donna, nimica di morte

. . .
nel magnanimo aspetto, fu ch'a sesta
un cerchio si movea grande e ritondo,
dal piè passando a lei sopra la testa.

Era sopra costei, e non invano
scritto un verso che dicea leggendo:
'Io son la Gloria del popol mondano'. [i]
(V. Branca, ed., *Tutte le opere di Boccaccio,* Milan, 1974; *Amorosa visione,* canto VI, vv. 47-69, 73-75).

17. Francesco Petrarca, *Trionfi. Opere* I (Florence: Sansoni, 1975), 191–238.

18. …*in una grande sala ci trovamo*
 chiara era e bella e risplendente d'oro,
 d'azzurro e di color tutta dipinta
 maestrevolmente in suo lavoro.
 Humana man non credo che sospinta
 mai fosse a tanto ingegno quanto in quella
 mostrava ogni figura lì distinta,
 eccetto se da Giotto, al qual la bella
 Natura parte di sé somigliante
 non occultò nell'atto in che suggella"
 (*Amorosa visione* IV, vv. 9–19).

5. EQUESTRIAN MONUMENTS: THE INDOMITABLE HORSEMAN[1]

IN THE COURSE of the fourteenth century and culminating at its end, three major developments may be discerned in the tradition of collective, heroic, commemorative portraiture discussed in the previous essay under the heading of "great men." All the major innovative works in this category from the early part of the century decorated the dwellings of rulers who were, or pretended to be, dynastic. Such works straddled the boundary between the private and public domains in that, while the patrons embodied civic government, they ruled by their personal authority, and their palaces were private property. At the end of the century the genre moves from this princely and private sphere into the public sphere, accessible to and oriented toward the ordinary citizen. Secondly, the tradition shifts from what might be thought of largely as the fulfillment of an abstract ideal, involving no geographical or national boundaries, to the realization of a distinctly local, and often patriotic identity. A third, concomitant transformation is that, increasingly, contemporary or at least relatively recent personages are included along with, or even independently of, much earlier prototypes of the pagan or Judeo-Christian past.

These developments are manifest in two undertakings in Florence, one in the religious, the other in the secular sphere, both probably inspired by the great early humanist statesman Coluccio Salutati (1331–1406), who was chancellor of the city of Florence from 1375 until his death.[2] Salutati was the author of a cycle of twenty-two epigrams on famous men whose portraits once decorated the audience hall of the town hall, or Palazzo Vecchio, in Florence.[3] With the exception of Constantine and Charlemagne the ancient figures portrayed were pagans, and all were rulers, military heroes, and statesmen. Most significant was the addition of several "modern" personages, all of them writers: Dante, Petrarch, Zanobi da Strada, and Boccaccio.[4] What is remarkable about this series is not simply the presence of a substantial number of moderns, but also their direct juxtaposition with ancient heroes, without reference to the Middle Ages. Equally striking is the fact that the ancients were all men of public life, the one exception being the poet

Claudianus,[5] who was thought to have been born in Florence. On the other hand, the moderns are all poets and natives of the city. The purpose was clearly not just to establish a coherent heroic type to which the moderns belonged, but also to create a confrontation between the ancient and modern protagonists. The viewer was presented with exemplary models from antiquity in order to affirm the stature of great, modern Florentines in relation to the classical prototypes. Finally it is noteworthy that the moderns are all poets. Salutati, who was himself a literary figure of considerable importance, evidently intended to equate the recent cultural achievements of his countrymen with the accomplishments of the ancient heroes of the *vita activa*.

In this context it may be seen that the shift from the private to the public domain corresponds to a process of self-definition of the state as a collective entity, and an entity defined not primarily by its military or even political prowess, but by the nature and quality of its culture. It must not be assumed, however, that the writers were there simply for the beauty of their poetry. It was they, above all, who celebrated the ancient heroes in the frescos placed before the citizens of Florence as models. This fact, in turn, acquires deeper significance if one considers that the line we draw between poet and historian is much too sharp for the early Renaissance. The mode of thought seems almost to reproduce that stage of development described by Giambattista Vico (1668–1744) in his *Discovery of the True Homer*[6] and by Roger Hinks (1903–63) in his *Myth and Allegory in Ancient Art*,[7] in which the junction of poetry and history gave rise to human self-consciousness and the sense of individual identity.

The other commemorative enterprise that took place under Salutati's chancellorship was a series of monuments to be placed in the cathedral of Florence. The series began in 1393 when the city fathers, the Signoria, voted to erect a tomb monument with inscriptions, marble figures and armorial bearings, in the cathedral, to honor the famous English mercenary John Hawkwood (c. 1323–1394; Giovanni Acuto in Italian), who was captain-general of the Florentine republic and had been named honorary citizen in 1391.[8] Although there was a long tradition for Italian communes to erect such monuments to

CHAPTER 5 ❧ EQUESTRIAN MONUMENTS

their military heroes, to do so while the recipient was still alive was unusual, if not unprecedented. Hawkwood died three years later, and it was then decided to bring together the Hawkwood monument with one of an earlier condottiere who had served Florence, Piero Farnese (1310/20–1363),[9] whose monument of 1367 in the cathedral had fallen into disrepair.

Designs for the two monuments were ordered in December 1395, from the painters Agnolo Gaddi (1350–95) and Giuliano Arrighi (Pesello, 1367–1446). The designs were evidently to be executed full scale, next to one another on the wall of the north aisle of the church, Farnese taking precedence nearer the altar. A few weeks later the same body ordered a memorial for Luigi de' Marsili (fl.1320–1400), a theologian, diplomat and humanist friend of Salutati. Finally, a year later, in December 1396, a remarkable measure was taken. The Signoria ordered a kind of communal memorial for a whole group of Florentine intellectuals and men of letters: the jurist Accursio (1182–1263) and the poets Dante, Petrarch, Boccaccio, and Zanobi da Strada (1312–61). It was to be "an eminent, magnificent, and honorable sepulcher, decorated with marble sculptures and other ornaments, as would befit the honor of the city of Florence and the fame and virtue of such men... for their perpetual fame and celebrated memory and those of the city and republic of Florence."

The idea of replacing the old monument to Piero Farnese and pairing it with the new one to Hawkwood was novel and reflects the desire to establish a tradition and collectivize the idea of the military hero. In the monument for the literary figures, this tendency to collectivization was carried to the point of merger. Not only were the individuals to be honored in a communal tomb but the monument testified implicitly, at least, to something like the native genius of Florence. This idea, after all, is very much in the spirit of the series of biographies of famous Florentines — the first of its kind — written 1395-96 by Salutati's friend, Filippo Villani (c. 1325-c. 1405).[10] Within a period of three years, in sum, monuments had been decreed for no less than eight heroes, two military, one religious, one jurist, and four poets. It is clear that Salutati's conception of the cathedral, if indeed he was

109

Fig. 5.1 (above). *Sarcophagus of Piero Farnese, 1367. Museo dell'Opera del Duomo, Florence.*
Fig. 5.2 (below). *Engraving of the Monument of Pietro Farnese, formerly in the Duomo of Florence.*

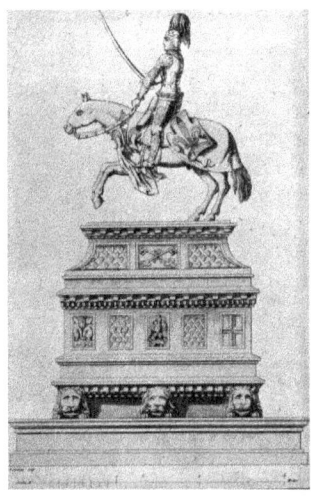

responsible, foreshadowed the later use of the Pantheon as a hallowed place to honor illustrious citizens from all walks of life, a counterpart in the religious sphere to the civic evocation in the town hall.

None of these projects was carried out as intended, and the documents give no clear picture of the form the memorials were to take, except that the military heroes were certainly to be portrayed as equestrians. The original monument of Piero Farnese (of 1367) had been, as far as I can discover, the first tomb honoring a modern military hero erected by public decree. It was preserved until the nineteenth century and parts of it still exist [Fig. 5.1]. The monument included above the sarcophagus a portrayal of Farnese in impermanent material — wood or tow or papier maché — and gilded [Fig. 5.2]. He was shown

CHAPTER 5 EQUESTRIAN MONUMENTS

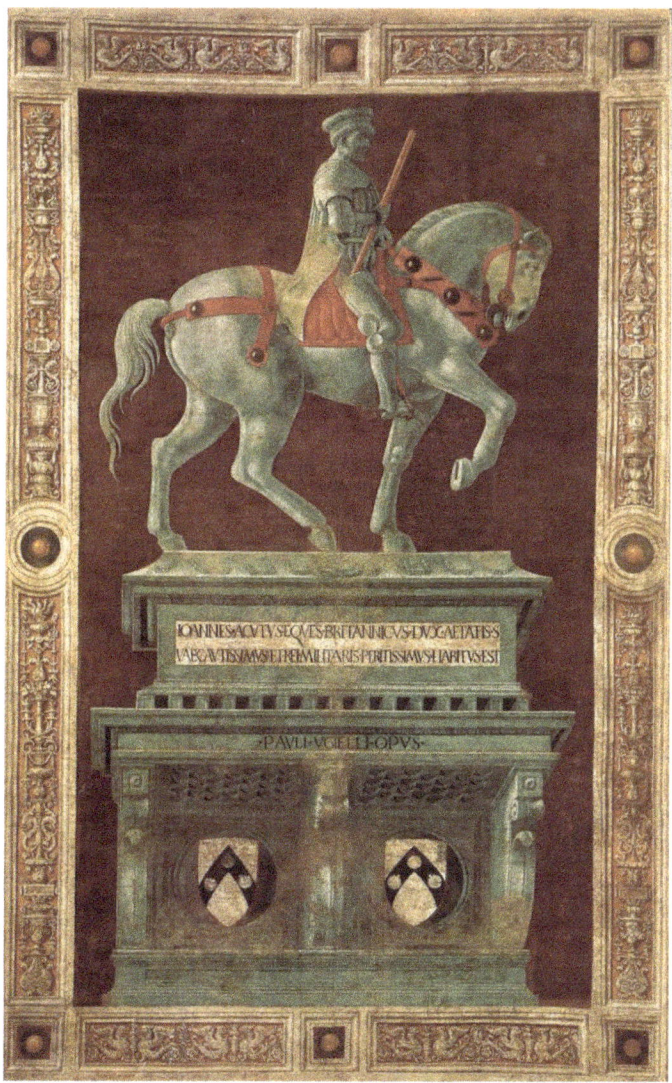

Fig. 5.3. Paolo Uccello, Equestrian Monument to John Hawkwood. Fresco, 1436. Duomo, Florence.

charging forward into battle mounted on a mule, in recollection of an episode of his heroism in the war with Pisa.

The project to pair the monument of Farnese with one for John Hawkwood languished, but in 1433 the idea for the Hawkwood monument was revived, and a new era in the history of figurated memory began. The overseers of the cathedral announced a competition for a model or design for the tomb that had been decreed in 1393.[11] Three years later in May 1436, Paolo Uccello (1397–1475) was ordered to paint Hawkwood on the wall where he had been portrayed before. The work was to be executed in *terra verde*, a greenish monochrome technique akin to grisaille, but suggestive of patinated bronze, rather than marble.[12] In June the *capomaestro* of the cathedral was ordered to destroy the horse and rider because it was not painted as was fitting. Two weeks later Uccello was ordered to repaint them; and six weeks later he was paid for both versions of the work, the original as well as the replacement [Fig. 5.3]. The fact that Uccello was paid for both versions suggests that the remake was not occasioned by a failure on the artist's part, as is usually assumed, but rather by some more appropriate idea of the work that had supervened. Finally, in December 1436, it was decided that the letters at the bottom of the monument be revised or replaced (*reactentur*).[13]

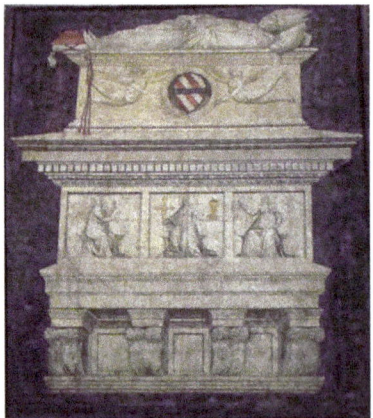

Fig. 5.4. Bicci di Lorenzo, *Cenotaph of Cardinal Corsini*. Detached fresco, c.1422. Duomo, Florence.

Uccello's mural follows two late medieval traditions for honorific tombs: that of portraying a military leader as an equestrian effigy atop his sarcophagus, and that of imitating an actual memorial in fresco. The latter idea may have begun as a temporary measure, the mural design serving as a model or tryout for a sculptured version. But by this time the grisaille imitation had surely already come to be conceived as the

CHAPTER 5 ❧ EQUESTRIAN MONUMENTS

memorial itself, as was the case with the monument of Cardinal Pietro Corsini in the cathedral of about 1422 [Fig. 5.4].[14] It was not simply an inexpensive substitute but merged the idea of a tomb with that of an honorific painting. At least two such painted tributes to condottieri are recorded in Siena, one a panel painting of Giovanni Pietramala, placed above the inside central portal of the cathedral. The painting was decreed following Pietramala's death in 1344 and showed him in full armor on a charging horse brandishing his sword. After the death in 1390 of Giovanni degli Ubaldini, who fought for Siena against Florence, his services for the city were recognized by a panel painting of him in full armor on horseback, also placed in the cathedral of Siena, in the chapel of S. Savino.[15] Uccello's use of *terra verde* to suggest bronze marked a bold departure from the medieval figures, which were gilded. Uccello was surely here evoking the classical tradition of bronze as the medium, par excellence, for equestrian monuments. Ancient equestrian figures were also gilt, of course, as many written sources attest. Uccello was therefore alluding to a classical sculpture in its "modern" state, i.e., ungilded and patinated.

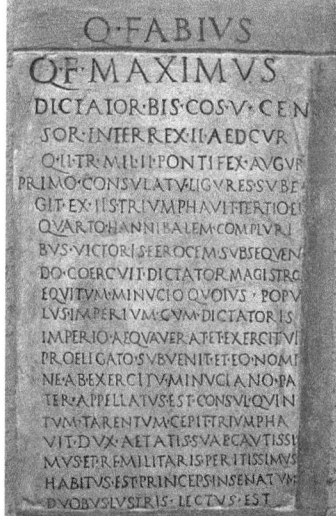

Fig. 5.5. *Inscription to Q. Fabius Maximus, after 209 CE. Museo Archeologico Nazionale, Florence.*

This suggestion of an antique bronze monument may be related to another extraordinary feature of Uccello's fresco, the inscription of the sarcophagus. It has been known at least since the eighteenth century that Uccello's text echoes that of a famous inscription eulogizing the great Roman general Q. Fabius Maximus (c. 280–203 BCE), who defeated Hannibal. The inscription, which still exists in the Archeological Museum in Florence [Fig. 5.5], was found in Arezzo, one of a series that reproduced a much

113

more famous series of elogia accompanying portrait statues erected by Augustus in his forum in Rome.[16] Suetonius (69–c.135 CE), Ovid (43 BCE–17/18 CE), and other ancient sources describe the forum, where Augustus (63 BCE–14 CE) honored the great men of the republic on one side and his own family on the other.

It can scarcely be coincidence that in 1436, the same year the final version of Uccello's monument was carried out, Plutarch's life of Fabius was translated into Latin in Florence. Plutarch (45–127 CE) records that a bronze equestrian statue honoring Fabius had been erected on the Capitol. Taken in conjunction with the previous series of monuments to be erected in the cathedral at public expense, it is evident that the cathedral was being thought of as a modern equivalent of those ancient precincts, temples or fora, in which the venerable heroes of local history were to be recalled as a matter of civic pride. No ancient precinct, however, contained the kind of professional mixture, from military heroes to poets, or the focus on modern heroes, that is apparent at Florence.

Particular interest attaches to the phrase from the long eulogy of Fabius selected for application to Hawkwood. The passage isolates above all the man's intellectual gifts. He is described as *dux aetatis suae cautissimus et rei militaris peritissimus:* the cleverest leader of his time and the most expert in military matters. The ancient inscription corresponds in an astonishing way to the phraseology that occurs in a vernacular *cantare* or verse song describing Hawkwood's funeral in 1393:

messer Giovanni Aguto, capitano franco, che'l baston teveva della giente dell'arme savio e astuto, del comun' di Firenze per volere la città sempre a libertà tenere.	To Mr. John Hawkwood Bold Captain who, wise and astute, held the Commander's Baton for the Commune of Florence, in fulfillment of that city's wish to remain always free.[17]

It would almost seem that the key words, *savio e astuto*, had found their fulfillment in the ancient inscription, the discovery of which — if one could only determine the exact date — might even prove to

CHAPTER 5 ❧ EQUESTRIAN MONUMENTS

Fig. 5.6. Paolo Uccello, Drawing for the Hawkwood Monument, c.1436. Gabinetto dei Disegni e delle Stampe, Galleria degli Uffizi, Florence.

have been the occasion for the repainting of Uccello's original inscription, perhaps even the repainting of the equestrian figure, as well.

We have no inkling of what Uccello's first version was like, but the fresco as we know it seems very much to embody, both in its own design and in the way it portrays the sitter, the qualities of knowledge and astuteness praised in both the ancient and the modern texts. I will not comment on the introduction and knowing transformation of classical motifs: in the architecture of the support, which approximates the late medieval type of wall tomb; in the marriage of ancient and gothic epigraphical forms in the inscriptions; in the use of *terra verde* to suggest bronze not only for the statue, but, unlike any classical monument, for the base, as well.

I do want to emphasize three equally knowing and astute innovations in the fresco that testify to a new purpose. The Hawkwood monument is the first documented instance we have of a new way of planning and executing monumental murals, namely, by means of a system of squaring that permitted precise enlargement and transfer to the wall (traces of the squares are still visible on the surface) from a preparatory drawing, still preserved in the Uffizi [Fig. 5.6].[18] Uccello's achievement on the wall of Florence Cathedral was planned, calculated and executed with the same kind of astuteness and ingenuity as were Hawkwood's achievements on the battlefield. What all this premeditation produced is an extraordinarily subtle spatial skew in

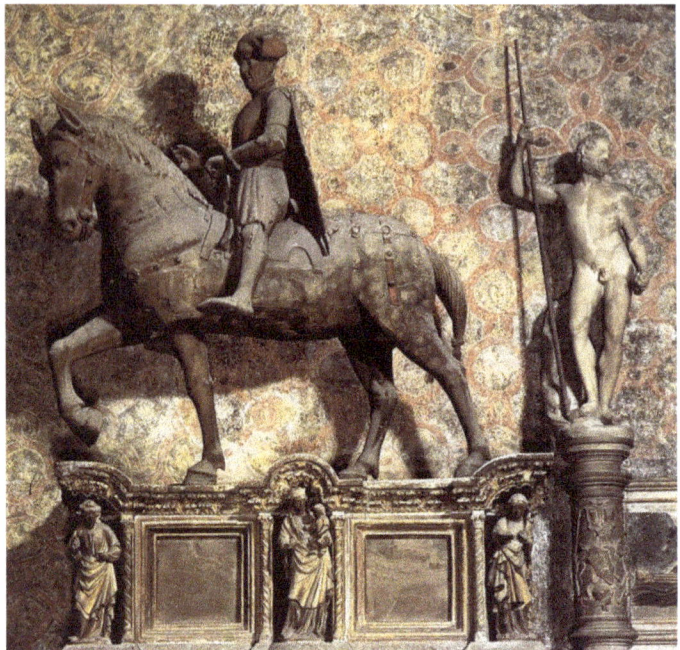

Fig. 5.7. Tomb of Paolo Savelli (d.1405). Sta. Maria dei Frari, Venice.

which the perspective angle, starting from the base shown from below and behind to augment the forward thrust of the gait, diminishes as the eye rises to the pure, immobile, iconic profile of the head.

Furthermore, the animal itself is of an altogether new breed, larger than the classical horse and far heavier than the lithe and graceful beasts of recent Gothic tradition [Fig. 5.7, c.1405]. It is well known that more powerful breeds than had occurred in antiquity were required to carry the full suit of armor worn by a medieval knight, and they appear in certain equestrian figures of the early fourteenth century [Fig. 5.8].[19] But none compare with Uccello's massive, arched-necked, high-stepping stallion.

The animal's gait is in fact the third major innovation I want to mention. Although the original 1393 plan for a Hawkwood

CHAPTER 5 ❧ EQUESTRIAN MONUMENTS

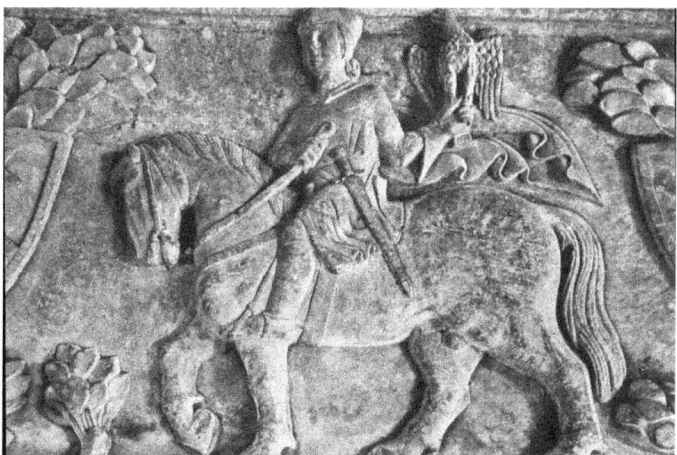

Fig. 5.8. Veronese Sculptor, Tomb of the Scotti-Gonzaga family. An Equestrian Knight Holding a Falcon (detail of relief on sarcophagus lid, Veronese breccia, c.1300. S. Giovanni in Canale, Piacenza.

monument was linked to that of Piero Farnese, this relationship was evidently no longer a consideration for Uccello; at least, he certainly rejected the prototype of the charging animal in favor of a slow, ceremonial gait inherited from antiquity and adopted for many depictions of horsemen including tomb monuments, in the Middle Ages. The gait of Uccello's horse, however, is subtly but fundamentally different from any of its predecessors in equestrian monuments, in that the right hind leg is raised so that the coffin joint is bent and the hoof is tilted off the ground.[20] Since the raised hind leg is on the same side as the raised foreleg, the gait is in effect a pace, in which two lateral legs move together — as distinguished from the trot, in which the diagonal legs move together, or the walk, in which two hind and one foreleg are on the ground. The point is that the gait of Uccello's horse is unstable, a point that was already noted, and criticized, by the ever vigilant Vasari:

> If Paulo had not represented the horse as moving his legs on one side only — something horses do not do naturally because they would fall — the work would be perfect. The error was probably due to the fact that he could not ride, and had no practical knowledge of horses as of other animals.[21]

117

Fig. 5.9 (above). Pirro Ligorio, Drawing of a Roman Equestrian Tomb. Sketchbook. Naples, Biblioteca Nazionale, MS XIII.B.B., 301.
Fig. 5.10 (below). Attributed to Pol de Limburg, Medallion of Constantine on Horseback. Copper alloy, 9.3 cm diam., c.1407. New York, The Metropolitan Museum of Art, acc. no. 1988.133.

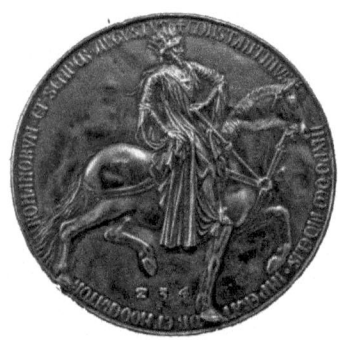

Vasari was right, of course; the animal can do it in emergencies or if he is forced by the trainer, but the pace is not a natural gait in the horse, and it had not, I repeat, previously been used in equestrian monuments, although it had occurred in narrative scenes. Interestingly enough, the eminent sixteenth-century antiquarian Pirro Ligorio (1514–83) made exactly the same criticism of the depiction in relief of an equestrian figure on a Roman tombstone, of which he provided a sketch in one of his manuscripts devoted to the recording of classical inscriptions [Fig. 5.9].[22] However, I suspect that what Uccello actually had in mind was the magnificent, mysterious equestrian medallion of Constantine the Great, made in Paris about 1400 and widely assumed to be an ancient work [Fig. 5.10].[23] If the Constantine medallion were taken as depicting an equestrian monument, it might have offered

CHAPTER 5 ⚜ EQUESTRIAN MONUMENTS

Fig. 5.11. *Nebuchadnezzar Commanding the Three Youths to Worship his Image*, sarcophagus of St. Ambrose, 4th c. CE. Sant'Ambrogio, Milan.

Uccello the authorization he needed to provide his rider with a gigantic, volatile, inherently unstable mount — just the right sort of super-horse to be effortlessly dominated and led by a *cautissimus* and *peritissimus condottiere*. The great innovations in Uccello's image — the spatial system converging on the head, the oversize, Herculean horse, the horse unable to stand on its own two feet — all these devices conspire to pay homage to the wondrous achievements of human knowledge and intelligence.

Uccello's Hawkwood remains first and foremost a tomb-monument, inside the church and attached to a wall. The alternative implication of this observation — the possibility of an exterior, public, non-funereal equestrian commemoration — was not drawn at Florence. We tend to overlook that fact, owing no doubt to the leading role Florentine artists played in the development of the genre outside their native city. Florence was a republic through this period, and although it was eager to honor its leading citizens, there were limits. To understand fully this diffidence with respect to public, monumental exaltation of ordinary mortals, two points should be borne in mind. By far the most familiar form of public portraiture in antiquity was the sculptured image on a base, which isolated the individual and set him above ordinary human beings. I remind you of the peculiar "magic" of portraiture, an effect achieved in the case of the Renaissance bust mainly by its shape. In the classical tradition, however, the bust accounts for only half the effect: the other half is due to the base. The potency of the statuary base or pedestal was eminently clear to the early Christians, who associated it — quite rightly — with idolatry in general, and with the imperial cult in particular: the pedestal was an integral part of the semi-divine portrait-image [Fig. 5.11]. From the beginning therefore, Christians went about literally knocking people off their pedestals. Conversely, the standard

119

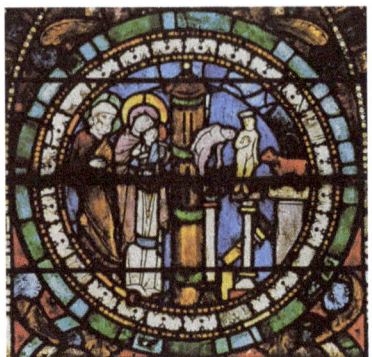

Fig. 5.12. *Holy Family in Egypt with Falling Idols and Broken Column*, stained glass, c.1295. S. Francesco, Assisi.

way of representing paganism was the statue on a base, especially a base in the shape of a column, which was the most supercharged form of physical elevation and exaltation [Fig. 5.12].

The second most potent form of elevation and exaltation was, of course, the horse, whose unique combination of strength, maneuverability, and intelligence was thought of as somehow superhuman and made that animal the most awesome extension of the human. In a number of medieval towns, in fact, a classical equestrian monument on a pedestal, whether preserved or remembered, was regarded virtually as an emblem of the city's pagan past [Fig. 5.13].

Fig. 5.13. Giovanni Villani, *Istoria Fiorentina*, mid-14th c. Rome, Biblioteca Apostolica Vaticana, Ms. Chigi L. VIII, 296, fol. 70r.

CHAPTER 5 ≈ EQUESTRIAN MONUMENTS

Fig. 5.14 (above). Attributed to Benedetto Antelami, Equestrian Oldrado da Tresseno, 1233. Palazzo della Ragione, Milan.
Fig. 5.15a–b. (below, left, right) Bonino da Campione, Tomb of Cansignorio della Scala, d.1387. Sta. Maria Antica, Verona.

The constraints imposed by these associations were less acutely felt in other city-states than Florence, especially those where the democratic tradition of the medieval communes was subverted to the rule of signorial tyrants. The difference was reflected in two notable developments in northern Italy in the later Middle Ages. There was a tradition of non-funereal, public equestrian commemorations attached to secular buildings. Still preserved on the facade of the Communal Palace

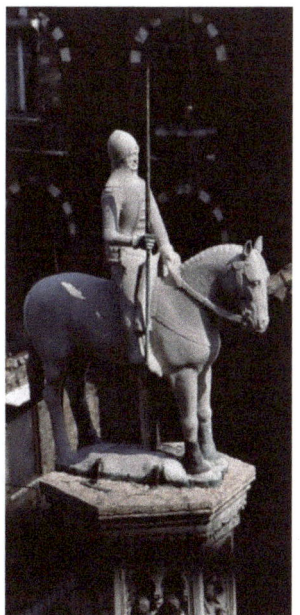

121

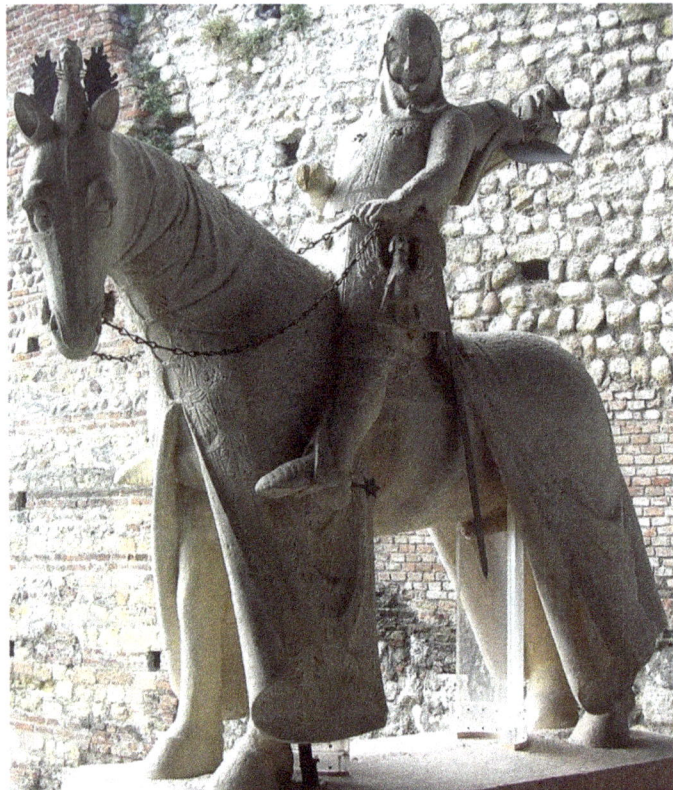

Fig. 5.16. *Cangrande della Scala, d.1329. Removed from top of his tomb, Sta. Maria Antica, Museo di Castelvecchio, Verona.*

(Palazzo della Ragione) in Milan is the equestrian figure of Oldrado da Tresseno, attributed to the great Lombard sculptor Benedetto Antelami (c.1150–after 1233, Fig. 5.14). An inscription, dated 1233, when Oldrado became podestà of Milan, records that the sculpture was made to commemorate his construction of the building, as well as his role as defender of the faith.[24] What might be called an equal and opposite tradition emerged around 1300 at Verona, where the Scaliger family reigned. The Scaliger commissioned the first free-standing equestrian monuments since antiquity, appropriating the imperial associations of the type to

CHAPTER 5 ❧ EQUESTRIAN MONUMENTS

their assertion of dynastic rule [Figs. 5.15–16]. These structures were specifically tombs, however, not honorific monuments. The pedestals included the sarcophagi and they stood on hallowed ground in the cemetery next to the parish church of the Scaliger family, Sta. Maria Antica.[25] In the former tradition, therefore, the equestrian monument was divorced from the tomb; in the latter, it was divorced from the building; and in both cases, the significance of the monument reached beyond sheer military prowess to the domain of civic leadership.[26]

Aspects of these traditions may be discerned at the end of the fourteenth century at Ferrara, where the commune honored the founder of the modern d'Este dynasty, Alberto (1347–93), with a standing portrait relief on the facade of the cathedral, dated 1393 [Fig. 5.17]. Unlike the north Italian antecedents, however, the relief shows Alberto dressed as a humble pilgrim. An accompanying inscription refers to his visit to Rome for a jubilee when he negotiated important concessions for the city in return for his allegiance to the papal cause against Milan.[27] Alberto is thus not portrayed as a ruler but is commemorated for his political achievement, under the aspect of his piety.

Fig. 5.17. Portrait relief of Alberto d'Este, 1393. Facade, Cathedral, Ferrara.

The convergence of traditions that seems to have taken place at Ferrara culminated there just before the middle of the fifteenth century, when two Florentine sculptors produced the first purely honorific, i.e., non-funerary, equestrian statue on a pedestal reaching to the ground since antiquity. In 1443 Antonio di Cristoforo and Niccolò Baroncelli (fl. 1434–53) won a competition for an equestrian statue honoring Niccolò III

Fig. 5.18 (L). [Reconstruction] Antonio di Cristoforo and Niccolo Baroncelli, Arch and Equestrian Statue of Niccolò III d'Este, 1443. Facade, Palazzo Ducale (now Palazzo Municipale), Ferrara.
Fig. 5.19 (R). Facade of Palazzo Ducale, Ferrara, with Equestrian Monument of Niccolò III d'Este. Woodcut, detail. Biblioteca Estense, Modena.

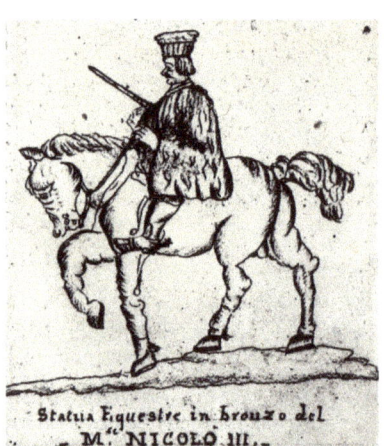

Fig. 5.20. Drawing of Bronze Equestrian Statue of Niccolò III d'Este, c.1443. Unpublished, Coll. Angelo Bargellesi-Severi, Ferrara.

d'Este, the father of the then reigning Marchese Leonello [Figs. 5.18–19]. The monument was commissioned officially by the Savi, the wise men of the city, two years after Niccolò's death. The competition was judged, at Leonello's behest, by Leon Battista Alberti (1404–72), the great Florentine humanist, art theoretician, and architect who was then visiting Ferrara. The document awarding the commission stipulated that the statue was to be made of bronze and was to be placed in the town square *(apponenda in foro)*. The visual records of the original monument are scant and crude, but they suffice to indicate its main features [Fig. 5.20].[28] Niccolò was shown

CHAPTER 5 EQUESTRIAN MONUMENTS

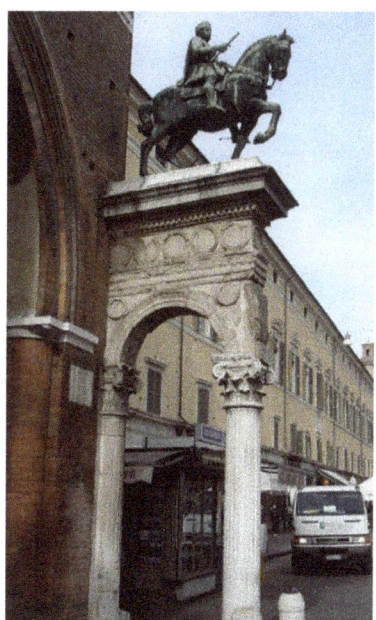

Fig. 5.21. *Pedestal, attributed here to Leon Battista Alberti, c.1451. Facade of Palazzo Ducale, Ferrara.*

with the regalia of the office of condottiere: the *berretto* or cap, a great cape, and the commander's baton. The animal was shown in the customary walk. The sculpture was placed on an architectural pedestal attached to the building, protruding into the piazza from beside the entrance to the Palazzo Ducale (now Palazzo Municipale, Fig. 5.21]. Completed in 1451 under Borso d'Este (1413–71), who succeeded his brother Leonello, the work remained intact until 1776, when the statue was melted down for canon during the Napoleonic occupation. The equestrian group was replaced by a reconstruction in modern times.[29]

The Ferrara monument was thus twice revolutionary: it was both the first monumental bronze equestrian group since antiquity, and it was the first non-funereal equestrian monument since antiquity with a pedestal reaching to the ground in a public place. There must have been a master mind behind it, and to my mind this can only have been Alberti's. Alberti has often been credited with designing the pedestal, the details of which have many echoes in his subsequent work at the Tempio Malatestiano (S. Francesco) in Rimini.[30] We know of his involvement from a short treatise he wrote on the theory and practice of breeding and training horses. In the dedicatory letter to Leonello he says he wrote the treatise, having become interested in the subject as a result of his being commanded by the prince to judge the competition. There is, I believe, a highly

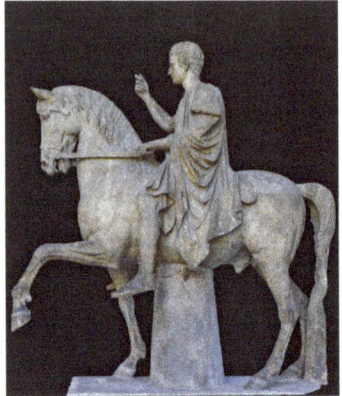 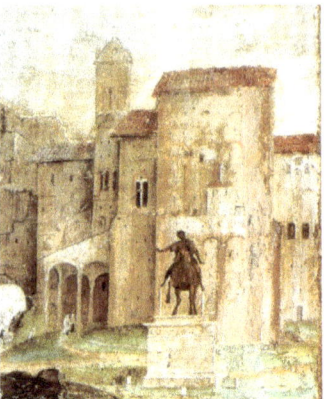

Fig. 5.22a (L). Equestrian statue of Marcus Nonius Balbus the Younger, from Herculanum forum. Marble, c.50 CE. Museo Archeologico Nazionale, Naples.
Fig. 5.22b (R). Filippino Lippi, Statue of Marcus Aurelius, detail of fresco, 1488–93. Carafa Chapel, Sta. Maria sopra Minerva, Rome.

significant coincidence in the fact that the same phrase — *in foro ponenda* — occurs in Alberti's dedicatory letter as had occurred in the document of 1443 awarding the commission.

The pedestal is normally considered in terms of its classicizing details — hesitation has even been expressed on the attribution because many motifs are "improperly" proportioned or juxtaposed. In fact, the structure combines several classes of prototypes into an extraordinary, new conception that is ultimately *sui generis*. By and large, ancient equestrian monuments might be grouped thematically in two categories: on the one hand "senatorial" or "equestrian" (in reference to the military order — *eques*), and on the other, imperial. Monuments of the former sort were placed on relatively low, rectangular statuary bases, whereas imperial monuments had high architectural supports: one or even two monumental columns, or a triumphal arch [Figs. 5.22a–b].[31] Alberti's base, which includes two columns, an arch, and an entablature, clearly alludes to the triumphal arch type, as we will see on certain Roman imperial coins. But it is equally clear that great care has been taken to differentiate the d'Este from the ancient model where, in proper classical fashion, the columns are

CHAPTER 5 ⚜ EQUESTRIAN MONUMENTS

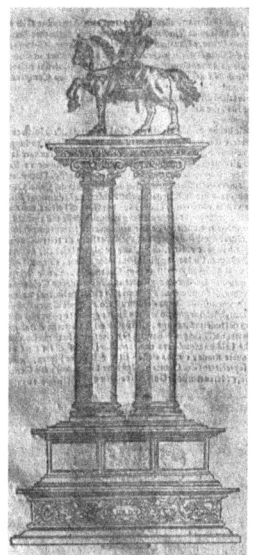

Fig. 5.23. Equestrian Monument of Ercole I, d'Este. 17th-century woodcut copy of design. (After Maresti).

attached to the piers supporting the arch. At Ferrara, in true medieval fashion, the columns support the arch — except at the front where the column also supports the entablature, and at the back where it is attached to the wall. We are not dealing simply with a legacy of the medieval system of supporting arches on columns, however. As I mentioned, equestrian statues were placed on paired columns in antiquity; and in 1496, the next generation at Ferrara planned a colossal monument to Ercole I that would have recapitulated this type [Fig. 5.23].[32] Hence it might be said that the medieval system offered Alberti a way, literally and deliberately, to fuse the triumphal arch with the double-columned pedestal types.

There is much more still in Alberti's reorientation of tradition. Classical equestrian monuments might be said to have been oriented in two, opposite, ways — not diametrically opposed, but opposed at 90 degrees. In the low, statuary type, the inscription was normally placed on the short side of the base toward which the horse and rider faced. In the architectural type, inscriptions were placed on the long sides of the pedestal. Alberti evidently understood this difference and merged the two alternatives by placing the inscription on the short, rather than the long, side of the arch. The reason, clearly, is that he wanted to turn the axis of the traditional medieval group from parallel to perpendicular to the wall, and so to establish the relative independence of the d'Este monument. Relative independence, I say, because the back of the pedestal is attached to the wall; or rather, its forms are only half visible and, like the early Renaissance portrait busts without bases, seem literally to emerge from the wall. This link to the fabric of the building may be seen as

127

Fig. 5.24 (L). Arnolfo di Cambio, Ciborium, c.1300. Sta. Cecilia in Trastevere, Rome.
Fig. 5.25 (R). Detail.
Fig. 5.26 (below). Arch of the Money Changers, 4th century; incorporated into S. Giorgio in Velabro, Rome, in the 7th century.

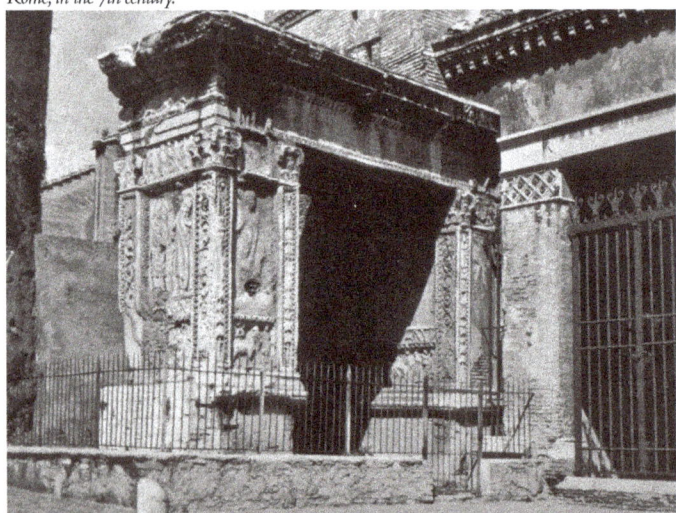

CHAPTER 5 ⁂ EQUESTRIAN MONUMENTS

an analogue of the critical phase in the emergence of the modern individual self from the corporate identity of the Middle Ages. Oddly enough, Alberti's arrangement may have been a compilation of two extraordinary precedents, one medieval, the other what might be called "pseudo-antique." Around 1300 Arnolfo di Cambio placed a frontal figure of an equestrian saint in a corner niche high up on his altar ciborium [Figs. 5.24–25] in the church of Sta. Cecilia in Trastevere, Rome. The figure, however, only half emerges from the architecture.[33] It also is possible that Alberti thought there was authority for his design in classical antiquity: one end of the Arch of the Money-Changers in Rome had been incorporated in the Middle Ages into the facade of the church of S. Giorgio in Velabro [Fig. 26], and Alberti saw it as we see it today.[34] Yet, such an arrangement is grotesque in terms of the classical vocabulary of design, and would only have been deliberately adopted as the base for a statue by someone to whom, whether consciously or not, a free-standing effigy, mounted on a pedestal reaching to the ground, still had an odor of brimstone.

Nevertheless, the design was an act of aggressive imposition upon the city; physically as well as metaphorically it bridges the gap between the closed fabric of the d'Este's private domain, and the public square of the people of Ferrara. Ideologically speaking, this exact point is made in the inscription once legible on the front of the pedestal:

THE REPUBLIC OF FERRARA DEDICATED TO THE SON OF ALBERTO, THE MARCHESE NICCOLÒ, THRICE BRINGER OF PEACE TO ITALY, [THIS MONUMENT], COMPLETED AT THE BEHEST OF THE BROTHER AND SUCCESSOR TO THE MARCHESE LEONELLO.[35]

The conundrum created by this miraculously worded text expresses the convergence of the body politic of Ferrara and the entire sequence of d'Estes, from Alberto the founder of their current hegemony, to the reigning Borso.

An equally penetrating glimpse into the nature of the monument is provided by the work that must have been its chief progenitor. This is the equestrian monument that appears on the coinage of the

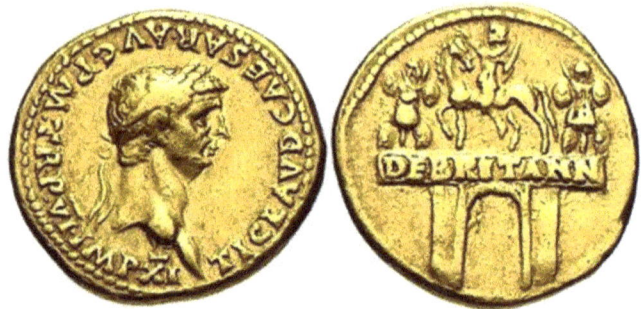

Fig. 5.27. Aureus of Claudius (10 BCE–54 CE), with Monument to Drusus.

emperor Claudius [Fig. 5.27]. It is one of those very rare instances when an ancient monument is known both from visual and from literary sources. It is, so far as I know, the only ancient depiction of an equestrian statue with a triumphal arch as its pedestal, which pedestal consists moreover of two columns, and an arch with an entablature. What the coins celebrate is a famous monument described in Suetonius' life of Claudius: dedicated by the Senate of Rome to Augustus's adoptive son, Drusus, in 41 CE, shortly after Drusus' grateful son, Emperor Claudius, began his reign.[36] Drusus, incidentally, was one of the members of Augustus' family whom the emperor had commemorated in his forum, along with Fabius Maximus, whose inscription had been appropriated by Uccello for John Hawkwood. The circumstances must have seemed

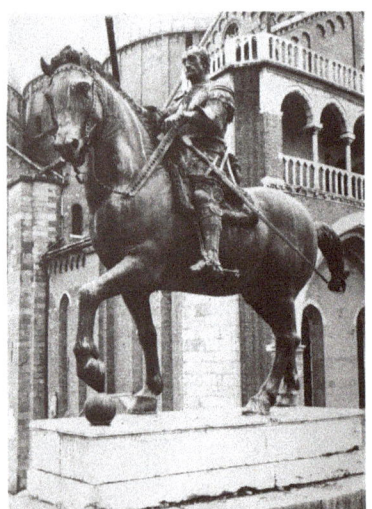

Fig. 5.28. Donatello, The Gattamelata Equestrian Monument. Bronze, 1447–53. Piazza del Santo, Padua.

CHAPTER 5 ❧ EQUESTRIAN MONUMENTS

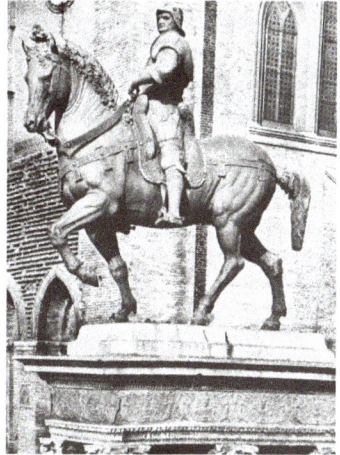 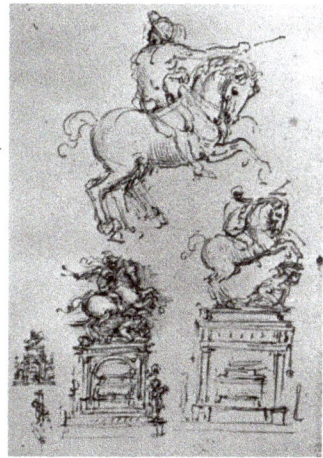

Fig. 5.29 (L). Andrea del Verrocchio, The Colleoni Equestrian Monument. Bronze, formerly gilded, Istrian marble base, 1480–96. Campo di SS. Giovanni e Paolo, Venice.
Fig. 5.30 (R). Leonardo da Vinci, drawings for Trivulzio Monument. Pen and ink, 1503. Windsor Castle.

made in heaven for application to those at Ferrara where, as I suspect, Alberti was moved to think about one man's dominion over other people, just as he had been moved to think about the human's dominion over the horse.

The first completely free-standing equestrian monument was, of course, the Gattamelata of Donatello, commissioned after the d'Este monument and completed before it [Fig. 5.28]. But the subsequent history of the Indomitable Horseman in the Renaissance, those by Verrocchio and Leonardo [Figs. 5.29–30], is so well known that I feel I can stop here and presume on your familiarity with the rest of the story.

I realize I have also presumed on your patience by, once again, considering largely of works of art that no longer exist. I promise that in my next and last essay, everything I discuss is still to be seen and admired on your next trip to Italy.

NOTES

1. This essay has not previously been published.

2. Ronald G. Witt, *Hercules at the Crossroads: The Life, Works, and Thought of Coluccio Salutati* (Durham, NC: Duke University Press, 1983); D. De Rosa, *Coluccio Salutati: Il cancelliere e il pensatore politico* (Rome: Aracne, 2014).

3. C. Francini, ed., *Palazzo Vecchio: Officina di opere e di ingegni* (Milan: Cinisello Balsamo, 2006).

4. Dante, Petrarch, and Boccaccio are well-known. For Zanobi da Strada, see Giacomo Ferraú, "Zanobi da Strada," *Enciclopedia Dantesca* (1970), online at http://www.treccani.it/enciclopedia/zanobi-da-strada_(Enciclopedia-Dantesca); Giuseppe Billanovich, "Petrarca, Boccaccio e Zanobi da Strada," in *Petrarca e il primo umanesimo* (Padua: Antenore, 1996), 158–67; and *Marco Tullio Cicerone: Il sogno di Scipione*, G. Solaro, ed., L. Canfora, intro. (Palermo: Sellerio, 2008).

5. C. Pfisterer Bissolotti, *Claudius Claudianus: L'epitalamio per Palladio e Celerina. Commento a carm. min. 25* (Frankfurt-am-Main: Peter Lang, 2017).

6. G. Vico, *Principj di una Scienza nuova*, P. Cristofolini, ed. (Pisa: Edizioni ETS, 2016), book III.

7. Hinks, *Myth and Allegory in Ancient Art*.

8. W. Caferro, *John Hawkwood, An English Mercenary in Fourteenth-Century Italy* (Baltimore, MD: Johns Hopkins University Press, 2006); S. Cooper, *Sir John Hawkwood* (Barnsley: Pen & Sword Military, 2008). Decorative frame added by Lorenzo di Credi in 1524.

9. See https://www.treccani.it/enciclopedia/pietro-farnese_(Dizionario-Biografico)..

10. Philippi Villani, *De origine civitatis Florentie et de eiusdem famosis civibus*, G. Tanturli, ed. (Padua: Antenore, 1997); Vicenzo Borghini, *Annotazioni sopra Giovanni Villani*, R. Drusi, ed. (Florence: L'Accademia della Crusca, 2001).

11. T. Verdon and A. Innocenti, ed., *Atti del VII centenario del Duomo di Firenze*, 3 vols. (Florence: Edifir, 2001).

12. M. Minardi, *Paolo Uccello* (Milan: 24 ore cultura, 2017).

13. See below note 17 for references.

14. By Bicci di Lorenzo, *"affresco staccato."*

15. J. Temple-Leader and G. Marcotti, *Sir John Hawkwood (L'Acuto): Story of a*

CHAPTER 5 ❧ EQUESTRIAN MONUMENTS

Condottiere, L. Scott, trans. (London: T. Fisher Unwin, 1889).

16. P. Zanker, *Il Foro di Augusto* (Rome: Fratelli Palombi Editori), 15–17.

17. Cafferro, *John Hawkwood*, 9-10; H. Hudson, "The Politics of War: Paolo Uccello's Equestrian Monument for Sir John Hawkwood in the Cathedral of Florence," *Paragone* 23 (2006): 1–33.

18. Silverpoint, white, and light green; 91 x 46 cm; Gabinetto dei Disegni e delle Stampe, Galleria degli Uffizi, Florence. Notable first use of over-lay grid to facilitate transfer from drawing to painting. See L. Melli, "Nuove indagini sui disegni di Paolo Uccello agli Uffizi: Disegno sottostante, tecnica, funzione," *Mitteilungen des Kunsthistorischen Institutes in Florenz* 42.1 (1998): 1-39. I thank Jack Freiberg for this reference.

19. Tomb of the Scotti Gonzaga family; relief on the lid by unknown Veronese sculptor, Mounted Knight holding a Falcon, c. 1300, S. Giovanni in Canale, Piacenza.

20. Best known horses of the late medieval period were destrier, heavy and strong enough to carry armor. There were also smaller breeds known as coursers and rounceys. The common term in English was "charger." The natural gaits are: walk, pace (2 rights together, left together; hard to right); trot (diagonal, 2 beat) (posting), canter, and gallop (faster, 4-beat canter). Learned gaits are: rack and running walk (head nods).

21. "La quale opera fu tenuta et è ancora cosa bellissima per pittura di quella sorte; e se Paulo non avesse fatto che quel cavallo muove le gambe da una banda sola, il che naturalmente i cavagli non fanno perché cascherebbano." See: https://it.wikisource.org/wiki/Le_vite_de%27_pi%C3%B9_eccellenti_pittori,_scultori_e_architettori_(1568)/Paulo_Uccello (Vasari, *Lives*, 1568).

22. Sketchbook. Naples, Biblioteca Nazionale, MS XIII.B.B., 301; Pirro Ligorio, *Libro delle iscrizioni dei sepolcri antichi*, S. Orlandi, ed. (Rome: De Luca, 2009).

23. R. Weiss, "The Medieval Medallions of Constantine and Heraclius," *The Numismatic Chronicle and Journal of the Royal Numismatic Society*, ser. 7.3 (1963): 129–44.

24. Oldrado da Tresseno was known for the law of 1228 that prescribed the burning of heretics. The inscription below the equestrian speaks of the application of the law on Cathars in 1233.

25. E. Napione, *Le arche scaligere di Verona* (Turin: U. Allemandi, 2009).

26. See P. Seiler, *Mittelalterliche Reitermonuments in Italien: Studien zu Personalen Monumentsetzungen in den italienishchen Kommunen und Signorien des 13. und 14. Jahrhunderts* (Heidelberg: University of Heidelberg, 1989), 172–214; idem, "Untersuchungen zur Entstehungsgeschichte des Grabmals von Cangrande I. della Scala," *Marburger Jahrbuch für Kunstwissenschaft* 25 (1998): 53–77; idem, "Das Lächeln des Cangrande della Scala," *Zeitschrift für Kunstgeschichte* 62.1 (1999): 136–43.

27. Alberto d'Este (Antonio Menniti Ippolito, d'Este, Alberto V), in *Dizionario Biografico degli Italiani* 43 (Rome: DBI, 1993), 295–97.

28. Drawing of Bronze Equestrian Statue of Niccolò III d'Este, unpublished. Coll. Angelo Bargellesi-Severi, Ferrara (kindly brought to my attention by Maestro Adriano Franceschini, Ferrara).

29. F. Borsi and S. Borsi, *Alberti: Une biographie intellectuelle,* H. Damisch, preface; K. Bienvenu and S. Rabau, trans. (Paris: Hazan, 2006).

30. M. Musmeci, ed., *Templum mirabile:Atti del convegno sulTempio Malatestiano, Rimini, Palazzo Buonadrata 21/22 settembre 2001* (Rimini: Fondazione Cassa di risparmio di Rimini, 2003).

31. See the references in H.W. Janson's essential article, "The Equestrian Monument from Can Grande della Scala to Peter the Great," reprinted in H.W. Janson, *Sixteen Essays,* Patricia Egan, ed. (New York: Abrams, 1974), 157–88, esp. 160 and fig. 4.

32. J. Manca, "The Presentation of a Renaissance Lord: Portraiture of Ercole d'Este, Duke of Ferrara (1471–1505)," *Zeitschrift für Kunstgeschichte* 52.4 (1989): 522–38.

33. A.M. Romanini, *Arnolfo di Cambio e lo "stil novo" del gotico italiano* (Florence: Sansoni, 1980).

34. Arch of the Money Changers. See E. Guiducci, A. Quadrini, L. Tursi, ed., *La chiesa di S. Giorgio in Velabro a Roma: Storia, documenti, testimonianze del restauro dopo l'attentato del luglio 1993* (Rome: Istituto poligrafico e Zecca dello Stato, 2002).

35. Thus the memorial was dedicated by Borso d'Este, brother of Leonello, son of Niccolò, who was the son of Alberto. Ernst Kantorowicz's classic article, "The Este Portrait by Roger van der Weyden," *Journal of the Warburg and Courtauld Institutes* 3 (1940): 165–80, follows this progression.

36. P.V. Hill, *The Monuments of Ancient Rome as Coin Types* (London: B.A. Seaby, 1989).

6. COLLECTIVE COMMEMORATION AND THE FAMILY CHAPEL

THERE HAVE BEEN two guiding principles in this series of essays so far, one explicit and positive, the other implicit and negative. In the first place, I have been concerned with the relationship between memory and the definition of the individual. In the second place, I have studiously, if not entirely, avoided tomb monuments. My reasons on this latter score are several. More study has been devoted to tombs, perhaps, than to any of the other forms of commemoration we have discussed.[1] Further, the number of tombs is so great as to make rather daunting the task of analyzing their development along the lines I have adopted. But most important is my feeling, admittedly a little arbitrary and personal, that a tomb is not in itself really a fully qualified commemorative monument, as I want to think of it: a monument intended to preserve the memory — not necessarily the body — of something more than simply the memory of a deceased person.

Nevertheless, two aspects of the development of Renaissance tomb design do seem to me of particular interest from our point of view. Obviously significant is the appropriation and adaptation of ancient tomb types and funereal symbolism. To be sure, whenever a tomb portrays mourning over the deceased, or a narrative of his life, retrospectivity is inevitably an integral part of both the content and the form. But citations of historical formulae are more than simple recollections: they are explicit puns — memory images quoted as or in memory images, reminders of remembrance, as it were. In this sense they relate the individual memorialized to a larger, historical domain of collective commemoration.

The second respect in which tombs are of special interest to us is precisely their context, because the context reveals much about how individual identities relate to one another. The study of tombs-in-context, unlike that of tombs-in-themselves, has scarcely begun. The subject holds many surprises for those guilty, as I have been so far, of thinking of the Renaissance too exclusively in terms of the rise of the self-conscious *individual*. The history of multiple, as well as family, memorials forms a fitting conclusion to our series precisely because taken together, as they were intended, they integrate and elevate the several components to a collective, supra-individual identity. The whole becomes greater than the sum of its parts.

Fig. 6.1. *Mausoleum of Rolandino de' Passaggeri, c. 1305. S. Domenico, Bologna.*

I MAY BEGIN by observing that in the early Middle Ages, one of the most conspicuous kinds of classical mortuary recollection — the individual tomb monument standing free out of doors — virtually disappeared: there was no place for such personal ego-fulfillment in the spiritual domain where the poor had inherited the earth. This kind of individual commemoration was revived only in the late thirteenth and early fourteenth centuries, in two superficially very different but ultimately related forms. For a period of three decades at Bologna there was erected a series of tombs for the great professors of jurisprudence at the university, the leading institution of its kind in Europe [Figs. 6.1–2]. The tombs consist of a base, often a colonnade, supporting an open colonnaded pergola, which contained the sarcophagus proper with relief sculpture, and covered by a canopy in the shape of a pyramid. They were placed in the churchyards adjoining the churches of the mendicant orders, the Franciscans and Dominicans.[2]

These monumental, free-standing, outdoor tombs testify eloquently to the wealth, power, and ambition of the Bolognese lawyers. The

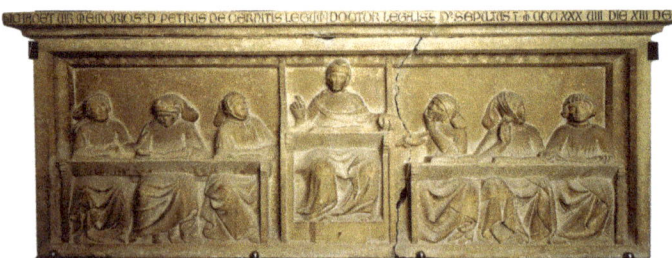

Fig. 6.2. *Roso de Parma, Tomb of Pietro Cerniti, d. 1338. Museo Civico Medievale, Bologna.*

CHAPTER 6 ❧ THE FAMILY CHAPEL

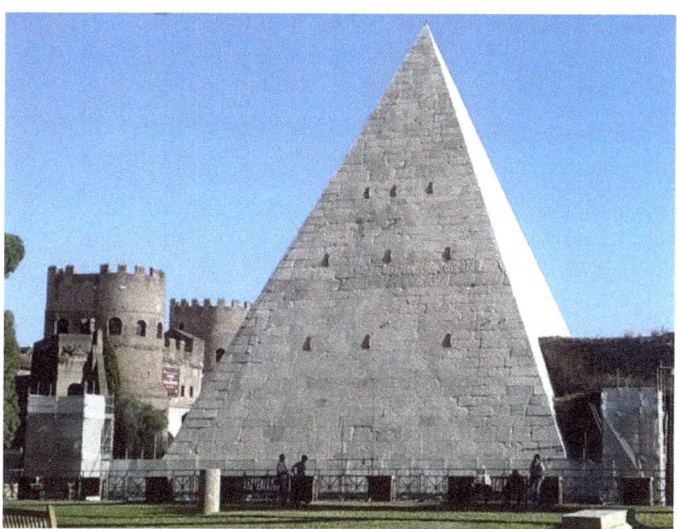

Fig. 6.3 (above). Pyramid of Cestius, Merchant's Tomb, 18–12 BCE. Rome, near Porta S. Paolo.
Fig. 6.4 (below L). Spina (turning point) Roman Circus, Vienne, France; popularly called "Tomb of Pilate."
Fig. 6.5 (below R). Reconstruction of pyramidal topped tomb. Al-Dana, Syria.

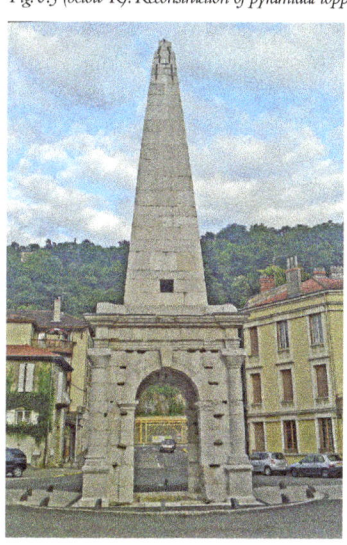 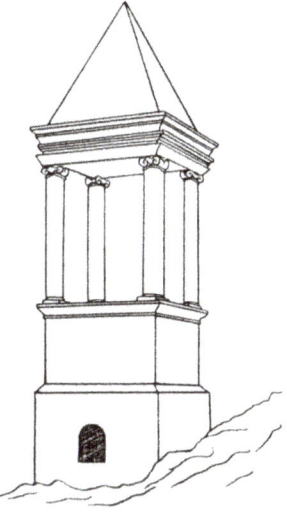

sarcophagi also revive the classical mode of showing the deceased engaged in his métier; the magister was shown *in cathedra*, as it were, teaching a class of students. In illustrations of the virtues, prudence might be shown as a teacher; and the law was, after all, a divine gift, its dissemination a sacred trust. The teacher of the law thus fulfills his sacred trust, performs a public service, and achieves a kind of immortality through his pupils. This academic aspect of the subject matter of the tombs is matched by that of its form, which revives, again for the first time since antiquity, the pyramid form, with all its associations of immortality and arcane wisdom.

Fig. 6.6 (L). Mastino II, Cangrande della Scala, d.1351. Museo di Castelvecchio, Verona.
Fig. 6.7 (R). Bonino da Campione, Tomb of Cansignorio, d.1375. Sta. Maria Antica, Verona.

We are all familiar with the famous Pyramid of Cestius in Rome [Fig. 6.3], but much closer comparisons to the Bolognese tombs can be found among monuments in much more remote places: at Vienne in southern France [Fig. 6.4], for example, or at Al-Dana in Syria [Fig. 6.5].³ University studies at Bologna were closely linked to those in France, and even the eastern antiquities might have been known, for example, from reports of Bolognese participants in the fifth crusade (1217–21), not long before our series begins. It is clear, in any case,

CHAPTER 6 ⚜ THE FAMILY CHAPEL

that the monuments were deliberately academic and recherché, intended to relate a distant and exotic past to the contemporary life of the law and its singularly distinguished practitioners.

The second group of monumental, free-standing, outdoor funerary monument emerged within a few years of the Bolognese series to the north at Verona. There the ruling family, the Scaliger, erected adjacent tombs in the cemetery adjoining the church of Sta. Maria Antica. These tombs were made in the second and third quarter of the fourteenth century, and their design was clearly derived from the lawyer's tombs at Bologna, including the pyramidal crown. The earlier two, that of Cangrande della Scala (d. 1329), and Mastino II (d. 1351, Fig. 6.6) have been dismantled, and the equestrian effigies placed in museum settings. But the latest of in the series, that of Cansignorio (d. 1375) is attached to the building and retains its pyramidal top [Fig. 6.7]. I am aware of no precedent for this combination of features, with its wonderful redundancy: the eternal life of the equestrian surmounts the eternal death of the pyramid — revived in a funereal context, from the ancient tradition of monumental horsemen. The com-mixture of exoticism and antiquity was no doubt deliberate: a visible parallel for the splendid redundancies of the names adopted by the Scaliger — Cangrande, Cansignorio — based on their dog-like fierceness, *cane* (dog), their motto, as in the sculptured dogs between the ears of their horses. The names are significant in another sense: the Scaliger were not of royal blood, but they aspired to powerful dynastic rule as if they were.[4]

The florescence of these groups of isolated tomb monuments was over by the late fourteenth century. But the fact that both series are generally similar in design and grouped together is indicative of an associative spirit they were meant to embody: the academic and professional status of the lawyers, the hegemonic role of a family, the Scaliger. In this sense they adumbrate a new phenomenon in Italy that would characterize the development of funereal commemoration for centuries to come. A new mode of commemorative coming-together emerged, now inside, rather than outside the church, with the development of the family chapel, one of the most conspicuous manifestations of the social transformation that accompanied the great process of urbanization in the late Middle Ages.

139

Several interrelated factors were involved in this development: the creation of a wealthy middle class with the desire and the means to perpetuate itself in a way perhaps comparable to, but also very different from, the aristocratic tradition of the feudal system. A second factor, which I still cling to despite passionate argument to the contrary, was the development of an increasingly coherent sense of the family as a private, consanguineous, "nuclear" (if I may still be allowed to use the word in this context) unit.[5] Still another essential factor was the foundation and phenomenal development of the mendicant orders, which dominated the spiritual life of the cities as the merchant families dominated the social life. The mendicants were above all urban preachers, and their success led to the building of innumerable new churches and the enlargement of old ones, enterprises that were financed by the orders' holy alliance precisely with the wealthy citizens of the city.[6] Typically, the arrangement was embodied in a legal contract between the order and the patron, who, in exchange for a perpetual and exclusive right of burial for himself and his family, would endow the construction, decoration, and liturgical officiation of a chapel in the church. Finally, the spiritual content of the family chapel was intimately bound up with the efflorescence of the cult of the personal or private or patron saint to whom the chapel would normally be dedicated. It was through the intercession of the patron saint that the individual became part of the community of the faithful.[7]

This entire development is in contrast to the medieval scruples against private burial within the church. The practice had been frowned upon since early Christian times, when Theodosius decreed against it, and it was condemned repeatedly thereafter by councils of the church. The proscription was especially strong in monastic churches — one more indication of the revolution brought about by the mendicant orders.[8] Needless to say, the proscription was often honored in the breach, and the feudal nobility had produced various kinds of precedents for the private family chapel: fully isolated private churches, chapel structures attached to the main church, family burial crypts beneath the main church.

The fact remains, however, that all the tombs in Florentine churches before the fourteenth century belong to high ecclesiastics and a

CHAPTER 6 ❧ THE FAMILY CHAPEL

Fig. 6.8. (above). Ground Plan, Sta. Croce, Florence.
Fig. 6.9 (below). Baroncelli Chapel, 1328, General View. End of South Transept, Sta. Croce, Florence.

very few exceptionally honored, secular individuals. Most of us realize the importance to the history of painting of Giotto's work in the Peruzzi Chapel in Sta. Croce. But it is also a striking fact that Donato Peruzzi's testament of 1292, in which he provides for the chapel, is the first known document that refers to an extant private family chapel in a Florentine church.[9]

Physically, the private family chapel had three main constituents: the fabric of the chapel itself, the altar dedicated to the patron saint, and the tomb or tombs of the patron and his family. Subsequent burials might be made without tomb monuments, in the mortuary chamber beneath the chapel floor. Once the components of the private family chapel were called into existence at the beginning of the fourteenth century — the structure itself, the altar, and the tomb — they entered into a kind of dialogue, or rather trialogue, on which we shall try to eavesdrop during the remainder of this discussion.

The earliest chapels that include tombs were commissioned around 1330 in the important Florentine Franciscan friary church of Sta. Croce by the Baroncelli and Bardi families.[10] [Fig. 6.8]. The series began with the Baroncelli Chapel (1328) at the end of the right transept [Fig. 6.9].

141

Fig. 6.10. (L) Attributed to Giovanni di Balduccio di Pisa, Tomb of Baroncelli. Facade, Baroncelli Chapel, Sta. Croce, Florence.
Fig. 6.11 (R). First Tomb of the Bardi Family, 1332. End of North Transept, Sta. Croce, Florence.

The frescos are by Taddeo Gaddi; the altarpiece by is by Giotto; and the tomb is attributed to Giovanni di Balduccio di Pisa [Fig. 6.10]. Each of the elements is conceived separately: the fresco cycle is a series of rectangular fields dividing the wall; the polyptych altarpiece resting on the altar; the tomb placed at the entrance and designed in such a way that it is as much a part of the transept of the church as it is a part of the chapel. The wall above the sarcophagus is even perforated to permit a glimpse from one realm to the other. The only sense of the elements belonging together are the correspondence in the heights of the lower levels of the designs: the height of the tomb, the height of the dado of the fresco, and the height of the altar are the same.

When the second chapel, at the opposite end of the transept was designed for the Bardi di Vernio family in 1332 [Fig. 6.11], it included, to the left of the entrance, a tomb that was clearly intended to match the earlier Baroncelli monument and so establish an echo that helps

CHAPTER 6 ❧ THE FAMILY CHAPEL

Bardi di Vernio Chapel, North Transept, Sta. Croce, Florence. Fig. 6.12 (L). View of left wall.
Fig. 6.13 (R). Maso di Banco and Taddeo Gaddi, Tomb niche with Deposition.
Fig. 6.14 (below). Bartolini Chapel, Right Wall, frescoes by Lorenzo Monaco, 1420–25. Sta. Trìnita, Florence.

to unify the effect of the building.[11] A similar but expanded motif was taken up in the second Bardi di Vernio tomb on the same wall [Fig. 6.12], with paintings by Maso di Banco and Taddeo Gaddi [Fig. 6.13],

143

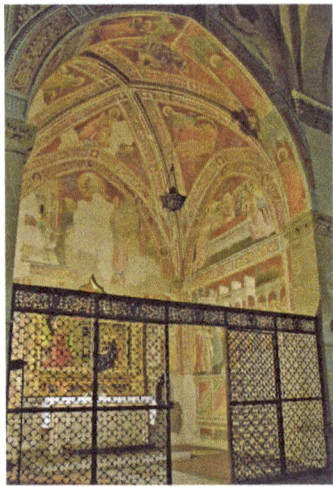

Fig. 6.15 (above). Bartolini Chapel, General View from outside. Sta. Trìnita, Florence.
Fig. 6.16 (below). Benozzo Gozzoli. Painted Altarpiece surrounded by Scenes of the Crucifixion and Saints, fresco, 1452. S. Francesco, Montefalco.

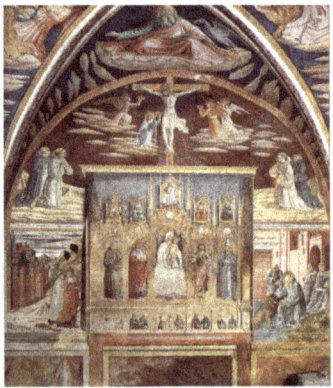

with no discernible relation to the surrounding decorations or the altarpiece except that the lowermost base moldings of the tombs are the same height.

The overall design has been coordinated to a far greater degree almost exactly a century later in a chapel of the Bartolini family in Sta. Trìnita [Fig. 6-14], with decorations by Lorenzo Monaco (1420–25).[12] In both design and subject matter the altarpiece now fits into the framing system and the narrative sequence of the scenes on the walls [Fig. 6.15]; and the height of the dado corresponds to the upper edge of the predella, so a continuous horizontal can be discerned here as well as at the springing of the arch.

In a chapel decoration at the middle of the century at Montefalco, by Benozzo Gozzoli [Fig. 6.16], a pinnacled Gothic altarpiece has been imitated in fresco and included in a rectangular frame, the whole appearing to rest on the altar. Here, the horizontal line corresponds to the altar itself rather than the upper edge of the predella.[13]

CHAPTER 6 ❧ THE FAMILY CHAPEL

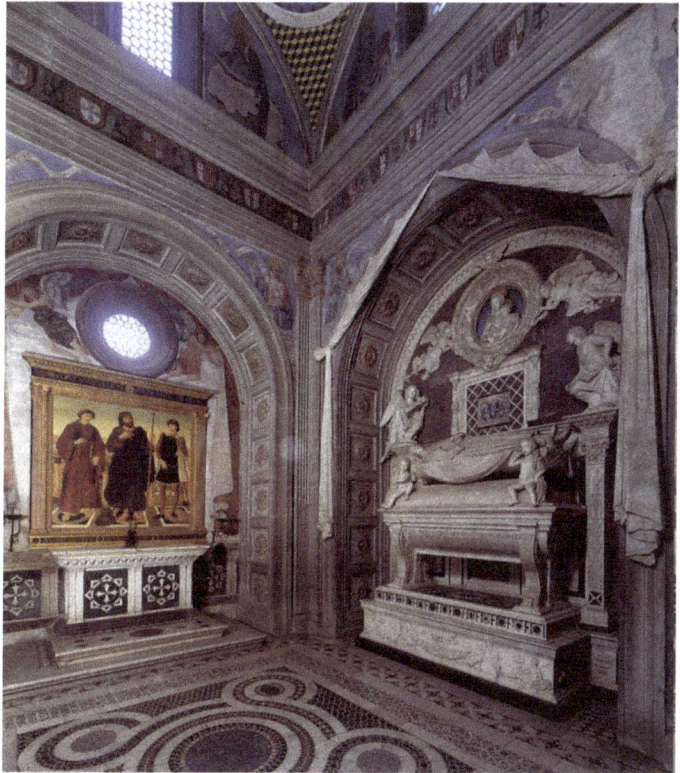

Fig. 6.17. Antonio di Ciaccheri Manetti, Antonio Rossellino, et al. *Chapel of the Cardinal of Portugal*, 1460–72, View toward the Tomb. S. Miniato al Monte, Florence.

WE CAN SPEAK for the first time of an integrated chapel design in the case of one of the jewels of Renaissance decoration, the tomb chapel of the Cardinal of Portugal, at S. Miniato al Monte [Fig. 6.17], with architecture by Antonio Ciaccheri, the altarpiece by Antonio and Piero Pollaiuolo, sculptures by Antonio and Bernardo Rossellino, and frescoes by Alesso Baldovinetti.[14] Although not a family burial chapel, we shall see that the monument nevertheless commemorates the deceased in relation to his family in an extraordinary way. Executed between 1460 and 1473, the chapel

145

Fig. 6.18. Chapel of the Cardinal of Portugal, View of the Entrance. S. Miniato al Monte, Florence.

was constructed *ex novo* and may also be the first coordinated use of architecture, sculpture, and painting in a coherent decoration [Fig. 6.18]. The fabric of the chapel is defined by a single architectural system consisting of corner pilasters supporting a continuous horizontal entablature and framing four arches that circumscribe the entrance and three niches. The pilasters framing an arch and

CHAPTER 6 ❧ THE FAMILY CHAPEL

Chapel of the Cardinal of Portugal. S. Miniato al Monte, Florence. Fig. 6.19 (L). Vault. Fig. 6.20 (R). Pavement.

 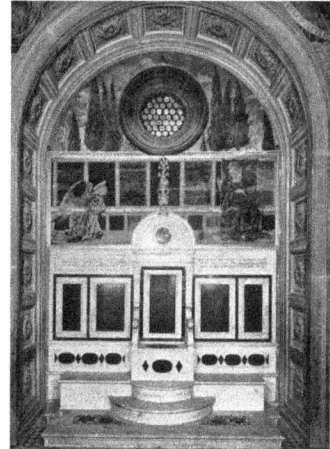

Chapel of the Cardinal of Portugal. S. Miniato al Monte, Florence. Fig. 6.21 (L). View of Back Wall. Fig. 6.22 (R). View of Left Wall.

supporting an entablature have been aptly described as a series of triumphal arches. The designs of the vault and the floor echo one another [Figs. 6.19 and 6.20], as do the elements in the niches. The tripartite design of the back wall [Fig. 6.21] — oculus, altarpiece, altar table (the wall dado and the altar table here have the same molding) — is paraphrased on the left wall [Fig. 6.22] — oculus, frescoed Annunciation, bishop's throne — and on the right wall — the Madonna and Child, a panel of marble incrustation that

147

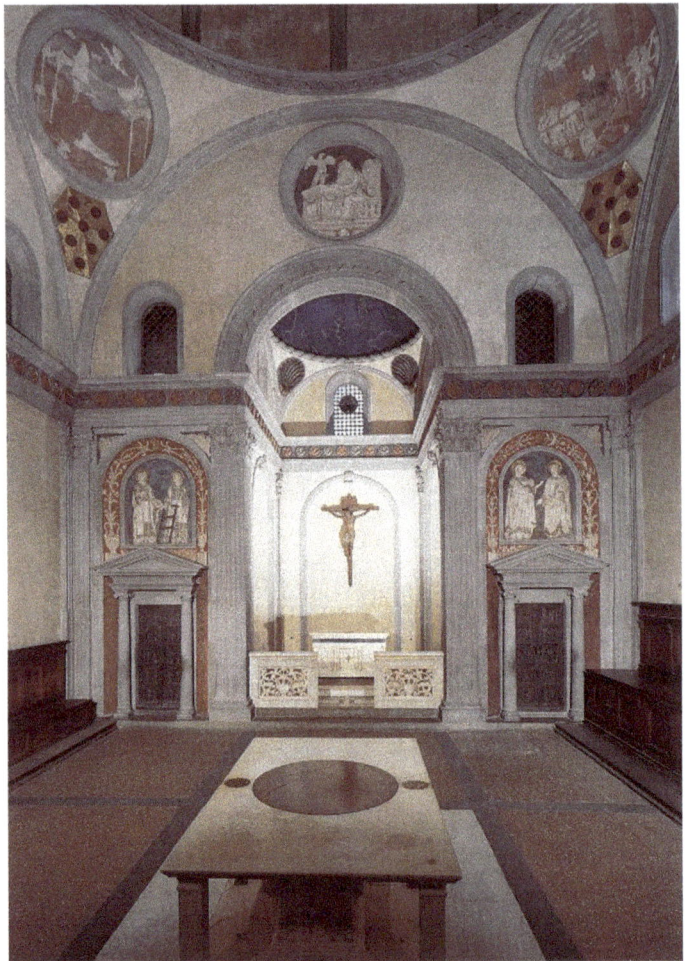

Fig. 6.23. Filippo Brunelleschi, Old Sacristy, 1421–40. S. Lorenzo, Florence.

suggests the kind of open work grille we saw earlier, and the sarcophagus with recumbent effigy below.

The design is clearly an extension of that of Brunelleschi's Old Sacristy in the Church of S. Lorenzo [Fig. 6.23], where also the

CHAPTER 6 ⚜ THE FAMILY CHAPEL

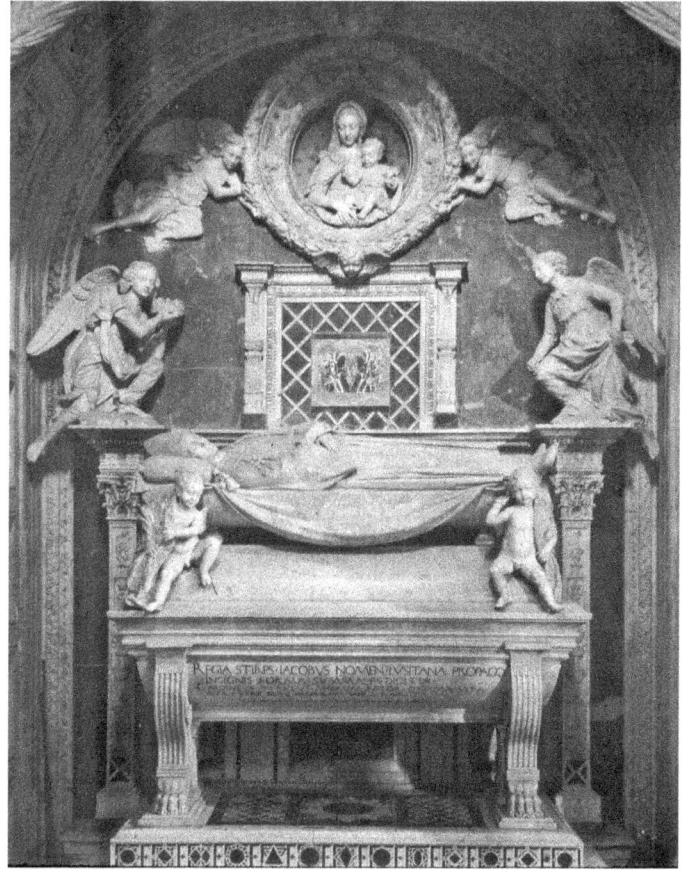

Fig. 6.24. Antonio Rossellino, Tomb of the Cardinal of Portugal. S. Miniato al Monte, Florence.

system of pilasters supporting an entablature and the arches of the vault, and framing arches below, unify the whole space. At S. Miniato the system is more powerful, tightly knit and insistent, a point that is especially evident from the treatment of the tomb [Fig. 6.24]. The type is that of the *arcosolium* tomb, a term derived from the early Christian custom of placing a sarcophagus of the deceased in a niche with a holy image above. Desiderio da Settignano's

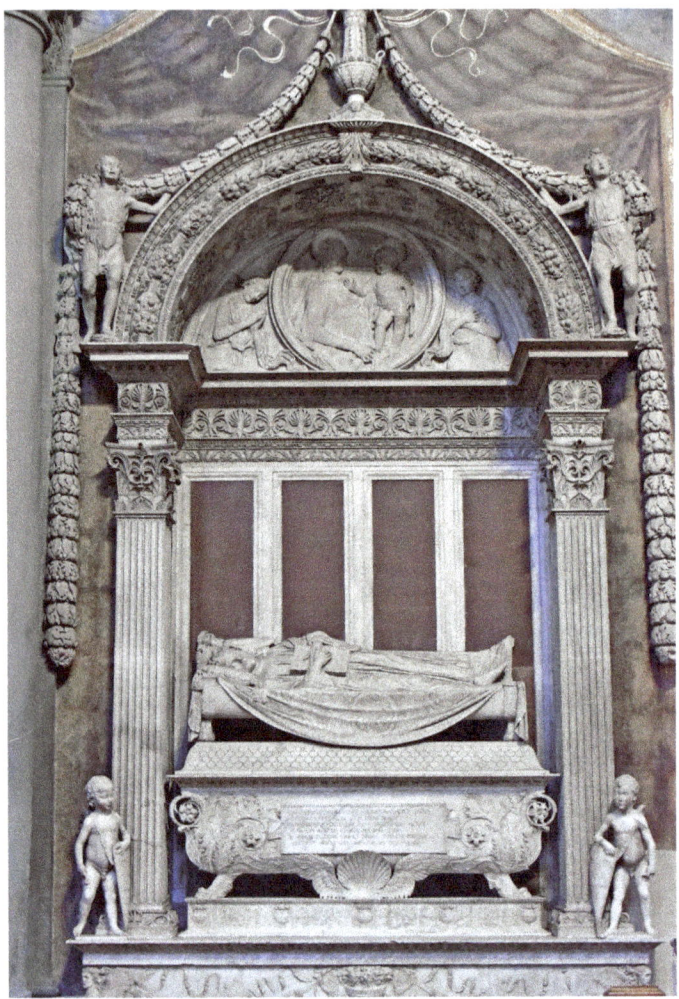

Fig. 6.25. Desiderio da Settignano, Tomb of Carlo Marsuppini, 1453–64. Sta. Croce, Florence.

tomb of Carlo Marsuppini [Fig. 6.25] is a famous Renaissance example of this type, where the niche is framed by pilasters supporting an arch. What is novel in the S. Miniato chapel is that the architecture of the chapel itself provides the frame for the niche, so that

CHAPTER 6 ❧ THE FAMILY CHAPEL

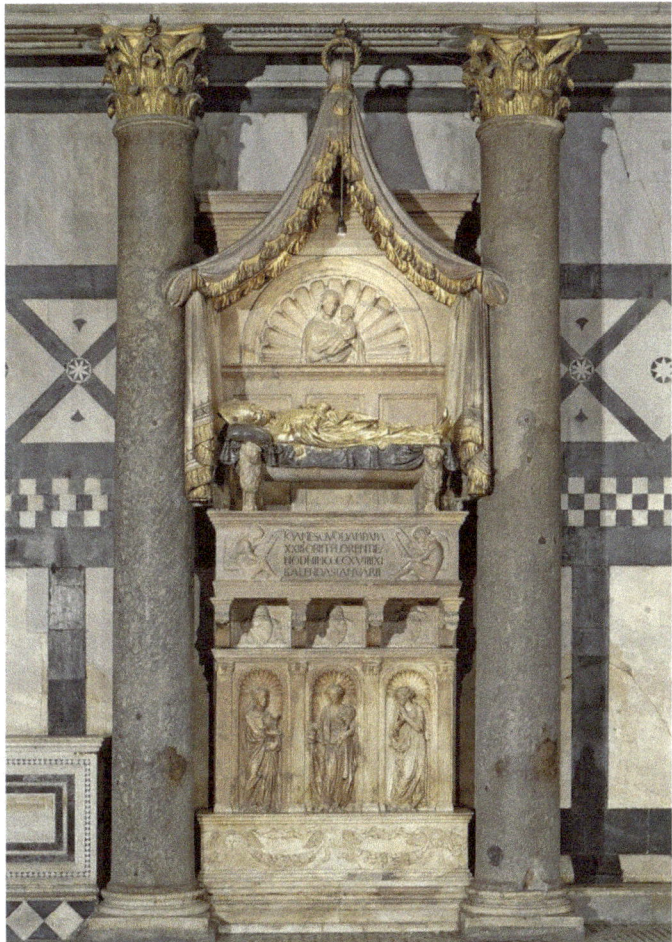

Fig. 6.26. Donatello, Tomb of Pope John XXIII (Baldassare Coscia, d.1419), 1425–27. Baptistry, Florence.

the tomb is literally woven into the overall structure. A precedent for using the architecture of a building as the frame for a tomb was provided by Donatello's tomb of Baldassare Coscia in the Baptistry of Florence [Fig 6.26]. There, however, the architecture pre-existed,

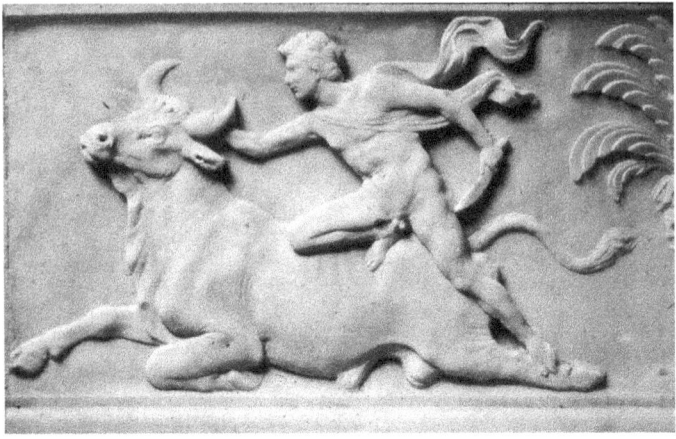

Details of Fig. 6.24. Fig 6.27 (above). Antonio Rossellino, Mithras Slaying the Bull.
Fig. 6.28 (below). Antonio Rossellino, Chariot of the Soul.

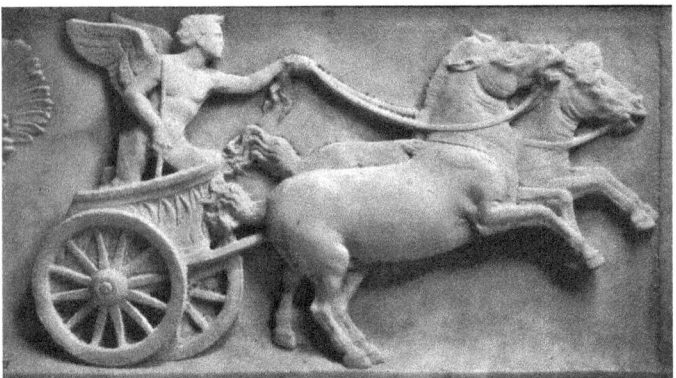

and the narrow space between the columns virtually dictated their incorporation into the tomb as a matter of expediency.

The decoration of the S. Miniato chapel is notorious in that the reliefs adorning the tomb, Mithras slaying the bull [Fig. 6.27], the Platonic chariot of the soul [Fig. 6.28], and other motifs were transferred directly from ancient pagan funerary symbolism. These images provide footnotes, as it were, to the classical spirit that pervades much of the design. But if one pays attention to the fact that the emblems

CHAPTER 6 ⚜ THE FAMILY CHAPEL

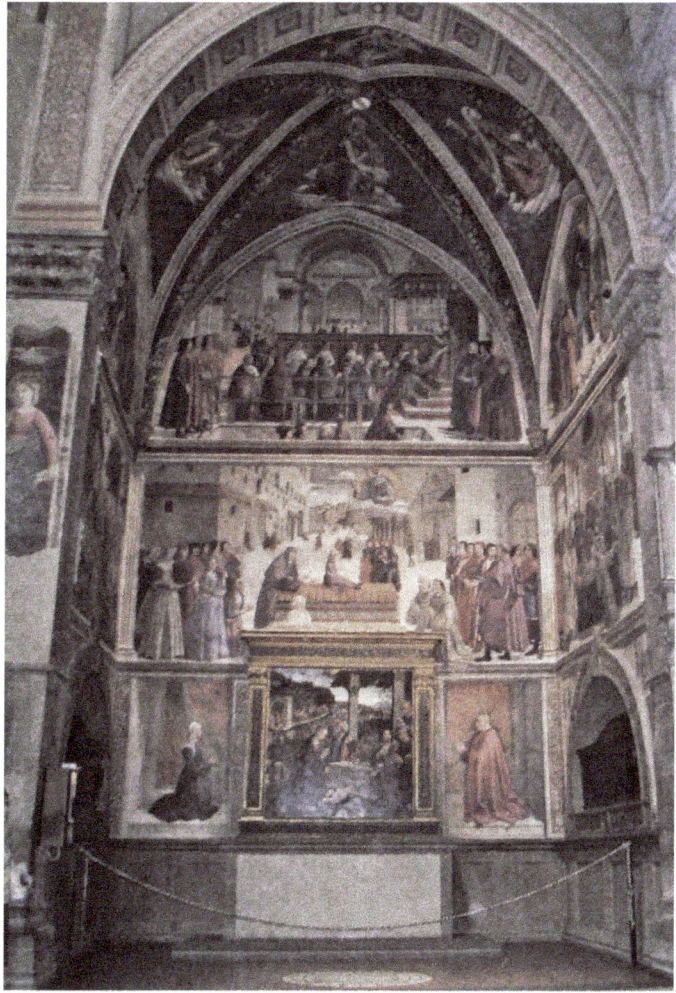

Fig. 6.29. Sassetti Chapel, 1483–86. General View. North Transept, Sta. Trinita, Florence.

are placed along the base of the tomb and are thus superseded by the image of the Virgin and Child above, one realizes that they form part of the triumphal imagery alluded to by the architecture itself.

153

Fig. 6.30. Domenico Ghirlandaio, View of the Right Wall, Sassetti Chapel. Sta. Trinita, Florence.

The "correlative" spirit in which the chapel was conceived is declared publicly in inscriptions. The cardinal had died young, and the building of the chapel was overseen by his friend and tutor, the Portuguese bishop Alvaro di Silves, who recorded that fact in the frieze above the entrance. The interior frieze is decorated with the coats of arms of the cardinal's relatives, and an inscription by the throne opposite his tomb states pointedly that the arms are arranged according to consanguinity, rather than rank; the closer the relationship, the closer the position to the cardinal's tomb. This explicit family unity seems almost a metaphor for the unity of the chapel's design.

In the 1480s, Domenico Ghirlandaio decorated a chapel in Sta. Trinita in Florence for the manager of the Medici bank, Francesco Sassetti, and his wife, Nera Corsi Sassetti [Fig. 6.29].[15] In this case, the task was a refurbishing of an earlier Gothic structure, which Ghirlandaio divided into large, simple panels containing the famous panoramic scenes from the life of St. Francis. The chapel marks a fundamental new achievement in the development we have been tracing. Here for the first time one can speak of a conception of the chapel as a totality that interconnects family tombs, altar, and the rest of the decoration. The tombs of Francesco and Nera [Fig. 6.30], are given the same forms and treated as facing pairs flanking the altar — an arrangement that became standard in funerary chapels for centuries thereafter. Moreover, the tombs are carefully related to the other elements of the organization. A base is provided for the whole structure by a dado on which the sarcophagi rest, as do the platforms on which the kneeling donors

CHAPTER 6 ❧ THE FAMILY CHAPEL

Fig. 6.31. Domenico Ghirlandaio, Statue of David, left Exterior Pilaster, Sassetti Chapel. Sta. Trinita, Florence.

are depicted on the back wall. The cornice-molding of the dado runs continuously round the chapel, incorporating the altar table. Above, the apex of the arches of the tombs touch another molding that also runs continuously, incorporating the architrave of the entablature of the altarpiece. From this molding, in turn, pilasters rise at the corners to frame the narratives on the side and back walls and to support the upper cornice above which the lunettes enframe further scenes.

The theme of the chapel's decoration is announced high on the outer wall above the entrance, where two motifs are depicted. At the left, *David* is shown in grisaille (with metal details in gold), as a statue standing on a pedestal that rests on a pilaster [Fig. 6.31], of which the pier below extends to the ground. David had long since become an emblem of the city of Florence, and Ghirlandaio is here echoing the famous bronze sculptures of Donatello (1430-1440) and Verrocchio (1473–75; Figs. 6.32a and 6.32b). There is a

155

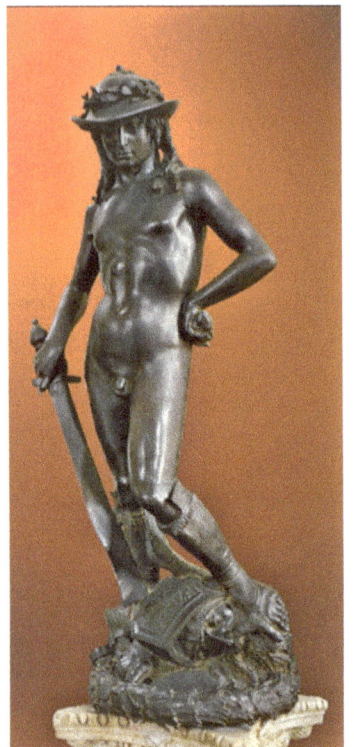 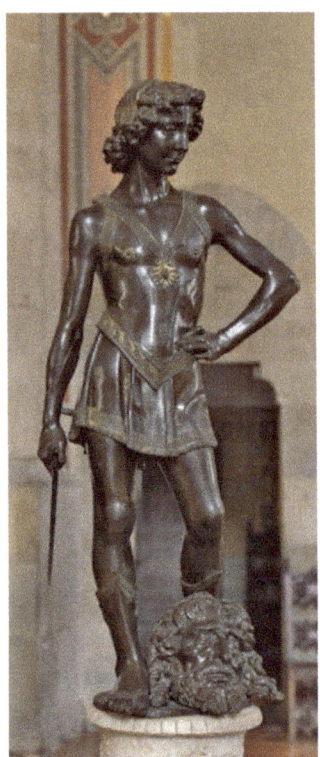

Fig. 6.32a. (L) Donatello, David. Bronze, 1430–40. Museo Nazionale del Bargello, Florence.
Fig. 6.32b. (R) Verrocchio, David. Bronze, 1473–75. Museo Nazionale del Bargello, Florence.

great difference, however, in that Ghirlandaio shows David not as a more or less nude and vulnerable boy, but as a youth in full armor (in the Bible, David rejects the wearing of armor). The dual significance of his role as a military hero is expressed by the inscription on the pedestal:

> TO THE SAFETY OF THE FATHERLAND AND TO CHRISTIAN GLORY, BY DECREE OF THE SENATE AND PEOPLE.

The ancient stigma of the statue on a pedestal has been overcome by baptism, as it were, anticipating what became a familiar act in the

CHAPTER 6 ❧ THE FAMILY CHAPEL

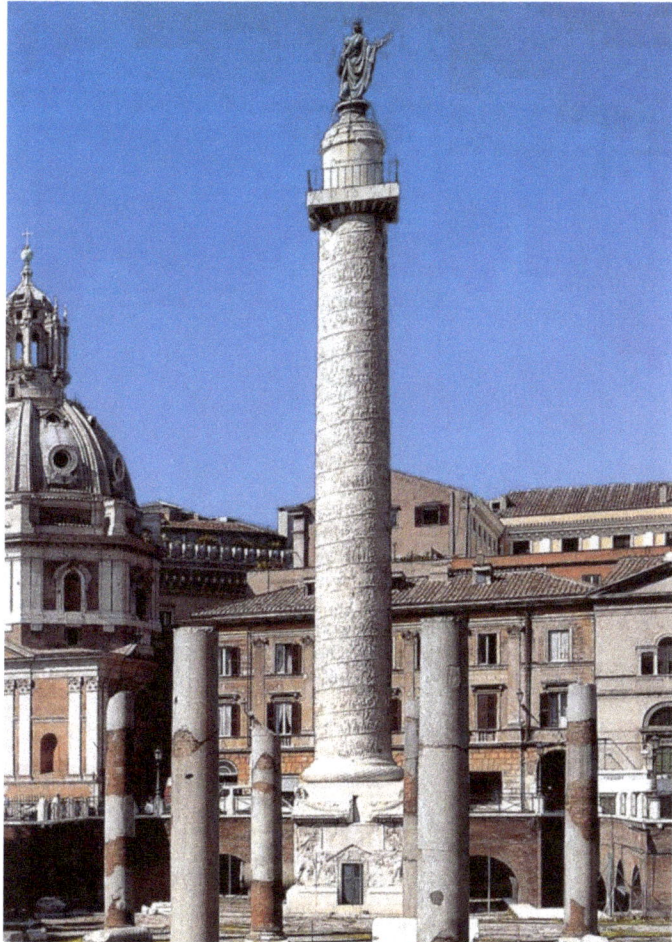

Fig. 6.33. Triumphal Column of Trajan, 106–113 CE. Forum of Trajan, Rome.

period of the Counter-Reformation when ancient statuary bases, notably the great spiral columns in Rome [Fig. 6.33], were actually exorcised and used as supports for statues of Saints Peter and Paul. Here, the leader of the Jews has become the defender of the new Jerusalem, Florence, and of the new faith, Christianity.

Fig. 6.34. Domenico Ghirlandaio, The Vision of Augustus on the Aracoeli, *exterior facade, Sassetti Chapel. Sta. Trìnita, Florence.*

Next to David, directly above the chapel entrance, is depicted a famous vision in which the Emperor Augustus, as prophesied by the Tiburtine Sibyl, saw from the Capitoline Hill in Rome, an apparition of the Savior in the heavens [Fig. 6.34]. The view of Rome from the hill above refers not only to the locale of the vision, but also the Church of the Franciscans on the Capitoline, Sta. Maria in Aracoeli, the Christian sanctuary that replaced the ancient one on the site.[16] In this rendition the usual image of the Virgin and Child is replaced by the Franciscan emblem, best known from St. Bernardino of Siena, of the monogram of Christ in a fiery aureole. As David portrayed the incorporation of Judaism into Christianity and the reincarnation of

CHAPTER 6 ❧ THE FAMILY CHAPEL

Fig. 6.35. *Francesco Sassetti's Tomb, Right Wall, Sassetti Chapel. Sta. Trinita, Florence.*

Jerusalem in Florence, so the story of Augustus and the Sybil converts Rome to Christianity as it is fulfilled in the Franciscan Order.

The theme of the chapel may thus be quite simply stated: the supersession of Hebrew Jerusalem and of pagan Rome, by Franciscan Florence. This concept merging the old and the new is taken up in the interior decorations. The tombs of the patron and his wife consist almost entirely of quotations from classical funerary monuments [Fig. 6.35], whence come the designs of the sarcophagi themselves and the figurative friezes below; and from coins, whence come the medallions and grisaille figure groups in the spandrels of the arches. In other words,

Fig. 6.36 (L). *Sestertius of Vespasian, obverse, 71 CE; Bust of Francesco Sassetti, detail of Fig. 6.35.*

159

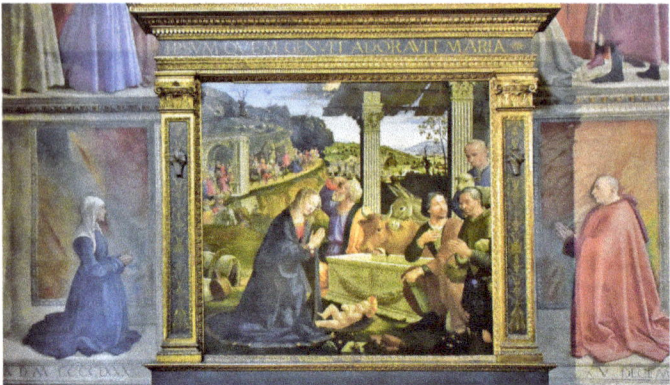

Fig. 6.37 (above). Domenico Ghirlandaio, Donors Flanking Altarpiece. Sassetti Chapel, Altar Wall, bottom tier, Sta.Trinita, Florence. Fig. 6.38 (below). William Sedgwick, Double tomb of Bishop Richard Fleming, 1640–41. Cathedral, Lincoln.

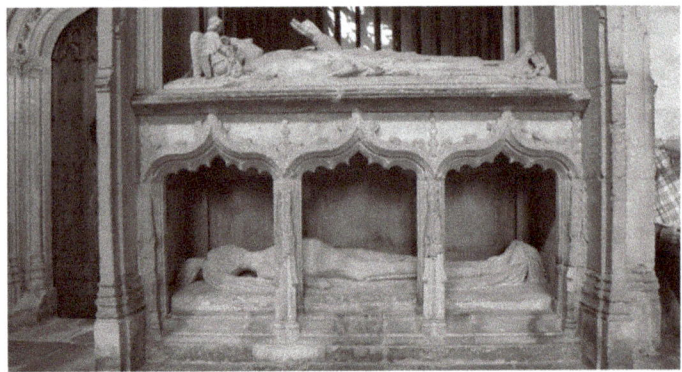

the borrowed motifs are either funereal or celebratory, some of the latter purely Roman, or commemorative, specifically allusive to the conquest of Judea by Vespasian, in 70 CE. The case in point are the nude profile portraits of Sassetti and his wife in roundels at the center of the lower friezes, clearly based on such imperial coin portraits, [Fig. 6.36].[17] They should be thought of in connection with the pairs of portraits on the altar wall [Fig. 6.37] since together they refer to a widespread medieval tradition of double-effigy tomb monuments, in which the deceased was shown twice, once dead and often decaying on the coffin and once above it [Fig. 6.38], resurrected and often kneeling in prayer.[18] The

CHAPTER 6 ❧ THE FAMILY CHAPEL

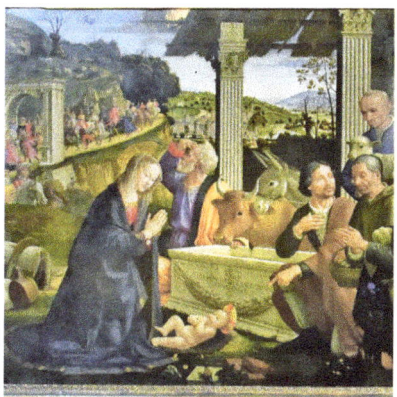

Fig. 6.39. Domenico Ghirlandaio, Nativity of Christ, altarpiece, 1485. Sassetti Chapel, Sta. Trinita, Florence.

medallion portraits here represent the ephemerality of the physical body in a wholly new way: by recalling it alive, but as a memory. This effect is achieved partly by showing the body incomplete, and partly by the reference to antiquity in a form — the numismatic profile portrait — that was specifically commemorative and celebratory. This reference is what creates the sense of nostalgia, of longing for something dead and in the past, yet worth remembering. Nostalgia is itself a form of immortality, after all, and in a Christian funerary context, the nudity of the image would also suggest the purity of the soul and the resurrection of the body at the end of time.

The altarpiece of the *Nativity* celebrates not only the birth of Christ, but also the birth of the new religion, again through the reminiscences evoked by the details [Fig. 6.39]. The Magi in the background pass through a triumphal arch with an inscription alluding to the replacement of the Old Temple by the church. A high priest of the Jews pays homage to the Roman general who, though victorious, yet restored him to the temple. The link between resurrection and the supersession of the old by the new is forged in the empty Roman sarcophagus that the Christ Child uses as a headrest, and from which the animals now are nourished. It bears an inscription referring to a Roman priest who fought against the Jews but in dying prophesied that a new divinity would be born from his tomb.

The narrative scenes are popular mainly, and justifiably, for the extraordinary contemporaneity of their setting and participants. They are redolent with depictions of real, extant buildings and places and

Sassetti Chapel, Sta. Trinita, Florence. Fig. 6.40 (above). Domenico Ghirlandaio, Confirmation of the Rule of St. Francis, *Altar Wall, top tier.*
Fig. 6.41 (below). Domenico Ghirlandaio, St. Francis Revives the Notary's Son, *Altar Wall, middle tier.*

portraits of real, living people. The two scenes on the altar wall are particularly remarkable in this respect because in both cases the famous events depicted took place in Rome, whereas here the settings are clearly identifiable as the Piazza Sta. Trinita below [Fig. 6.40], and the Piazza della Signoria above [Fig. 6.41]. Rome is thus figuratively replaced by Florence as the site hallowed by David's protection and the Sybil's prophecy.

CHAPTER 6 ❧ THE FAMILY CHAPEL

It will already have become apparent that there is a marked difference, in this respect, between the lower and upper parts of the decoration. The explicit Judaic and classical references are virtually all concentrated in the tombs and altarpiece, while the Franciscan scenes above have a vivid sense of modernity. This distinction, in turn, should be considered in relation to the subtle but insistent way in which the sense of resurrection flows through the compositions on the altar wall. It rises vertically from the sarcophagus in the Nativity, through the resuscitating youth in the miracle depicted above, and culminates in the confirmation scene at the top. There a procession of figures — Francesco Sassetti's patron, Lorenzo de' Medici, and his family — seem to rise from the underworld to participate in this utterly mystical event, the benediction of St. Francis and his rule in the town square of modern-day Florence. It is as though the chapel itself were a metaphor for the dual process of supersession and resurrection that is the core of the decoration's meaning. As one rises from the lower to the higher reaches, the glories of the past are lovingly recalled in order to magnify the glories of the present depicted in the scenes above.

The things that distinguish this chapel — the richness and accuracy of its historical references, the richness and unity of the chapel itself, its theme and its design, elements that bind the decorations, the altarpiece, and the patrons into a coherent whole — had not seen their measure, together, before. My argument is, in effect, that these things developed together because they are interrelated and mutually dependent. Memory of the past serves to create awareness and meaning in the present.

I AM MINDFUL that the previous essays have been unbalanced because they focused on memory and the sense of the individual self, primarily as a route to the definition of personal identity. I hope my comments on the family chapel will help to return the scales to something approaching equilibrium. For in becoming aware of himself, the individual becomes aware of his fellows, and I know of no more personal way in which this fact is revealed than in the

development of the family and — in our context — the family chapel. On the tomb of Nera Corsi Sassetti, Francesco had inscribed the following sentence:

> DEDICATED BY FRANCESCO SASSETTI TO THE OMNIPOTENT GOD OF NERA CORSI, MOST GENTLE WIFE [CONIUGI DULCISSIMAE] WITH WHOM HE LIVED GRACIOUSLY [CUM QUA SUAVITER VIVIT].

He repeated the same phrase in Italian in his testament: *"dolcissima et suavissima compagnia."* On his own tomb he had inscribed:

> DEDICATED TO THE OMNIPOTENT GOD BY FRANCESCO SASSETTI FOR HIMSELF, WHILE STILL ALIVE.

He placed the following inscription on the lids of both sarcophagi:

> MADE BY FRANCESCO DI TOMMASO FOR THE GENIUS OF THE SASSETTI.

The phraseology of these inscriptions is common enough separately, but together they draw, with the force of repetition, concentric circles of personal relationships to which Sassetti felt bound by devotion. This larger framework is the last of the series of circles I have been trying to draw in these essays; the increased explicitness and comprehensiveness of historical reference, the increased sense of individual identity and, finally, the increased sense of the individual as part of a larger whole.

This development in the family funerary chapel has analogy in the development of the family itself. Sociologists have described the transformation in the course of the Renaissance from the far-flung and loosely defined, quasi-feudal allegiances of the late Middle Ages to the more coherent and tightly knit "nuclear" family that led in the course of the sixteenth century to the "gentrification" of Renaissance society. In Florence, the shift from republic to dukedom was accomplished by the transformation of the leading families into a true and proper aristocracy.

A centerpiece in this process is the *Treatise on the Family* written by Leon Battista Alberti, the first three books of which were composed 1432–34: Book I on the education of children, Book II on marriage,

CHAPTER 6 ❧ THE FAMILY CHAPEL

and Book III on family and property management.[19] The work is a landmark of Renaissance historicism, for it returns to the ancient form of discourse on moral and civic subjects — the dialogue — and many of its leading precepts derived from classical authors. But it is completely different from the ancient dialogue: written in the vernacular, the characters are members of Alberti's own family, and much of the discourse is couched in terms of contemporary problems and activities. The treatise is also unlike any previous work I can discover in actually being titled "Della Famiglia," and in actually focusing on the family as a conceptual and social entity, which Alberti believes can be preserved and made to prosper by the practice of virtue.

Finally, an interesting and important fact in our context is that a few years later Alberti added a fourth book devoted to friendship, in which the individual's relations to others are extended through the family to the world at large. Friendship is viewed as analogous to the sacrament of marriage. Alberti is at pains to emphasize the difference among individuals; but he also offers a brilliant theory of reconciliation: that the differences are God-given, so that men may have need for one another, and make up for each other's deficiencies. Justice, equity, liberality, and love are instilled in humans by God in order to bind them together in society. One's need for another serves as the cause and means to keep all united in general friendship and alliance. In the end, I suppose, this new ideal of social cohesion, imbued both in form and in substance with the spirit of classical antiquity, is perhaps the noblest achievement of the Renaissance art of commemoration.

❧

NOTES

1. The inaugural and classic study was E. Panofsky's *Tomb Sculpture: Four Lectures on its Changing Aspects from Ancient Egypt to Bernini*, H.W. Janson, ed. (New York: H.N. Abrams, 1964).

2. Figure 6.1 is the Mausoleum of Rolandino de'Passaggeri (Italian Jurist, c.1215–1300), outside S. Domenico, Bologna. See G. Tamba, ed., *Rolandino, 1215–1300: Alle origini del notariato moderno. Catalogo della mostra (Bologna, Museo civico medievale, 12 ottobre–17 dicembre 2000)* (Bologna: Fondazione Cassa di Risparmio in Bologna, 2000). Fig. 6.2 is a relief from the tomb of Pietro Cerniti, 1338, by Roso de Parma, Bologna, Museo civico medievale. See R. Grandi, L. Cervelli, S. Paganelli, and G.L. Reggi, *Per un Museo Medievale e del Rinascimento* (Bologna: Comune di Bologna, 1974).

3. For the Pyramid of Cestius, see C. Di Meo, *La piramide di Caio Cestio e il cimitero acattolico del Testaccio: Trasformazione di un'immagine tra vedutismo e genius loci* (Rome: Palombi Fratelli, 2008). The pyramid in Vienne, France, was the central building of the Roman *circus maximus*. The 25-meter-high obelisk stood in the center of the sand track. Its location on an axial platform *(spina)* was confirmed by excavations in the nineteenth and at the beginning of the twentieth century. Popular legends say that it is the tomb of Pontius Pilate who, after being governor of Judea, died in exile in Vienne. H. Chisholm, "Vienne (town)," *Encyclopædia Britannica*, 11th ed. (Cambridge: Encyclopædia Britannica, 1911). Fig. 6.4: a reconstruction and a rending of a pyramidal-topped tomb at Al-Dana. See E. Lipinsky, *The Aramaeans: Their Ancient History, Culture, Religion* (Sterling, VA: Peeters, 2000); D. Darke, *Syria*, 2nd. ed. (Old Saybrook, CT: Bradt Travel Guides, 2010).

4. It is thought that, at an early time, the name alluded to the great emperor Genghis Khan (c.1162–1227), of the House of Borjigin, Mongolia, but was soon transformed and personalized into *Cane*. See Leonardo Olschki, "Asiatic Exoticism in Italian Art of the Early Renaissance," *The Art Bulletin* 26.2 (1944): 95–106.

5. E.D. Widmer and R. Jallinoja, ed., *Beyond the Nuclear Family: Families in a Configurational Perspective Format* (Bern: Peter Lang, 2008).

6. S.J. Cornelison, N. Ben-Aryeh Debby, and P. Howard, ed., *Mendicant Cultures in the Medieval and Early Modern World: Word, Deed, and Image* (Turnhout: Brepols, 2016).

7. See "Patron Saints," *The Catholic Encyclopedia*, 15 vols. (New York: Encyclopedia Press, 1913). 11:562–67.

CHAPTER 6 ※ THE FAMILY CHAPEL

8. See "Christian burial," at: http://www.newadvent.org/cathen/03071a.htm.

9. L.Tintori and E. Borsook, U. Procacci, preface, *Giotto:The Peruzzi Chapel* (Turin: Edizioni d'arte Fratelli Pozzo, 1965).

10. J. Poeschke, *Italian Frescoes: The Age of Giotto, 1280–1400* (New York: Abbeville Press, 2005).

11. Ibid.

12. A. Tartuferi and D. Parenti, ed., *Lorenzo Monaco: A Bridge from Giotto's Heritage to the Renaissance* (Florence: Giunti, 2006).

13. D.C.Ahl, *Benozzo Gozzoli* (New Haven: Yale University Press, 1996).

14. See the classic study: F. Hartt, G. Corti, and C. Kennedy, *The Chapel of the Cardinal of Portugal, 1434–1459, at San Miniato in Florence* (Philadelphia: University of Pennsylvania Press, 1964).

15. Again classic studies: C. de Tolnay, "Two Frescoes by Domenico and David Ghirlandajo: Sta. Trìnita in Florence. Aby Warburg in Memoriam," *Wallraf-Richartz Jahrbuch* 23 (1961): 237–50; E. Borsook and J. Offerhaus, *Francesco Sassetti and Ghirlandaio at Santa Trinità, Florence: History and Legend in a Renaissance Chapel* (Doornspijk, Holland: Davaco, 1981).

16. See now Claudia Bolgia, *Reclaiming the Roman Capitol: Santa Maria in Aracoeli from the Altar of Augustus to the Franciscans, c.500–1450* (London: Routledge, 2017).

17. For example, a Vespasian sestertius, struck in 71 CE to celebrate the victory in the first Jewish-Roman war. The legend on the reverse says: IVDEA CAPTA, "Judaea conquered." .

18. See, for example, the tomb of Bishop Richard Fleming, founder of Lincoln College, Oxford, reproduced in N.H. Bennett, ed., *The Register of Richard Fleming, Bishop of Lincoln: 1420–1431* (York: Canterbury & York Society, 2009), 1:99.

19. Leon Battista Alberti, *The Family in Renaissance Florence (I libri della famiglia)*, Renée Neu Watkins, trans. and intro. (Prospect Heights, IL: Waveland Press, 1994); idem, *De la famille*, M. Paoli, pref.; M. Castro, trans. (Paris: Belles lettres, 2013).

BIBLIOGRAPHY

Ahl, Diane C. *Benozzo Gozzoli.* New Haven: Yale University Press, 1996.

Alberti, Leon Battista. *De la famille.* M. Paoli, pref.; M. Castro, trans. Paris: Les Belles Lettres, 2013.

———. *The Family in Renaissance Florence (I libri della famiglia).* Renée Neu Watkins, trans. and intro. Prospect Heights, IL: Waveland Press, 1994.

Alföldi, Andreas. "Insignien und Tracht der romischen Kaiser." *Mitteilungen des deutschen archaeologischen Instituts, Römische Abteilung* 50 (1935): 116–17.

Ameri, Gianluca. *Lo specchio del principe: I beni preziosi e il collezionismo di Leonello d'Este,* Genoa: Genova University Press, 2016.

Augustine of Hippo. *De doctrina christiana Libri Quattuor.* Turnhout: Brepols, 1982.

———. *De Trinitate libri quindecim. S. Aurelii Augustini Opera Omnia.* Patrologia Latina 42. Paris: Migne, 1969.

Avery, C.B. *The New Century Handbook of Greek Mythology and Legend.* New York: Appleton-Century-Crofts, 1972.

Babelon, Jean. "Un médaillon de cire du Cabinet des Médailles: Filippo Strozzi et Benedetto da Majano." *Gazette des Beaux-arts* 3 (1921): 203–10.

Bacchi, A., et al., ed. *Bernini and the Birth of Baroque Portrait Sculpture.* Los Angeles and Ottawa: National Gallery of Canada, 2008.

Barocchi, Paola. *Trattati dell'arte del cinquecento.* 3 vols. Bari: Laterza, 1960–62.

Baxandall, Michael. *Giotto and the Orators: Humanist Observers of Painting in Italy and the Discovery of Pictorial Composition, 1350–1450.* Oxford: Clarendon Press, 1971.

Becker, Erich. "Protest gegen den Kaiserkult und Verherrlichung des Sieges am Pons Milvius in der christlichen Kunst der konstantinischen Zeit." In *Konstantin der Grosse und seine Zeit. Römische Quartalschrift.* Supplementheft 19. F.J. Dölger, ed. Freiburg i. B.: Herder, 1913, 155–90.

Bednarski-Lwów, Adam. "Die anatomische Augenbilder in der Handschriften des Roger Bacon, Johann Peckham and Watelo." *Sudhoffs Archiv für Geschichte der Medizin* 24 (1931): 60–78.

Benndorf, O. "Bildnis einer jungen Griechen." *Jahreshefte des österreichischen archäologischen Institutes in Wien* 1. Vienna: Hölzel, 1898.

Bennett, N.H., ed. *The Register of Richard Fleming, Bishop of Lincoln: 1420–1431.* 1. York: Canterbury and York Society, 2009.

Bergin, T.G., and M.H. Fisch. *The New Science of Giambattista Vico.* Ithaca, NY: Cornell University Press, 1968.

Bernard, Aldo S. "The Selection of Letters in Petrarch's *Familiares*." *Speculum* 35.2 (1960): 280–88.

Bianchi-Bandinelli, Ranuccio. *Storicità dell'arte classica.* Florence: Electa, 1950.

Bienkowski, P. *Note sur l'histoire du buste dans l'antiquité.* Paris: Ernest Leroux, 1895.

Billanovich, Giuseppe. "Petrarca, Boccaccio e Zanobi da Strada." In *Petrarca e il primo umanesimo.* Padua: Antenore, 1996, 158–67.

Blaauw, S. de. *Arnolfo's High Altar Ciboria and Roman Liturgical Traditions.* In *Arnolfo's Moment: Atti del convegno internazionale (Villa I Tatti, 26–27 maggio 2006).* D. Friedman, J. Gardner, M. Haines, ed. Florence: Olschki, 2009, 123–40.

Blanck, Horst. "Porträt-Gemälde als Ehrendenkmäler." *Bonner Jahrbücher* 68 (1968): 1–12.

Blümel, C. *Staatliche Museen zu Berlin: Romische Bildnisse.* Berlin: H. Schoetz, 1933.

Boccaccio, Giovanni. *Genealogia deorum gentilium.* V. Zaccaria, ed. In *Tutte le opere.* V. Branca, ed. 10 vols. Milan: Mondadori, 1998, 7–8:1–1813.

—. *Genealogy of the Pagan Gods.* J. Solomon, trans. 2 vols. Cambridge, MA: Harvard University Press, 2011–17.

Bode, Wilhelm von. "Die Ausbildung des Sockels bei den Büsten der italienischen Renaissance." *Amtliche Berichte aus den preussischen*

Kunstsammlungen 40 (1918–19): cols. 112 ff.

Bolgia, Claudia. *Reclaiming the Roman Capitol: Santa Maria in Aracoeli from the Altar of Augustus to the Franciscans, c.500–1450.* London: Routledge, 2017.

Borsi, Franco and Stefano Borsi. *Alberti: Une biographie intellectuelle.* H. Damisch, pref.; K. Bienvenu, S. Rabau, trans. Paris: Hazan, 2006.

Borsook, Eve, and Johannes Offerhaus. *Francesco Sassetti and Ghirlandaio at Santa Trinità, Florence: History and Legend in a Renaissance Chapel.* Doornspijk, Holland: Davaco, 1981.

Bundy, Murray Wright. "The Theory of Imagination in Classical and Mediaeval Thought." *University of Illinois Studies in Language and Literature* 12 (1927): 1–289.

Buonarroti, Michelangelo. *Complete Poems and Selected Letters of Michelangelo.* Creighton Gilbert and Robert N. Linscott, ed. and trans. New York: Random House, 1982.

—. *Rime e lettere di Michelangelo Buonarroti.* Antonio Corsaro and Giorgio Masi, ed. Milan: Bompiani, 2016.

Burckhardt, Jacob. "Skulptur der Renaissance." In *Jacob Burckhardt-Gesamtausgabe* 13. Stuttgart: Deutsche Verlags-Anstalt, 1934.

—. *Civilization of the Renaissance in Italy.* S.G.C. Middlemore, trans. London: Phaidon, 1995.

Caferro, William. *John Hawkwood: An English Mercenary in Fourteenth-Century Italy.* Baltimore, MD: Johns Hopkins University Press, 2006.

Caplan, Harry. "Memoria: Treasure-House of Eloquence." In *Of Eloquence: Studies in Ancient and Mediaeval Rhetoric by Harry Caplan.* A. King and H. North, ed. Ithaca, NY: Cornell University Press, 1970, 196–246.

Chini, Valerie Niemeyer. *Stefano Bardini e Wilhelm Bode: Mercanti e connaisseur fra Ottocento e Novecento.* Florence: Polistampa, 2009.

Cicero, Marcus Tullius. *De inventione; De optimo genere oratorum; Topica.* Harry Mortimer Hubbell, trans. Cambridge, MA: Harvard University Press, 2006.

Clarke, Edwin, and Kenneth Dewhurst. *Illustrated History of Brain Function*. Berkeley, CA: Norman Publishing, 1972.

Collignon, Maxime. *Les statues funéraires dans l'art grec*. Paris: E. Leroux, 1911.

Cooper, Stephen. *Sir John Hawkwood*. Barnsley, South Yorkshire: Pen & Sword Military, 2008.

Corna da Soncino, Francesco, et al. *Fioretto de le antiche de Verona e de tutti i suoi confini e de le reliquie che se trovano dentro in ditta citade*. Verona: Stamperia Valdonega, 1973.

Cornelison, Sally J., Nirit Ben-Aryeh Debby, and Peter F. Howard, ed. *Mendicant Cultures in the Medieval and Early Modern World: Word, Deed, and Image*. Turnhout: Brepols, 2016.

Darke, Diana *Syria*. Bradt Travel Guides. Old Saybrook, CT: The Globe Pequot Press, 2010.

De Rosa, Daniela. *Coluccio Salutati: Il cancelliere e il pensatore politico*. Rome: Aracne Editrice, 2014.

Di Meo, C. *La piramide di Caio Cestio e il cimitero acattolico del Testaccio: Trasformazione di un'immagine tra vedutismo e genius loci*. Rome: Palombi, 2008.

Drusi, Riccardo, ed. *Annotazioni sopra Giovanni Villani: Vicenzo Borghini*. Florence: Accademia della Crusca, 2001.

Egidius of Rome. *Tractatus aureus Egidii Romani De formatione corporis humani in utero ... cum Tractatu ejusdem De archa Noe, correctus ... per ...Johannem Benedictum Moncetum de Castelione Aretino*. Paris: Poncet Le Preux, 1515.

Felletti Maj, Bianca Maria. *Museo nazionale romano: I ritratti*. Rome: Roma Libreria dello Stato, 1953.

Ferraú, Giacomo. "Zanobi da Strada." *Enciclopedia Dantesca* (1970). At http://www.treccani.it/enciclopedia/zanobi-da-strada_(Enciclopedia-Dantesca).

Ferri, Silvio. "Busti fittili di Magna Grecia e l'origine dell'erma." *Atti della Accademia Nazionale dei Lincei. Rendiconti* 18 (1963): 29–42.

Forster, Kurt W. "Metaphors of Rule: Political Ideology and History in the Portraits of Cosimo I de' Medici." *Mitteilungen des kunsthistorischen Institutes in Florenz* 15 (1971): 65–104.

Francesco da Barberino. *I documenti d'amore. Documenta amoris.* 2 vols. Lavis (Trento): La Finestra, 2008.

Francini, Carlo, ed. *Palazzo Vecchio: Officina di opere e di ingegni.* Florence: Silvana, 2006.

Friedlaender, Ludwig. *Darstellungen aus der Sittengeschichte Roms in der Zeit von Augustus bis zum Ausgang der Antonine.* 4 vols. Leipzig: S. Hirzel, 1919–21.

Fritze, H. von. *Die Münzen von Pergamon.* Berlin: Verlag der Akademie der Wissenschaften, 1910.

Furlan, F., and G. Venturi, ed. *Gli Este e l'Alberti: Tempo e misura. Atti del Convegno Internazionale (Ferrara, 29 novembre–3 dicembre 2004).* Pisa: F. Serra, 2010.

Gaullier-Bougassas, Catherine. *Les Vœux du paon de Jacques de Longuyon: Originalité et rayonnement.* Paris, Éditions Klincksieck, 2011.

Ginzburg, Carlo. *Jean Fouquet: Ritratto del Buffone Gonella.* Modena: F.C. Panini, 1996.

Giuliano, Antonio. "Busti femminili da Palestrina." *Mitteilungen des deutschen archaeologischen Instituts. Römische Abteilung* 60–61 (1953–54): 172–83.

Gmelin, Hermann, *Personendarstellung bei den florentinischen Geschichtsschreibern der Renaissance.* Leipzig: B.G. Teubner, 1927.

Gordon, D.J. "Giannotti, Michelangelo and the Cult of Brutus." In *Fritz Saxl 1890–1948: A Volume of Memorial Essays from His Friends in England.* D.J. Gordon, ed. London: Nelson, 1957, 281–96.

Gragg, Florence Alden trans., and Leona C. Gabel, ed. *Memoirs of a Renaissance Pope: The Commentaries of Pius II. An Abridgement.* New York: Capricorn Books, 1959.

Grandi, R., with L. Cervelli, S. Paganelli and G.L. Reggi. *Per un Museo Medievale e del Rinascimento.* Bologna: Grafis industrie grafiche, 1974.

Haftmann, Werner. *Das italienische Säulenmonument*. Leipzig: Gerstenberg, 1939.

Hager, Werner. *Die Ehrenstatuen der Päpste*. Leipzig: Poeschel & Trepte, 1929.

Hartt, Frederick, Gino Corti, Clarence Kennedy. *The Chapel of the Cardinal of Portugal, 1434–1459, at San Miniato in Florence*. Philadelphia: University of Pennsylvania Press, 1964.

Harvey, E. Ruth. *The Inward Wits: Psychological Theory in the Middle Ages and the Renaissance*. London: Warburg Institute, 1975.

Heikamp, Detlef. "Die Bildwerke des Clemente Bandinelli." *Mitteilungen des kunsthistorischen Institutes in Florenz* 9 (1959–60): 130–36.

—. "In margine alla 'Vita di Baccio Bandinelli' del Vasari." *Paragone* 191 (1966): 52–62.

Hekler, Antal. "Studien zur römischen Porträtkunst." *Jahreshefte des österreichischen Archäologischen Institutes in Wien* 21–22 (1922–24): 172–202.

Helbig, Wolfgang. *Führer durch die öffentlichen Sammlungen klassischer Altertümer in Rom*. 4th ed. Tübingen: E. Wasmuth, 1963–72.

Hermann, H.J. "Pier Jacopo Alari-Bonacolsi, genannt Antico." *Jahrbuch der kunsthistorischen Sammlungen des allerhöchsten Kaiserhauses* 28 (1909–10): 201–88. Vienna: Tempsky, 1910.

Hersey, George L. *Alfonso II and the Artistic Renewal of Naples, 1485–1495*. New Haven: Yale University Press, 1969.

Hill, George F. *Medals of the Renaissance*. Oxford: Clarendon Press, 1920.

Hill, Philip V. *The Monuments of Ancient Rome as Coin Types*. London: Seaby, 1989.

Hinks, Roger P. *Myth and Allegory in Ancient Art*. London: The Warburg Institute, 1939.

Holmes, George. *The Florentine Enlightenment, 1400–1450*. New York: Pegasus, 1969.

Hudson, Hugh. "The Politics of War: Paolo Uccello's Equestrian Monument for Sir John Hawkwood in the Cathedral of Florence." *Paragone* 23 (2006): 1–33.

Janson, Horst W. "The Equestrian Monument from Cangrande della Scala to Peter the Great." In *Aspects of the Renaissance: A Symposium.* A. Lewis, ed. Austin, TX: University of Texas Press, 1967, 73–85. Reprinted in *Sixteen Essays by H.W. Janson*. Patricia Egan, ed. New York: Harry N. Abrams, 1974, 157–88.

Jenkins, Marianna. *The State Portrait: Its Origin and Evolution.* New York: College Art Association, 1947.

Jucker, Hans. *Das Bildnis im Blätterkelch.* Olten: Urs Graf-Verlag, 1961.

Kantorowicz, Ernst. "The Este Portrait by Roger van der Weyden." *Journal of the Warburg and Courtauld Institutes* 3 (1940): 165–80.

Karovsov, S. *National Archaeological Museum: Collection of Sculpture. A Catalogue.* Athens: National Archaeological Museum, 1968.

Kaschnitz-Weinberg, Guido von. *Ausgewählte Schriften.* Berlin: Gebr. Mann, 1965.

Keil, Josef. "Hellenistische Grabstele aus Magnesia a. M." *Jahreshefte des österreichischen archäologischen Institutes in Wien* 16 (1913): 178–82.

Keller, Harald. "Die Entstehung des Bildnisses am Ende des Hochmittelalters." *Römisches Jahrbuch für Kunstgeschichte* 3 (1939): 227–356.

—. *Das Nachleben des antiken Bildnisses von der Karolingerzeit bis zur Gegenwart.* Freiburg i. B: Herder, 1970.

Kemp, Martin. "Il 'concetto dell anima' in Leonardo's Early Skull Studies." *Journal of the Warburg and Courtauld Institutes* 34 (1974): 115–34.

Keutner, Herbert. *Sculpture Renaissance to Rococo.* Greenwich, CT: New York Graphic Society, 1969.

Klibansky, Raymond, Erwin Panofsky, and Frix Saxl. *Saturn and Melancholy: Studies in the History of Natural Philosophy, Religion and Art.* London: Nelson, 1964.

Knoche, Ulrich. "Der römische Ruhmesgedanke." *Philologus* 89 (1934): 102–34.

Kolve, V. A. *Chaucer and the Imagery of Narrative: The First Five Canterbury Tales*. Stanford: Stanford University Press, 1984.

Kruse, H. *Studien zur offiziellen Geltung des Kaiserbildes im römischen Reiche*. Paderborn: F. Schöningh, 1934.

La chiesa di San Giorgio in Velabro a Roma: Storia, documenti, testimonianze del restauro dopo l'attentato del luglio 1993. Rome: Istituto poligrafico e Zecca dello Stato, 2002.

Ladendorf, H. *Antikenstudium und Antikenkopie*. Berlin: Akademie-Verlag, 1953.

Langedijk, Karla. "De Portretten van de Medici tot omstreeks 1600." Diss. Amsterdam, 1968.

Lavin, Irving. "On the Sources and Meaning of the Renaissance Portrait Bust." *The Art Quarterly* 33 (1970): 207–26. Reprinted with additions in *Looking at Italian Renaissance Sculpture*. Sarah Blake McHam, ed. New York: Cambridge University Press, 1998, 60–78.

Lemetti, J. "Imagination and Diversity in the Philosophy of Hobbes." Diss., University of Helsinki, 2006.

Leone de Castris, Pierluigi. *Giotto a Napoli*. Naples: Electa, 2006.

Liddell, H. G., and R. Scott. *Greek-English Lexikon*. Oxford: Clarendon Press, 1953.

Liebeschütz, H. ed. *Reginon Prumiensis Abbas en De Harmonica Institutione, el tercer Mitógrafo Vaticano, John Ridewall en Fulcientius metaforalis*. Leipzig: B. G. Teubner, 1926.

Lipinsky, E. *The Aramaeans: Their Ancient History, Culture, Religion*. Sterling, VA: Peeters, 2000.

Lomartire, S. "'Iustitia, maiestas, curialitas:' Oldrado da Tresseno e il suo ritratto equestre nel broletto di Milano." *Arte medievale*, ser. 4.5 (2015): 101–36.

Lorenz, T. *Galerien von griechischen Philosophen und Dichterbildnissen bei den Römern*. Mainz: Zabern, 1965.

Luchs, Allison. *Tullio Lombardo and Ideal Portrait Sculpture in Venice, 1490–1530*. Cambridge: Cambridge University Press, 1995.

Manca, Joseph. "The Presentation of a Renaissance Lord: Portraiture of Ercole d'Este, Duke of Ferrara (1471–1505)." *Zeitschrift für Kunstgeschichte* 52.4 (1989): 522–38.

Manzoni, L. *Bibliografia statutaria e storia italiana*. 3 vols. Bologna: Romagnoli, 1876–93.

Meller, Peter. "Physiognomical Theory in Renaissance Heroic Portraits." In *Acts of the Twentieth International Congress of the History of Art, New York, 1961*. 4 vols. Princeton, NJ: Princeton University Press, 1963, 2:53-69.

Mellini, G.L. *Altichiero e Jacopo Avanzo*. Milan: Edizioni di Comunità, 1965.

—. "Considerazioni su probabili rapporti tra Altichiero e Petrarca." In *Da Giotto al Mantegna: Padova, Palazzo della Ragione, 9. guigno–4. novembre 1974*. Claudio Bellinati and Lucio Grossato, ed. Milan: Electa, 1974, 81-88.

Melli, Lorenza. "Nuove indagini sui disegni di Paolo Uccello agli Uffizi: Disegno sottostante, tecnica, funzione." *Mitteilungen des Kunsthistorischen Institutes in Florenz* 42.1 (1998): 1-39.

Minardi, Mauro. *Paolo Uccello*. Milan: 24 ore cultura, 2017.

Mommsen, Theodore E. "Petrarch and the Decoration of the *Sala Virorum Illustrium* in Padua." *The Art Bulletin* 34.2 (1952): 95–116.

Moretti, Mario. *Il museo nazionale di Villa Giulia*. Rome: Tipografia Artistica Editrice, 1962.

Müntz, Eugène. *L'art à la cour des papes pendant le XVe et le XVIe siècle*. 3 vols. Paris: Thorin, 1879–82.

—. *Les collections des Medicis au XVe siècle*. Paris: Librairie de l'art, 1888.

Musmeci, Marco, ed. *Templum mirabile: Tempio Malatestiano*. Rimini: Fondazione Cassa di Risparmio di Rimini, 2003.

Napione, Ettore. *Le arche scaligere di Verona*. Venice: Allemandi per Istituto veneto di scienze, lettere ed arti, 2009.

Nievergelt, Marco, and S.A. Viereck Kamath Gibbs. *The Pèlerinage Allegories of Guillaume de Deguileville:Tradition, Authority and Influence.* Cambridge: D.S. Brewer 2013.

Noble, T.F.X., trans. *Charlemagne and Louis the Pious: Lives by Einhard, Notker, Ermoldus.* State Park: Pennsylvania State University Press, 2009.

Olschki, Leonardo. "Asiatic Exoticism in Italian Art of the Early Renaissance." *The Art Bulletin* 26.2 (1944): 95–106.

Orlandi, Silvia, ed. *Libro delle iscrizioni dei sepolcri antichi: Pirro Ligorio.* Rome: De Luca, 2009.

Panofsky, Erwin. *Tomb Sculpture: Four Lectures on Its Changing Aspects from Ancient Egypt to Bernini.* H.W. Janson, ed. New York: Abrams, 1964.

Passavant, Gunter. *Verrocchio.* London: Phaidon, 1969.

Paulus Orosius. *Historiarum adversus paganos libri VII. Translated Texts for Historians* 54. A.T. Fear, trans. Liverpool: Liverpool University Press, 2010.

Perry, Marilyn. "A Greek Bronze in Renaissance Venice." *Burlington Magazine* 117 (1975): 204–11.

Petrarca, Francesco. *De viris illustribus. Opere storiche* 3. *De Gestis Cesaris.* S. Ferrone, ed.; G. Nanua, trans. 2 vols. Florence: Le Lettere, 2003–2006.

—. *Familiarium Rerum Libri.* Vittorio Rossi and Umberto Bosco, ed.; Ugo Dotti, Italian trans. 5 vols. Turin: Nino Aragno Editore, 2004.

—. *Letters on Familiar Matters.* Aldo S. Bernardo, trans. 3 vols. New York: Italica Press: 2005.

—. *Sonnets & Songs.* A.M. Armi, trans.; T.E. Mommsen, intro. New York: Grosset & Dunlap, 1946.

Pfisterer Bissolotti, Chiara. *Claudius Claudianus: L'epitalamio per Palladio e Celerina. Commento a carm. min. 25.* Frankfurt-am-Main: PL Academic Research, 2017.

Planiscig, Leo. *Venezianische Bildhauer der Renaissance.* Vienna: A. Schroll, 1921.

BIBLIOGRAPHY

Poeschke, Joachim. *Italian Frescoes: The Age of Giotto, 1280–1400*. New York: Abbeville Press, 2005.

Pope-Hennessy, John, assisted by R. Lightbown. *Catalogue of Italian Sculpture in the Victoria and Albert Museum.* 3 vols. London: H.M. Stationery Office, 1964.

Preimesberger, Rudolf. *Paragons and Paragone: Van Eyck, Raphael, Michelangelo, Caravaggio, and Bernini.* Los Angeles: Getty Research Institute, 2011.

Robert, Louis. "Recherches épigraphiques." *Revue des études anciennes* 62.3 (1960): 276–361.

Romanini, Anna Maria. *Arnolfo di Cambio e lo "stil novo" del gotico italiano.* Florence: Sansoni, 1980.

Rubinstein, Nicolai. "Political Ideas in Sienese Art: The Frescoes by Ambrogio Lorenzetti and Taddeo di Bartolo in the Palazzo Pubblico." *Journal of the Warburg and Courtauld Institutes* 21.3–4 (1958): 179-207.

Schefold, Karl. *Die Bildnisse der antiken Dichter, Redner und Denker.* Basel: B. Schwabe, 1943.

Schlosser, Julius. *Die Kunstliteratur: Ein Handbuch zur Quellenkunde der Neueren Kunstgeschichte.* Vienna: A. Schroll, 1924.

Schottmüller, F. *Die italienischen und spanischen Bildwerke der Renaissance und der Barock 1. Die Bildwerke in Stein, Holz, Ton und Wachs.* 2nd ed. Berlin: De Gruyter, 1933.

Schubring, Paul. *Cassoni.* Leipzig: K.W. Hiersemann, 1923.

Schweitzer, Bernhard. *Die Bildniskunst der römischen Republik.* Leipzig: Koehler & Amelang, 1948.

Sciaparelli, Attilio. *La casa fiorentina e i suoi arredi nei secoli XIV e XV.* Florence: Sansoni, 1908.

Seiler, Peter. "Das Lächeln des Cangrande della Scala." *Zeitschrift für Kunstgeschichte* 62.1 (1999): 136–43.

—. "Untersuchungen zur Entstehungsgeschichte des Grabmals von Cangrande I. della Scala." *Marburger Jahrbuch für Kunstwissenschaft* 25 (1998): 53–77.

—. *Mittelalterliche Reitermonuments in Italien: Studien zu Personalen Monumentsetzungen in den Italienishchen Kommunen und Signorien des 13. Und 14. Jahrhunderts.* Heidelberg: University of Heidelberg, 1989.

Simon, J. "Gods, Greeks, and Poetry *(Genealogia deorum gentilium).*" In *Boccaccio: A Critical Guide to the Complete Works.* Victoria Kirkham, Michael Sherberg, and Levarie Smarr, ed. Chicago: University of Chicago Press, 2013, 235–44.

Solaro, Giuseppe, L. Canfora, and Angelo Mai, ed. *Il sogno di Scipione: Marco Tullio Cicerone, Zanobi da Strada, Metastasio.* Palermo: Sellerio, 2008.

Sorabji, Richard. *Aristotle on Memory.* London: Bristol Classical Press, 1972.

Strenk, N.H. "Albert on the Psychology of Sense Perception." In *Albertus Magnus and the Sciences: Commemorative Essays.* J.A. Weisheipl, ed. Toronto: University of Toronto Press, 1980, 263–90.

—. "Albert the Great on the Classification and Localization of the Internal Senses." *Isis* 65 (1974): 193–211.

Sudhoff, Walther. "Die Lehre von Hirnventrikeln in textlicher und graphischer Tradition des Altertums and Mittelalters." *Archiv für Geschichte der Medizin* 7 (1914): 149–205.

Tamba, Giorgio, ed. *Rolandino, 1215–1300: Alle origini del notariato moderno. Catalogo della mostra (Bologna, Museo civico medievale, 12 ottobre–17 dicembre 2000).* Bologna: Consiglio nazionale del notariato, 2000.

Tartuferi, Angelo, and Daniela Parenti, ed. *Lorenzo Monaco: A Bridge from Giotto's Heritage to the Renaissance.* Florence: Giunti, 2006.

Temple-Leader, John, and Giuseppe Marcotti. *Sir John Hawkwood (L'Acuto): Story of a Condottiere.* L. Scott, trans. London: T. Fisher Unwin, 1889.

Tintori, Lionello, and Eve Borsook; Ugo Procacci, preface. *Giotto: The Peruzzi Chapel.* Turin: Fratelli Pozzo, 1965.

Tolnay, Charles de. *The Tomb of Julius II.* Princeton, NJ: Princeton University Press, 1954.

—. "Two Frescoes by Domenico and David Ghirlandajo: Sta Trinità in Florence. Aby Warburg in Memoriam." *Wallraf-Richartz Jahrbuch* 23 (1961): 237–50.

Venturi, Adolfo. *Storia dell'arte italiana*. 11 vols. Milan: Ulrico Hoepli, 1901–39.

Verdon, Timothy, and Annalisa Innocenti, ed. *Atti del VII centenario del Duomo di Firenze*. 3 vols. Florence: Edifir, 2001.

Vermeule, Cornelius C. *Roman Imperial Art in Greece and Asia Minor*. Cambridge, MA: Harvard University Press, 1968.

Vessberg, Olof. *Studien zur Kunstgeschichte der römischen Republik*. Acta Instituti Romani Regni Sueciae 8. Lund: C.W.K. Gleerup, 1941.

Vico, Giambattista. *Principj di una Scienza nuova 3*. Paolo Cristofolini, ed. Pisa: Edizioni ETS, 2016.

Villani, Filippo. *Philippi Villani De origine civitatis Florentie et de eiusdem famosis civibus*. Giuliano Tanturli, ed. Padua: Antenore, 1997.

Vollenweider, Marie-Louise. *Die Porträtgemmen der römischen Republik*. Mainz: P. von Zabern, 1974.

—. "Der Traum des Sulla Felix." *Schweizerische numismatische Rundschau* 39 (1958–59): 22–34.

Wegner, Max. *Die Herrscherbildnisse in antoninischer Zeit*. Berlin: Mann, 1939.

Weinberg, Bernard. *History of Literary Criticism in the Italian Renaissance*. 2 vols. Chicago: University of Chicago Press, 1961.

Weiss, Roberto. "The Medieval Medallions of Constantine and Heraclius." *The Numismatic Chronicle and Journal of the Royal Numismatic Society* 7th ser. 3 (1963): 129–44.

Widmer, Eric D. and Ritta Jallinoja, ed. *Beyond the Nuclear Family: Families in a Configurational Perspective Format*. Bern: Peter Lang, 2008.

Wilk, Sarah (McHam). "Tullio Lombardo's 'Double Portrait' Reliefs." *Marsyas* 16 (1972–73): 67-86.

Winkes, Rudolf. *Clipeata imago: Studien zu einer Römischen Bildnisform.* Bonn: R. Habelt, 1969.

Witt, Ronald G. *Hercules at the Crossroads: The Life, Works, and Thought of Coluccio Salutati.* Durham, NC: Duke University Press, 1983.

—. "The Rebirth of the Romans as Models of Character *(De viris illustribus)*." In *Petrarch: A Critical Guide to the Complete Works.* Victoria Kirkham and Armando Maggi, ed. Chicago: University of Chicago Press, 2009, 103–11.

Wolfson, Harry Austryn. "The Internal Senses in Latin, Arabic, and Hebrew Philosophic Texts." *The Harvard Theological Review* 28 (1935): 69–133.

Yates, Frances, A. *The Art of Memory.* Chicago: University of Chicago Press, 1966.

Zadoks, Annie N., and Jitta Josephus. *Ancestral Portraiture in Rome and the Art of the Last Century of the Republic.* Amsterdam: N. v. Noord Hollandsche uitgevers-mij., 1932.

Zak, Gur. "Petrarch and the Ancients." In *The Cambridge Companion to Petrarch.* Albert Russell Ascoli and Unn Falkeid, ed. Cambridge: Cambridge University Press, 2015, 141–53.

Zanker, Paul. *Il Foro di Augusto.* Rome: Fratelli Palombi Editori, 1997.

INDEX

A
Accursio 109
Acerenza, cathedral 30
Achilles 70, 71
Acuto, Giovanni. *See* Hawkwood, John
Adam 73
Aeneas 71, 74
Aethalides 9
Akhnaton 48
Alberti, Leon Battista 124–27, 129, 131, 165
Al-Dana 137, 138, 166
Alexander the Great 71, 73, 89
Altichiero (Aldighieri da Zevio) 77, 80–81, 83, 87, 91, 100
Antelami, Benedetto 121, 122
Antinous 59–60
Apollonio di Giovanni, *Triumph of Fame* 99
Arezzo 113
Aristotle 9, 10, 11
Arnolfo di Cambio 128, 129, 134
Arrighi, Giuliano 109
Arthur, king 73
Assisi 69, 95, 96; S. Francesco 89, 120
άτομο 45
Attila 74
Augustine of Hippo 10, 12, 13, 16, 21, 22, 73
Augustinian Hermits 16
Augustus, emperor 43, 84–86, 114, 130, 158, 159, 167
Aurelia Monnina 24
Avanzi, Iacopo 81
Averroes 11
Avicenna 10, 16

B
Baldovinetti, Alesso 145
Bandinelli, Baccio 58, 59, 60, 61, 64, 67
Barberino, Francesco da 92–97, 103; Giotto 100, 101
Bardi di Vernio 142–43
Bargellesi-Severi, Angelo 124, 134
Baroncelli: family 141–42; Niccolò 123–24
Baxandall, Michael 7
Beatrice of Aragon 54
Benzo d'Alessandria 82
Bernardino of Siena 158
Bible 12, 156; Genesis 16; Old Testament 71, 74, 92
Boccaccio, Giovanni 109; *Amorosa Visione* 97, 100, 101; *Decameron* 101; *De genealogia deorum* 95
Bologna 17; S. Domenico 136; tomb monuments 136–39
Boniface VIII, pope 16
Bonino da Campione 121, 138
Bracci, Alessandro 36, 37, 49, 50
Bracciolini, Poggio 66
Brunelleschi, Filippo 48, 148
Brutus 57, 58, 67
Buonarroti, Michelangelo. *See* Michelangelo.

Burckhardt, Jacob 6, 21, 41, 64, 66
busts, reliquaries 31–34, 51, 67
bustum 29, 30–32, 40, 50

C

Caesar, Julius 58, 71, 73
Calliope 13
caput 46
Caracalla, emperor 42, 57
Cardinal (James) of Portugal 145, 146, 147, 149, 167
Carrara 80; Francesco il Vecchio da 87; library 75
Cassirer, Ernst 1
Cathars 133
Cellini, Benvenuto 60, 61, 64, 67
Cerniti, Pietro 136, 166
Charlemagne 71, 72, 73, 74, 85, 102, 107
Charles V, emperor 61
Chrysostom, John 92, 103
Ciaccheri, Antonio 145
Cicero 12, 13, 15, 21, 45
Cimabue 100
Claudianus (poet) 108, 132
Claudius, emperor 130
cognitive theory 1
Constantine, emperor 107, 118
Corna da Soncino, Francesco 80
Corsi, Nera. *See* Sassetti, Francesco.
Corsini: Pietro 113; Roberto, cardinal 112, 113
Coscia, Baldassare. *See* John XXIII, anti-pope.
Counter-Reformation 64, 157

D

da Maiano, Benedetto 39
Dante 20, 49, 101, 132; Florence 109; Salutati 107
Da Settignano, Desiderio 52, 66, 149
David, king 2, 73, 155, 156, 158, 167
de'Dagomari, Pagolo 7
de Degeuileville, Guillaume 13
degli Albizzi, Albiera 36, 50
della Luna, Rinaldo 39
della Mirandola, Pico 35
della Porta, Guglielmo 63, 64
della Scala 86; Cangrande 41, 122, 138–39; Cansignorio 80, 83, 121, 138–39; Mastino II 138–39
del Sellaio, Jacopo 25
d'Este: Alberto 123, 129; Borso 41, 125, 129, 134; Ercole I 127; Leonello 124, 125, 134; monuments 126–27; Niccolò III 123–24, 134; rule in Ferrara 129
di Cristoforo, Antonio 123, 124
Diogenes Laertes 9
di Silves, Alvaro 154
disjecta membra 19
Dominican Order 136
Donatello 32, 33, 67, 91, 130, 131, 151, 155–56
Drusus 130

E

Einard's *Lives* 102
ekphrasis 37

England, cognitive theory 17
equestrian monuments 23,
 107–34
Erasmus, Desiderius 36

F
Fabius, consul 113, 114, 130
Farnese, Piero 109–10, 112, 117
Ferrara 41, 127, 129, 131; Napoleonic occupation 125; Palazzo Ducale 124–25
Ficino, Marsilio 36
Firenzuola, Agnolo 45
Fleming, Richard 160, 167
Florence 100: Badia 48; Casa Palmieri 35, 44; cathedral 108–9, 112–15, 133; Franciscans 159, 163; Giotto 69; grand duchy 57; historiography and rhetoric 68; humanism 36; illustrious men 80; New Jerusalem 157, 159; new Rome 163; Palazzo Medici 24, 48; Palazzo Vecchio 107; Piazza della Signoria 162; Piazza Sta. Trinita 162; republic 57, 108–9, 114, 119, 164; Signoria 108, 109; S. Lorenzo 148, 149; S. Miniato al Monte 145–50, 152; Sta. Croce 141–43, 150; Sta. Trinita 143–44, 153–55, 158, 159, 161, 162; tomb monuments 140; Via de' Pianellai 35, 44
Fludd, Robert 17
Foster, Phillip 66
Franceschini, Adriano 134

Franciscan Order 136, 158; Florence 141; Rome 159
Francis of Assisi 89, 154, 162, 163
Frederick II, emperor 30, 47

G
Gaddi, Agnolo 109, 142, 143
Galen 10
Genghis Khan 166
Ghiberti, Lorenzo 69
Ghirlandaio, Domenico 154–56, 158–62
Gilbert, Felix 68
Gilles of Rome (Egidius Romanus) 16
Gilles of Viterbo 16
Giotto di Bondone 7, 69–79, 90, 97, 104; Altichiero 100; Arena Chapel 89, 100; Assisi frescoes 89, 95; Boccaccio 97, 101; *Invidiousness* 100; Milan, *Gloria* fresco 87, 95, 96, 97, 100; Naples frescoes 44, 49, 57, 63, 69, 71, 73, 74, 79, 89, 100, 101, 133; painting of Virgin 101; Peruzzi Chapel 141, 142; Petrarch 101; secular paintings 91
Giovanni da San Miniato 38
Giovanni di Balduccio 142
Giugni, Bernardo 48
Godefroi de Bouillon 73
Gonella, comedian 7, 21
Gozzoli, Benozzo 144, 167
Grace Dieu 13–14

H
Hadrian, emperor 59
Hannibal 89, 113
Hawkwood, John 108–12, 114–16, 119, 130
Hector 71, 73, 74
Hercules 71, 74
herma 29
Hermes, god 9
Hinks, Roger 1–3, 9, 21, 101, 108
Hobbes, Thomas 19
Homer 20

I
ἰδιώτης 45
imagines clipeatae 29, 39, 45, 46, 84
individuus 29
Ingelheim 71, 74
inscriptions 26, 37, 83, 86, 108, 115, 118, 127, 154, 164

J
Jerusalem: destruction of 82, 83, 87; heavenly 13; Hebrew 159; New 157 (*see also* Verona); war 80–81
John XXIII, anti-pope 151
Josephus 80, 82, 83
Joshua 73
Judas Maccabeus 73
Julius II, pope 16
Junius Bassus, prefect 96, 97

K
Kitzinger, Ernst 47
Knoche, Ulrich 91, 92, 103

L
La Manta 72, 73
Laurana, Francesco 54
Leonardo da Vinci 131
Leoni, Leone 61, 62
Leo X, pope 16
Ligorio, Pirro 118, 133, 178
Lombardo della Seta 75, 88; portrait 91
Longobard kingdom 74
Lorenzetti, Ambrogio 67, 79
Louis the Pious 102
Luther, Martin 34, 36

M
Maestro delle Vele 96
Manetti: Antonio di Ciaccheri 145; Giannozzo 35, 48, 49
Manfredi, Astorgio 38
Mansionario, Giovanni 84, 85
Mantegna, Andrea 81
manuscripts: Darmstadt, Hessische Landesbibliothek, Ms. 101 77, 88; Florence, Biblioteca Laurenziana, Ms. Strozzi 174 70; Florence, Biblioteca Ricciardana, Ms. 1129 99; Naples, Biblioteca Nazionale, MS XIII.B.B., 301 118; Paris, Bibliothèque nationale de France, Ms. Fr. 143 5; Ms. Fr. 823 14; Ms. Gr. 139 2; Ms. Lat. 6069 I 75; Ms. Lat. 6069 I 76; Ms. Lat. 11229 11; Rome, Biblioteca Apostolica Vaticana, Ms. Barb. Lat. 4076 93, 94; Ms. Barb. Lat. 4077 93,

INDEX

95; Ms. Chig. I, VII, 259 85;
Ms. Chigi L. VIII, 296 120;
Ms. Pal. Lat. 1066 15; Rossano,
Codex Rossanensis 3; Vienna,
Oesterreichische Nationalbibliothek, Ms. 5210 11
Marcus Nonius Balbus the Younger, 126
Marsili, Luigi de' 109
Marsuppini, Carlo 150
Maso di Banco 143
Maximinus I Thrax, emperor 84
medallions 23, 34, 80, 82 84, 91, 96, 118, 159, 161
medals 23, 84, 87
Medici, de': Cosimo 35, 61, 64, 67; Cosimo I, grand duke 56, 58, 60, 61, 67; Giuliano 42, 44, 54; inventory 42, 46, 49; Lorenzo 36, 163; Piero 24, 35, 38
Mellini, Pietro 39
memory 1, 2, 3, 8–22, 69, 109, 112, 135, 161, 163
Michelangelo 2, 13, 17, 18, 19, 21, 57, 58, 59, 67
Middeldorf, Ulrich 43, 49
Milan 74, 77–79, 87, 89, 95, 97, 100, 101; Palazzo della Ragione 121, 122; papacy 123; Sant'Ambrogio 119
Mini, Alessandro 38
Mino da Fiesole 24, 38, 39, 48
Mithras 152
Monaco, Lorenzo 143, 144
Montefalco 144
Moses 73

N
Naples: Castel Nuovo 69; Giotto frescoes 44, 49, 57, 63, 69, 71–74, 79, 89, 100–101, 133
Nemesius of Emesa 10
Neroni, Dietisalvi 39
Nigellus 71, 74, 102
Nine Worthies 72, 73
Noah 82
Novato, Mabilio 50

O
Octavian 64
Oldrado da Tresseno 121, 122, 133
Ovid 92, 114
Oxford, Lincoln College 167

P
Padua 69, 76, 103; Arena (Scrovegni) Chapel 78, 89, 90, 100; Carrara court 75, 80, 87, 88, 91; Gattamelata Equestrian Monument 130, 131; Piazza del Santo 130; Sala dei Giganti 87, 88, 91; university 89
Pallivicino, Pietro Sforza 45
Palmieri, Matteo 35, 39, 44, 49
Panofsky, Erwin 5
Paris 118; Louvre 48
Paris, hero 71
Parler, Peter 30
Pastrengo, Guglielmo da 82
Paul III, pope 63, 64
Paulus Orosius 72, 102

187

Penthesilea 71
Peruzzi, Donato 141
Petrarch, Francesco 4, 17–19, 132; Carrara 75, 101; Charles IV, emperor 86; *De viris illustribus* 73, 74, 75, 76, 77, 83, 87, 88, 89, 100; Florence 109; Francesco il Vecchio da Carrara 87; Giotto 101; *I Trionfi* 100; Naples frescoes 100; Padua 87, 100; Pastrengo 83; portrait of in Padua 88, 91; portrait of in Verona 80, 82, 86; Salutati 107; Scaliger palace 80, 82, 83, 100; *Spirto gentil* 17–18; Titus 83; Vespasian 86, 102
Piedmont 72, 73
Piero di Cosimo 42
Pietramala, Giovanni 113
Pippin, prince 102
Pius II, pope 46, 49, 67
Plato 9, 11, 12, 34
Pliny, elder and younger 43, 44, 85, 86
Plutarch 73, 114
Pol de Limburg 118
Polixena 70, 71
Poliziano, Angelo 36, 50
Pollaiuolo: Antonio 40, 145; Piero 145
Pompey the Great 64
portrait style: Florence 61; Rome 64; Venice 62
Prague Cathedral 30
Probus, emperor 96
πρόσωπον 46

προτομή 46
protome 28, 29, 30, 34, 46
Pyrrhus 89
Pythagoras 9

Q
Q. Fabius Maximus 113

R
Ravenna, S. Vitale 84
Ridewall, John 14, 15
Rienzo, Cola di 17
Rimini, Tempio Malatestiano (S. Francesco) 125
Robert of Anjou, king 69, 73
Rolandino de' Passaggeri 136, 166
Romano, Paolo 46, 67
Rome: ancient monuments 89; Arch of the Money-Changers 129; Capitoline Hill 114, 158; Francis of Assisi 162; imperial coins 126; jubilee 123; Pantheon 110; Pyramid of Cestius 137, 138, 166; S. Giorgio in Velabro 129; Sant'Andrea in Catabarbara 96; spiral columns 157; Sta. Cecilia in Trastevere 129; Sta. Maria in Aracoeli 158
Romulus 83, 89
Roso de Parma 136, 166
Rossellino: Bernardo 66, 145; Antonio 35, 38, 39, 51, 52, 56, 66, 145, 149, 152
Rossore, St. 32, 33, 34, 67

S
Salutati, Coluccio 107, 108, 109

INDEX

Saluzzo, marquis 72, 73
Samson 71
Sangallo, Francesco da 55, 56, 58, 60, 61
Sassetti Chapel. *See* Florence: Sta. Trìnita.
Sassetti: Francesco 39, 154, 159, 160, 163, 164
Scaliger. *See* della Scala.
Scheggia, Giovanni, *Triumph of Fame* 98
Sculptured busts 23
Sedgwick, William 160
Shakespeare, William 20
Shem 82
Siena 79, 113
Solomon 71
Soncino, Francesco Corna da. *See* Corna da Soncino, Francesco.
Strozzi: Filippo 39; Niccolo 38
Suetonius 114, 130

T
Tertullian 92, 103
Theodosius, emperor 140
Tiburtine Sibyl 158, 159, 163
Titus and Vespasian 80, 81, 83, 86, 159, 160, 167
tomb monuments 108, 117, 119, 135–168
totus homo 34–36
Trajan, emperor 89, 157
Treviso 100
Trionfo, Agostino, OSA 17
truncus 29

U
Ubaldini, Giovanni degli 113
Uccello, Paolo 111–19, 130, 133

V
Vasari, Giorgio 41, 42, 69, 80, 81, 82, 83, 86, 117, 118
Venice 62, 131; republicanism 63; Sta. Maria dei Frari 116
Verino, Ugolino 50
Verona: Minor Jerusalem 82; Scaliger palace and court 80–84, 86, 122, 123, 139; Sta. Maria Antica 121–23, 138, 139
Verrocchio, Andrea del 53, 54, 55, 56, 67, 131, 155, 156
Vico, Giambattista 1, 19, 20, 108
Vienne 137, 138, 166
Villani: Filippo 7, 8, 21, 109; Giovanni 120
Visconti, Azzone 74
Vittoria, Alessandro 62, 63
Voeux du Paon 73
vultus 46, 50

W
Warburg Institute 1
Wenceslaus I, king 30
whole man. *See totus homo.*
Wittkower, Rudolf 34

Y
Yates, Frances 9, 21

Z
Zanobi da Strada 107, 109, 132
Zeus 2

*Production of This Book Was Completed on
1 September 2020 at Italica Press,
Clifton, Bristol, United Kingdom.
It Was Set in Adobe Bembo,
Adobe Bembo Expert &
Montotype Botanical
Ornaments*

www.ingramcontent.com/pod-product-compliance
Lightning Source LLC
Chambersburg PA
CBHW040107180526
45172CB00009B/1258